Watercolour Painting

Ron Ranson

WATERCOLOUR PAINTING

The Ron Ranson Technique

BLANDFORD

Blandford Press

an imprint of
Cassell plc
Villiers House,
41–47 Strand,
London, WC2N 5 JE

First published 1984
Reprinted February 1985
Reprinted October 1985
Reprinted December 1985
Reprinted June 1986
First paperback edition May 1987
Reprinted February 1988
Reprinted June 1989
Reprinted October 1990

British Library Cataloguing in Publication Data

Ranson, Ron
 Watercolour painting.
 1. Water-color painting—Technique
 I. Title
 751.42′2 ND2420

ISBN 0 7137 1991 5

Distributed in the United States by
Sterling Publishing Co., Inc.,

387 Park Avenue South,
New York, N.Y. 10016

Distributed in Australia by
Capricorn Link (Australia) Pty Ltd.,
PO Box 665, Lane Cove, N.S.W. 2066

Typeset by Polyglot Private Limited
Printed in Hong Kong by Wing King Tong Co. Ltd.

Contents

Acknowledgements

I would like to offer my grateful thanks to Julia Evans and Megan Harris for typing the manuscript from my almost unintelligible scribble, and to Ray Mitchell for taking all the photographs. Being determined to design the book myself, from cover to cover, I would like to acknowledge, gratefully, the hours of patient collaboration that Sue Lovatt has given me in this direction.

Finally, I am indebted to my patient and understanding wife, Audrey, who as well as providing thousands of cups of coffee at all hours, has supported me loyally throughout this long task.

Introduction

Please don't skip this bit!

Over the years a false mystique has been built up around the subject of watercolour painting and the practice has seemed to be weighed down by rigid rules, dogma and ritual. This has had the effect of scaring would-be watercolourists and filling them with so many inhibitions that some never get around to the sensual pleasures of loose washes and risky wet-into-wet techniques but pick their way carefully and slowly through tight little pictures, fearing to make mistakes, preferring safety to flair.

In this book I hope to sweep aside the cobwebs and let some air into the subject—to give you a taste of the fantastic excitement of the medium once you have cast aside the shackles.

I myself, like many of you who are reading this book, started the painting game late in life. Having been told at school that no one could ever make a living out of art, which was my only good subject, I went into engineering and then publicity.

Finally, losing my job in middle age through takeovers, and without any formal art training, I decided to try and make my living by painting. No one had ever told me it was too difficult so I chose watercolour—the best decision I ever made.

Once the die was cast, I had to learn fast. I hadn't time for a leisurely progression through art school, or even local evening classes, some of which seemed to me to be nothing more than social gatherings, with little attempt to teach or learn positively.

No, I had to find my own way to turn out reasonably professional work in as short a period as possible. Work, not for indulgent friends and family to coo over, but which would, I hoped, sell anywhere in the world, and keep me reasonably solvent for the rest of my life.

Being a Capricorn I did however possess a burning ambition and that absolutely essential ingredient—enthusiasm. Happily, I've found that enthusiasm is infectious and I've discovered I have the God-given gift of passing this on to literally thousands of people all over the world, through demonstrations, seminars, painting holidays, magazine articles and now through this book.

I'm not an academic. Of necessity I've learnt my craft, which I've come to know and love, in as short a time as possible. The techniques are based largely on common sense and I am anxious to share the details with as many like-minded people as I can. Flip through this book and if the work shown is not your idea of watercolour, put the book back on the shelf. But if you like what you see—follow me!

Fears, faults and philosophy

I'm a compulsive collector of books on painting and have a large library of them at home. Even when I'm abroad I still manage to find a few more I haven't seen before to add to my hand luggage. Many are excellent, but the majority of them seem to follow the same basic pattern of a collection of work by 'the master' in his own inimitable style, with each painting divided into the various stages from the basic drawing to the finished work. Incidentally, I don't know if you agree with me but I nearly always prefer the painting at the stage before the last. Even some of the professionals can't resist the temptation to over elaborate at the end—I even remember one of them admitting to it!

Why should I then, a relative newcomer to painting, presume to produce anything different? Well, the one thing I want to do in this book is to work from the other end. Rather than push my own work down your throat and say, 'Paint like me,' the main purpose of this book is to concentrate on all the mistakes, fears, misconceptions and faults made by most leisure painters in watercolour and try to eliminate them by a mixture of common sense and down to earth psychology.

In the last few years, watercolour has taken me all over the world, holding seminars, demonstrations, having one-man shows and running painting holidays, as well as taking residential watercolour courses, all year round, at my home in the Wye Valley.

This has given me a unique opportunity of meeting and working with hundreds of watercolourists. One thing that has struck me is that they virtually all share the same aforesaid fears and faults.

First, let's start with the fears. Before even attempting watercolour one is discouraged by this false mystique that's been built up around the subject. It's this business of 'They say.' 'They say it's so much more difficult than oil painting because you can't alter anything once you've put it down.' This is rubbish—there are many ways of altering whole areas of the painting without harming the paper surface. More of this later.

There's the fear of spoiling that virgin sheet of paper you've paid good money for. The fear of actually starting—any excuse will do. 'The lawn needs cutting first', or 'I must do the shopping before I start painting.' Let's admit it—we've all done it. It's really, I suppose, a fear of failing. Finally, there's the fear of wasting paint. A terrible meanness seems to come over so

many people when they get a small tube of expensive paint in their hands. A minute quantity goes on the palette and the top is then hastily screwed on again.

These fears all show in the tightness of the students' work as they edge forward inch by inch, reluctant to make a bold statement in case they make a mistake and afraid of putting too much paint on at once. The end result is often a meticulous, weak, muddy, over-elaborate painting which is the last thing they really want. Even during my demos there's usually a gasp that goes up when a stormy sky is dropped in and someone always says, 'I wish I had the courage to do that', or 'I wouldn't dare do that.' It is almost as if one were in a cage with six lions rather than tackling a defenceless piece of paper—you've got to let it know who's boss.

Now let's look at the main faults of watercolourists. First and foremost is 'fiddling'— that dreadful urge to over-elaborate long after you should have finished. There must be little devils sitting on all our shoulders whispering, 'Go on, put a bit more in.' I feel that if a painting had a graph, it would rise as the painting progressed to a point where it suddenly nosedived, and that point would be about half-an-hour before you actually stopped.

The other main fault is using too much water and not enough paint. This is reluctance to commit oneself to put in the really strong darks where necessary which usually makes the finished picture look as if it has a sheet of tissue paper over it.

Let's look at one of the other hazards of would-be-watercolourists—the materials. I find so many painters unknowingly don't give themselves a chance from the beginning. They struggle with old paintboxes, often handed down from aunty Lil, with rows of little hard pans which require scrubbing to get any paint off at all, and with no possibility of producing good rich washes. They often start with too many colours, in hope of having a ready-made colour for every occasion, and finish up being thoroughly confused as to which of their four blues they should use for the sky.

They often proudly show a fistful of brushes, in sizes ranging from 00 to 4 which, in the main, are far too small to produce large, fresh washes, and present an absolute invitation to 'fiddle'. Palettes are also usually too small and pokey with no room to mix enough paint for large areas. Finally, there's the paper. This is often too thin and cockles badly when wet, unless it's stretched

on a board—a process which seems to make it even more terrifyingly virginal to paint on.

One gets so many people who say, 'I've been painting in watercolours for some years but my work is too pernickety and tight. I'd love to paint in a loose, fresh way but something always prevents me.' That something is often complication and over-working.

To me there are two words which are all important when producing a watercolour—simplicity and purity. I make no apology for repeating them to students ad infinitum. Simplicity is putting on paint directly and decisively, then leaving the damned stuff alone—often the most difficult thing to do as there's an awful temptation to go on poking at it. Purity is the transparency you must try to keep, not just in a light sky, but in your strong darks. You can get this by using rich colour put in first time and not by painting it on in four weak, muddy layers.

I always feel that watercolour is rather like golf—the fewer strokes you use the more professional it looks. Just look at a good golfer on the green, he takes his time to size the whole situation up, tries a practice stroke away from the ball, then finally commits himself to getting the ball directly in the hole. Too many watercolourists, in effect, tap the ball along the ground inch by inch just to make sure it goes in the hole.

To make another comparison, many painters use their brushes like shotguns, peppering the paper with strokes thereby hoping that at least one of these strokes will be in the right place, whereas they should be using the brush like a rifle making every stroke count but that, of course, means having to think about it a lot more beforehand.

Nearly everyone is too anxious to get the paint on the paper and to decide what to do with it afterwards, which usually results in alterations and mud.

One of the most difficult things to teach is not the actual use of the painting tools, together with their potential, but the thought process before actually touching a brush—choosing a simple subject and proceeding to simplify it. I feel that the artist's job is to get the essence of the scene, cutting out superficial detail and putting down on paper a distillation to transmit to the audience, be it a morning mist on the river or a hot, sunny, cafe scene. This actually means taking the audience into partnership, treating them like intelligent people and letting them use some of their

own imagination too. It is the same as in a radio play where the listener creates his characters from the voices. To me, that is impressionism in watercolour.

I've found one way of helping people to loosen up is to give them a set time to do a painting and then to stop them on the dot. It really makes the adrenalin flow and they have to go for the essential things first. By the time they reach the usual fiddling stage it's too late and the result is a fresh, lively painting—try it yourself.

Remember, in watercolour confidence is essential and that it is brought about by being in complete control of your tools and techniques. No one can write a beautiful poem before first acquiring a proper vocabulary. Too many watercolourists want to do a concert performance every time without bothering to do their five-finger exercises.

Let me emphasise that in this book I'm going to try and put over my own philosophy for loosening up painters who really want to paint that way—and it works! However, I realise that a lot of things I'm going to say, particularly about my choice of materials, are very controversial. If you're already painting fresh watercolour to your entire satisfaction don't change. But, then, you probably wouldn't have read this far anyway.

You may think I'm overplaying the psychological angle in watercolour, but have you noticed how much more relaxed you feel painting on a scrap piece of paper? Take, for example, the misty river scene in the 3rd colour section. It was painted on the back of a complete failure. I'd already ruined the paper so what had I got to lose? The result was quite a loose, relaxed painting. When you're painting in watercolour one of the main things you need is courage. Remember, it's only a piece of paper—if you're going to have a failure let it be a really glorious failure rather than a weak, miserable, timid one.

If at least some of these remarks have struck a chord in you, you've begun to understand the psychology and basic purpose behind this book.

In some of the following chapters I'm going to list the most common faults that occur in specific areas such as skies, trees, reflections and figures, etc., followed by my ideas on how to overcome them.

Materials

I've devised a perhaps unconventional collection of materials specifically to overcome most of the aforementioned hang-ups and hazards. I've rigorously cut them down to the basic necessities, as it were, so that each item, including each individual colour, becomes a trusted friend which you get to know intimately rather than possessing a lot of vague acquaintances.

First let's consider the paints. I use, and recommend my students to use, a very restricted palette of only seven colours. These are: Raw Sienna, Ultramarine, Lemon Yellow, Paynes Grey, Burnt Umber, Alizarin Crimson and Light Red, but more of these later. It means that there are less decisions to make and one then quickly begins to utilise fully the potential of each colour in relation to the others.

To get over the awful 'meanness' with paint, I recommend large 21 ml tubes of Winsor & Newton Cotman colour which, because it's less expensive and there's more of it than artist's quality colour, it immediately seems to make students use it with more abandon and panache. Rowney's Georgian range is equivalent in price and quality.

My complete collection of colours.

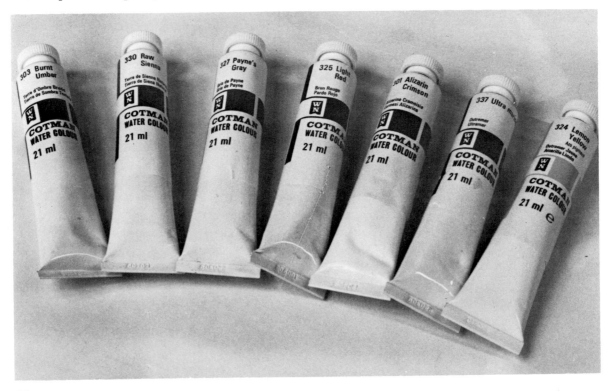

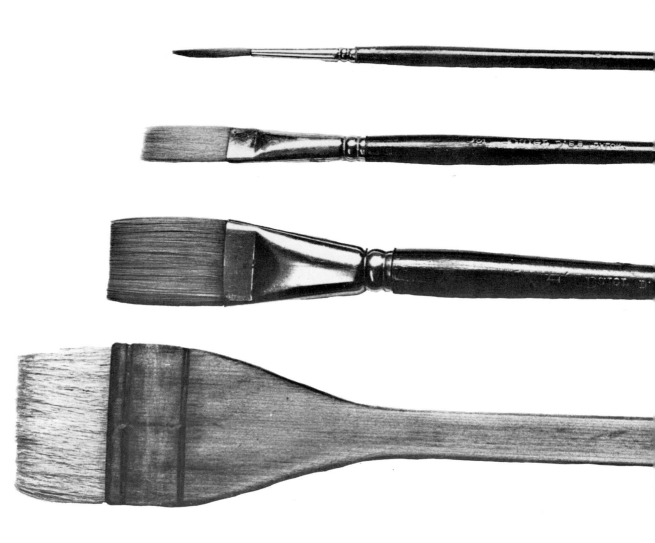

In descending order, the rigger, the two flat brushes, and the hake.

The Brushes. Again, these are deliberately chosen to force students to work more directly and economically. My main weapon is a flat 2 in traditional Japanese hake brush, which wears to a knife edge with use. It is often regarded with horror by newcomers at first but quickly becomes an inseparable companion once it has been trained. I do 90% of my painting with it.

In complete contrast, I use a No. 3 long-haired rigger—the Dalon series 99 is ideal. This is for all the delicate 'calligraphy' like branches, grasses and figures.

Finally, I have a 1 in as well as a $\frac{1}{2}$ in flat Dalon brush for painting in such things as buildings and boats crisply with the minimum number of strokes. This is a total of four brushes.

As for the palettes, I find those normally sold in art shops are far too small and pokey, so we use white plastic butchers' or picnic trays, light in weight and with masses of space for moving large washes. They're cheap too—about £1 from most local household shops.

Materials

I don't know why most traditional watercolour easels are so complicated. I've seen so many elderly ladies holding up limp, dangling examples with the plea, 'Ron, do help me. I can never find how these things work.' The tiny wing nuts don't help either because if they're not tightened up really well the whole thing can collapse.

The simplest thing I've found so far is the metal easel illustrated and is the one I use for outside work. The adjustments are far easier to manage and it has even got a proper lever for changing the angle of the board—much better than the dreaded wing nuts for elderly hands to operate, and with suitable hooks built on to hang the water-pot. Incidentally, a piece of suitable hardboard cut to fit your normal size paper is light and stiff enough for general use as a backing.

Another idea is to buy a good, simple photographer's tripod—these are made of aluminium and are very light. A lot of work has gone into the design of tripods by the Japanese, probably because there are more photographers than artists in the world. They are more compact than easels and very easily operated, with cams taking the place of wing nuts. However, you will need to have a little plate made locally that fixes on your board, with a threaded hole the same size as that on the standard camera.

My water-pot is plastic and collapses like a Japanese lantern.

I carry everything in a fisherman's plastic box with trays which fold out when the box is opened. Naturally, the art materials manufacturers have used this idea and you can now buy them as 'art bins' but at about twice the price.

When I'm out on a painting expedition my needs are so few that I carry everything under one arm without much effort. However, one sees so many people staggering desperately across fields with masses of equipment and materials, most of which they never use but bring along 'just in case'. Some seem to have so much they have to pull it around on trolleys. No—I'm convinced that the less equipment you have to worry about, the clearer your mind will be when you actually come to paint.

The only adjustments I make when I'm painting in the studio is to use a butcher's white enamelled tray rather than a light plastic one, and I have a goldfish-bowl sized container for my water.

I also bought a very old, draughtsman's adjustable board, some years ago, which I covered with Formica so I can make as

Opposite page, left: An extremely simple, metal easel for outdoor use.

Right: The photographer's tripod together with a home-made plate screwed on the chipboard.

Below right: A plastic box with my few assorted materials including water bottle.

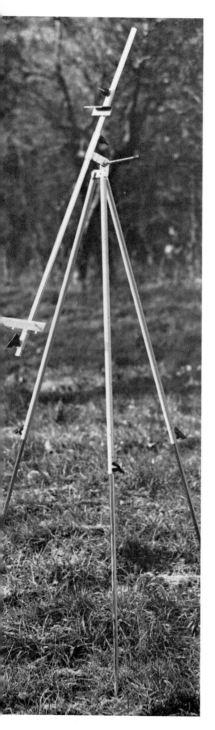

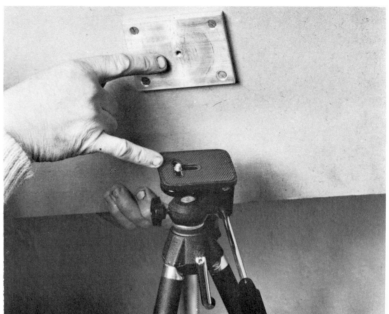

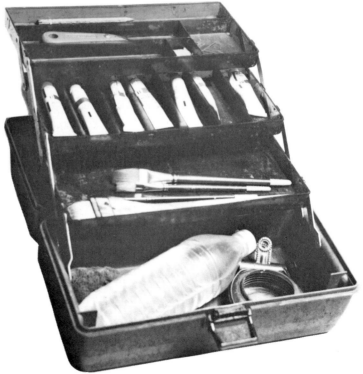

Materials

Left: My indoor water bowl which is about 10 in high.

Below: The collapsible, Japanese water pot, shown open and closed, for outdoor use.

Bottom: A typical, white plastic tray bought from an ironmonger's.

much mess as I like and wipe it clean afterwards with a damp cloth. The angle adjusts easily, and I even use the parallel motion gadget to grip my paper at the top.

There is a bewildering range of watercolour papers for you can buy in various thicknesses, surfaces and prices. I've tried most of them at various times but I still come back to my old favourite, 140 lb Bockingford, which is thick enough not to cockle when wet and is predictable. You get to know its qualities and limitations quickly and it is reasonably priced. What's more, you can paint on both sides of it. I myself nearly always use it in wire-bound books of twelve sheets with cardboard backing. This is very easy to carry around and is instantly ready for use without bothering with drawing pins, tape or clips. Blocks of paper which are stuck together on all four edges I find a bit annoying as the paper, not being able to expand or contract, tends to cockle and somehow I always manage to tear or cut it in my impatience to separate it on completion.

The expensive handmade papers are beautiful to work with but no good if they are going to inhibit you. Use them later when you are full of confidence.

Regarding pencils, I find a 2B is a good all-round grade. So many watercolourists use a pencil that is too hard, drawing faintly, afraid that it will show through the finished painting. As a result, all their preparation is lost as soon as their first wash goes on and they are left like a traveller without a map. The answer is to use the 2B with confidence, and when the painting is completely dry a putty rubber used lightly will, surprisingly, remove the pencil marks without disturbing the paint.

A putty rubber is much more gentle on your paper if you have to make corrections on your drawing but you still have to be careful not to disturb the surface too much or it will affect the quality of the washes afterwards.

Two simple designs for home-made table easels, both of which are used extensively in my studio for students. The one on the right consists of hardboard nailed to two wedges with a strip across the bottom edge. The one on the left is adjustable by wing nuts and simple to make.

The hake and how to use it

This is a traditional Japanese watercolour brush, 2 in wide, in natural wood, with the pony hair stitched into a slot in the top of the handle. When you first use the hake you may find loose hairs appear on the side but these wear off after a time and, believe me, the brush gets better and better the more it's used. I have one that has been in continuous use for about four years and the hairs, although short, have worn down to a knife edge. But why use the hake at all? It looks crude and unwieldy when one first picks it up. I found one in a local art shop—it looked interesting so I thought I'd try it—and I've used one ever since. It has transformed my approach and also, I'm pleased to say, of thousands of other people who wanted to paint loosely in a more impressionistic style. It's not a question of what it allows you to do, which is plenty, it's more what it stops you from doing, i.e. that dreaded fiddling which makes so many amateur paintings *look* amateur. My aim is to get your pictures looking professional, whether you're going to earn your living from them or not.

Hardly a week goes by when I don't pick up the phone and someone says 'Guess what Ron, I'm now selling my pictures regularly at last,' or 'I just won an award at the local art show, thanks to your methods and "the Brush".'

Of course, its not just the brush, its the new attitude of mind it evokes. It forces you to simplify, to think that bit more before you put the paint on the paper. Try to say in one stroke what it took ten to say before.

Hold the hake lightly and touch the paper as lightly as a feather and, of course, with as few lines as possible, make every stroke count. It can and does hold large amounts of unseen water which is a big advantage when you are painting in a large sky area with lots of fleecy clouds. You can dance quickly across the paper and in minutes you're watching the whole thing soften and settle down.

However, if you want to put in strong, rich colour or even do dry brush work you must first get rid of the excess water by squeezing gently between the finger and thumb, taking care not to pull the hairs downwards.

I once rashly lent one of my worn-down brushes, matured and sharpened over the years, to a lady (she was very pretty!). Within an hour she had managed to pull the hairs out and it was difficult to explain that the new one she offered at once to buy me was

Opposite page, top left: The brush holds a deceiving amount of water which can weaken your mixtures too much unless you first squeeze it out, as shown, before mixing.

Opposite page: The hake and a typical 10-second doodle, showing its capabilities.

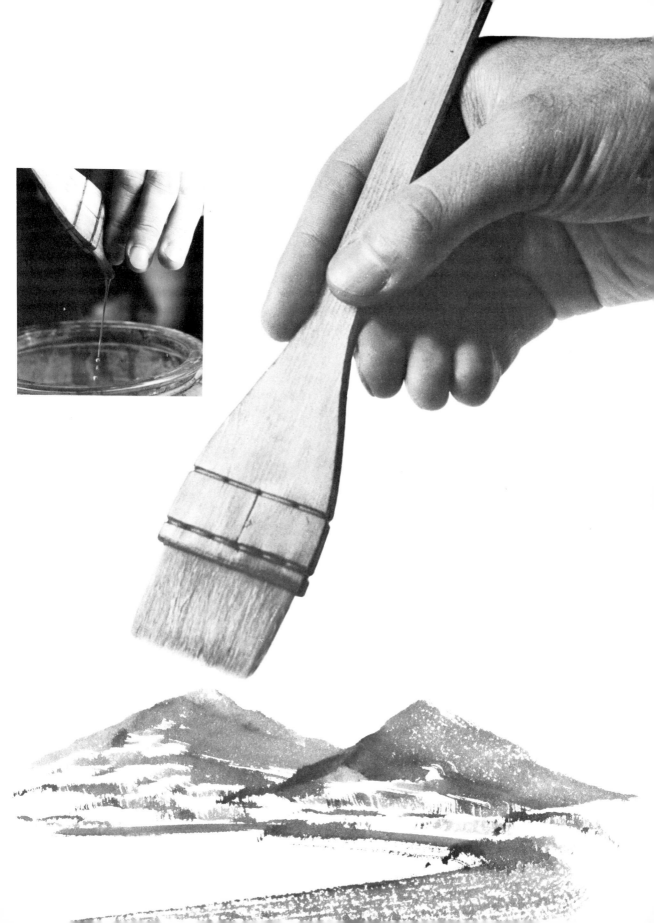

The hake and how to use it

little compensation—I was heartbroken. One comes to regard a brush almost like a faithful dog and secretly dreads the thought of it finally passing away.

Don't think you're going to learn to use it in an hour, or two even. It will take time and you'll need to persevere and be shown lots of ways of using it. The main thing is don't try to make it do what it was never intended to do, like delicate branches or sharp crisp edges. There are other brushes for that. Once mastered however, it will enable you to tackle loose skies, trees and dramatic foregrounds. (Over-worked foregrounds are the sure sign of an amateur).

If at first it seems to divide in two, just dip it in water and, very gently, smooth the hairs with a finger and thumb.

Below: The portion of the brush generally used for foliage.

Bottom: Another example of its use, reproduced actual size.

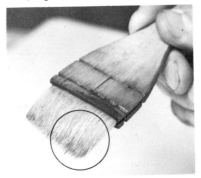

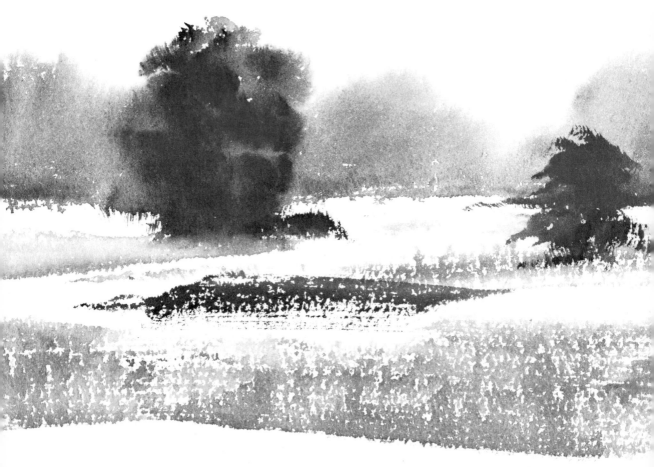

Right: Producing a graduated wash by gradually weakening the strength of the paint mixture. Use the whole arm rather than the wrist.

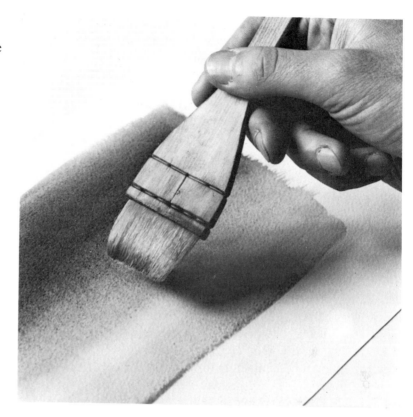

Below right: A typical tree technique with fairly strong paint.

Below left: The method of tilting the brush at an angle.

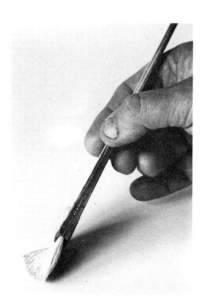

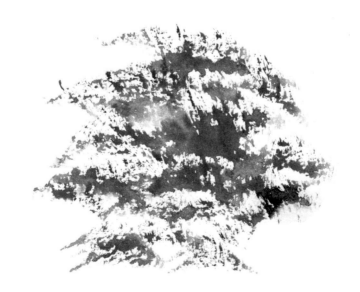

Using the flat brushes

Basically, these brushes are used for everything that has a sharp edge. The ones I use are made by Daler and are nylon. The big advantage is that they form a knife-edge when they are wet and can be used with the utmost economy of stroke to indicate such delicate things as railings or the masts of distant yachts.

I show a few doodles here, done entirely with these flat brushes to give you some idea of the possibilities.

They should be used with the lightness of a feather and great delicacy of touch. You'll be delighted with the exciting effects you can get with them. I find them excellent for indicating a jumble of distant farm buildings, or boats or boat sheds. Incidentally, just because you're using, say, a 1 in brush it doesn't mean that you've got to produce a little line 1 in long. Just by tipping it over on one side you can get shorter lines—it's all a question of practice.

When portraying the architecture of buildings you can give a general impression of accuracy and detail without actually doing much work at all. The windows and railings in the picture of the Highgate street in the colour plates is a good example.

Don't try to use the flats for indicating soft edges when painting trees, for example, as the hake is much better.

The $\frac{1}{2}$ in brush, of course, is used in exactly the same way and it's very useful for putting in smaller windows and roofs.

Below and opposite: The 1 in brush and some quick examples.

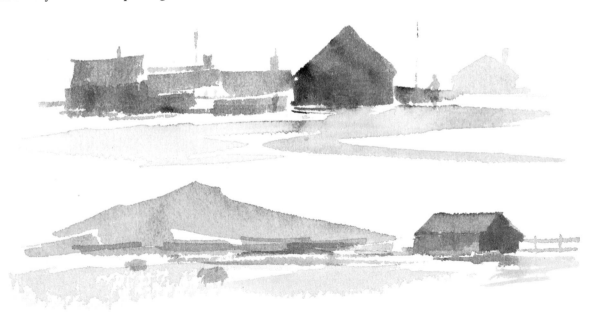

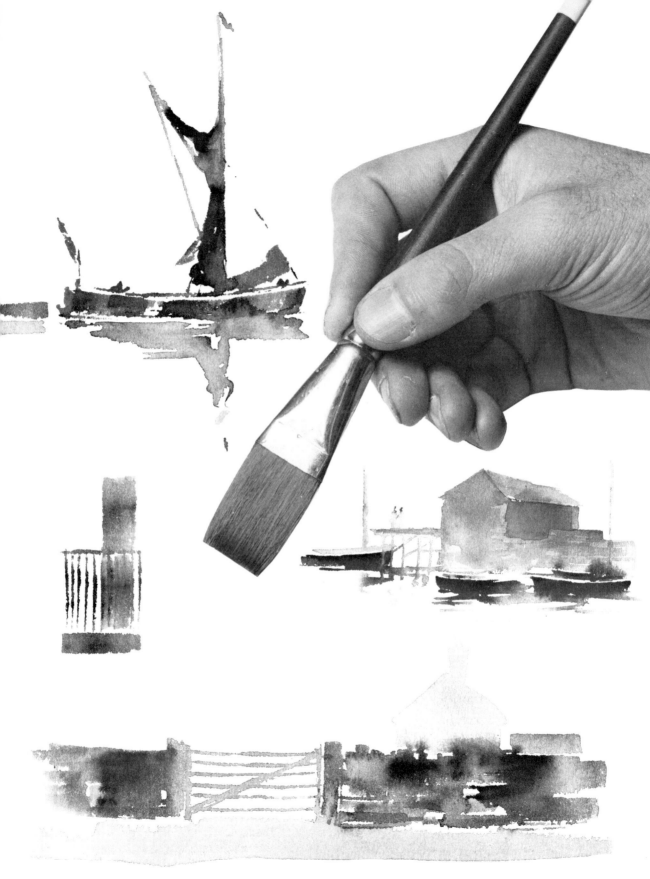

Using the rigger

This brush is in complete contrast to the hake and is one that has become almost indispensable to me now. The secret is that it has very long hair which enables you to produce, with practice, an enormous variety of widths of stroke depending on the pressure on the brush. You can go from $\frac{1}{4}$ in wide to the width of a hair.

The name 'rigger' goes back to sailing ship times when the brush was used for putting in the rigging. The one I usually use is a number 3 and is a Daler series D99. The range runs from 0 to 6 and, being nylon, is relatively cheap.

To control it properly and to use the brush to its fullest extent needs a fair amount of practice and can I get most of my students to practise?—can I hell! They all want to produce finished masterpieces without the tedium of exercises, so I have to resort to subterfuge and make them paint winter trees for half a day. These need gradually tapering branches and what better brush to do them with than the rigger.

I hold the brush not in the middle but right at the end of the handle, which gives it more flexibility of stroke, rather like having a dog with a long lead. When I want a tapering line I move my fingers not my whole hand. It is the action of the brush coming off the paper in an arc which gives that delicacy of stroke like copper-plate handwriting.

So do practise with it—it will repay you over and over again by giving you much more convincing and professional looking trees and grasses in the future.

I also use it for most of my figures in landscapes but you will see later how useful it is in this area.

Below left: Typical brush strokes made with the rigger.

Below: Two views showing how the hand is kept still and the fingers are moved to produce an arc.

Opposite page: Some of the results which can be achieved by the brush.

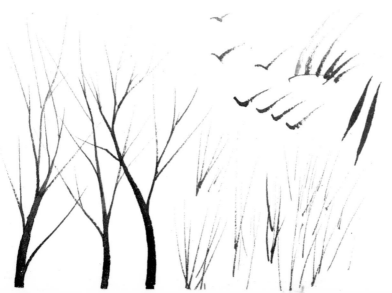

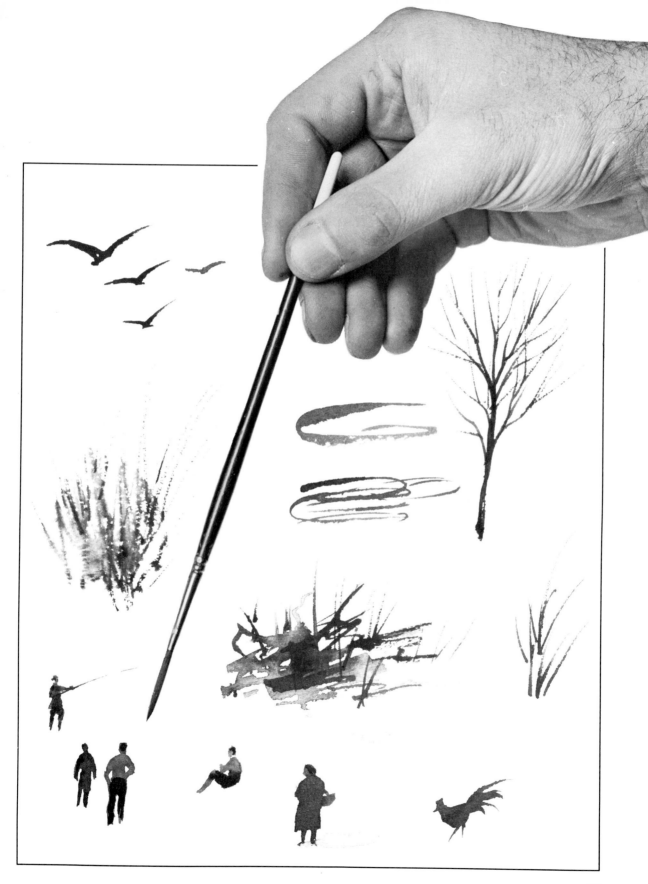

Wet-into-wet techniques

There's no experience more exhilarating than dropping rich colour on to wet paper and watching things happen. However, wet-into-wet is a bit of a misnomer because if you do actually drop wet paint on to a wet surface you then get two lots of water and the result is weak, runny and out of control. It's so difficult to convince students that since the paper is already wet they can then use the paint thick, almost straight from the tube. It will mix with the water on the paper and soften but will stay rich and controllable. No matter how often I demonstrate this they still seem to go back and add that disastrous second lot of water.

Apart from describing the main pitfalls, there's no way I can really explain the technique. You just have to experience it and experiment yourself. Try it out with just one colour first, say Burnt Umber, and be prepared to waste a few sheets of paper. Let yourself go fearlessly, don't be timid.

Always have the painting on a gentle slope and use gravity to help you, which can be rather like swimming with the current. It's so much less effort and you'll need less strokes—always a good thing.

Opposite page: A good example of the use of wet-into-wet, reproduced actual size. Quite strong paint was used to get the dark trees on the left whilst the distant hill was still damp. The branches were put in with the rigger slightly later but before the surface had completely dried. The contrasting corner of the bank in the centre was painted dry. The river was then painted over with clear water and the reflections dropped in. The streak was done with one quick flick with a finger wrapped in a handkerchief, and the foreground grass was put in afterwards when everything else was dry.

Below: Wet-into-wet doodle using hake, rigger and fingernails.

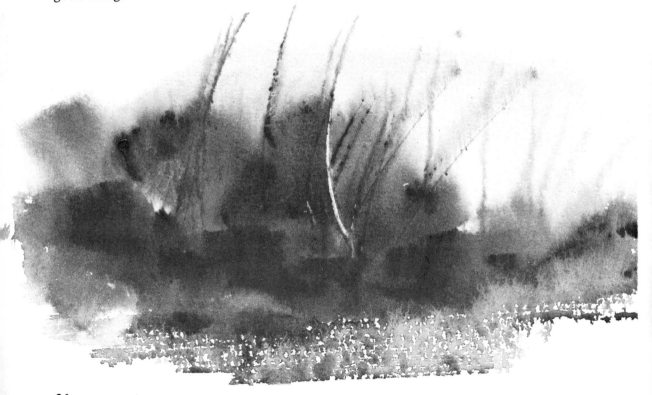

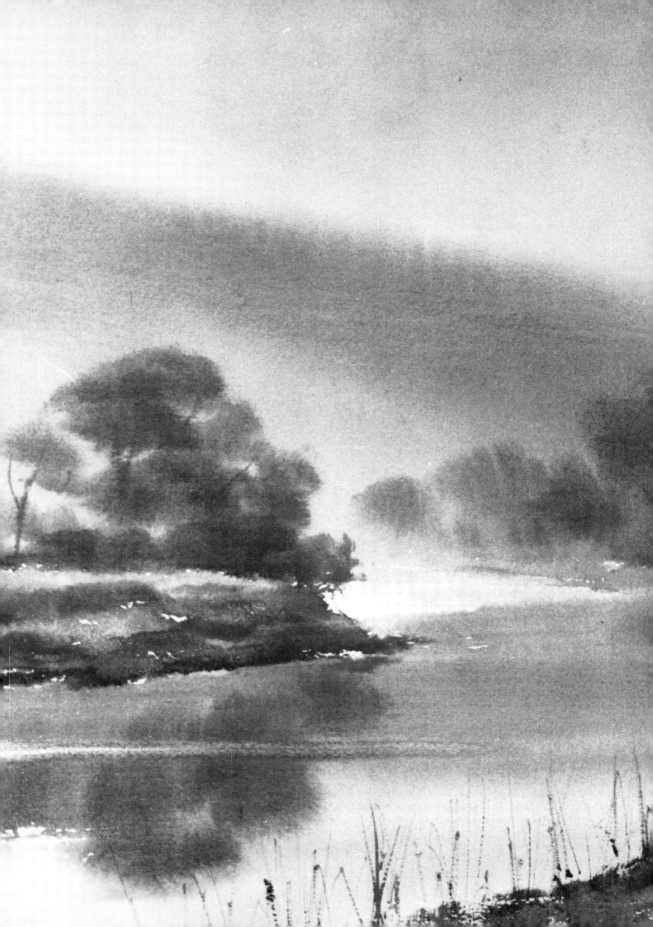

Wet-into-wet technique

The technique is ideal for doing such things as cloudy skies, mists, billowy trees and surging surf, but don't attempt to do the whole painting in wet-in-wet, it will just look out of focus. It's much more effective when the soft edges are contrasted with sharp edged areas and calligraphy applied after the paper has dried or almost dried.

I find wet-into-wet particularly useful for putting in a line of distant trees. I paint the sky down to the horizon and, while it's still wet, I push the tree colour—usually a fairly bluey green—up into the sky from the horizon, leaving a sharp edge at the base of the trees.

A word of warning, never use wet-into-wet for foregrounds, they, at least, should be crisp and sharp, otherwise it will look as if you're wearing the wrong glasses.

Looking through my own paintings I find that wet-into-wet techniques have formed an important part in most of them, perhaps because they always seem to sell well (it's what most people think of as watercolour), but mainly just because I really enjoy doing it so much.

Finally, always allow for the fact that the resultant painting will dry lighter—that's another thing that seems to surprise students constantly even after they've done scores of water-colours. Think of a wet pebble on a beach that you've picked up because you liked the rich colour and then been disappointed because by the time you got it home it had dried paler. Learn to compensate for this phenomenon.

A quick doodle showing the use of strong, thick paint on a damp surface.

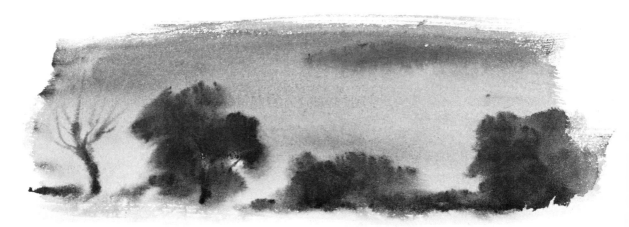

Top right: Squiggles on a damp surface with a hake and rigger.

Below: A typical wet-into-wet painting with sharp touches added for contrast.

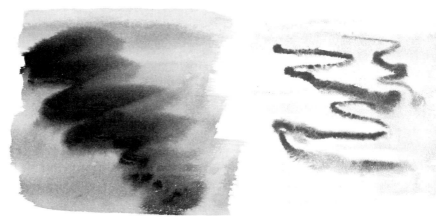

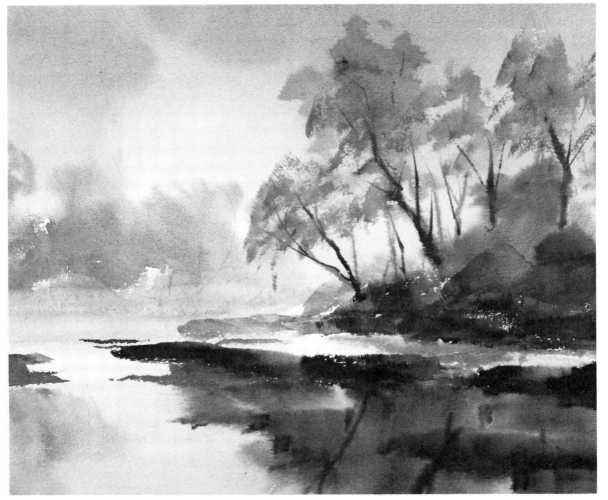

Dry brush

The first thing to say about dry brush technique is not to overdo it. It's very useful to produce textures and to suggest detail. The paint is put on with the brush quickly skimming over the surface of the paper, leaving the colour only on the ridges of the irregular surface. The colour and the brush itself is kept very dry and appears on the paper with hundreds of gaps which allows the paper or underpainting to show through. This dryness can be controlled by keeping a rag or paper towel handy to give a quick sweep to reduce the moisture before you work on the painting.

You should experiment to discover all the many textures available. Push, stroke, or even pat the brush on the paper. Try holding the brush almost parallel to the paper so that the hairs barely graze it. The dry brush has many uses—to suggest the bright shimmer of the sun on water, the texture of pebbles on the shore, the rough bark on a tree trunk or the weathered surface of a plaster wall.

Do practise this technique, although it probably won't come off at first. In any case, it's always a good thing to have a spare piece of paper by your side so that you can try the effect to see if you've got just the right amount of moisture in the brush before you put it on your finished painting.

Finally, let me warn you again. Use this effect with discretion.

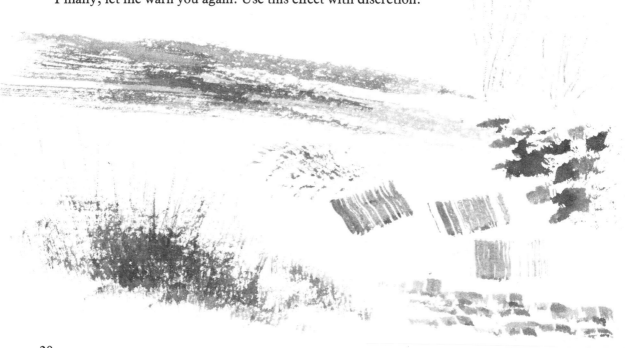

Combining all the techniques

We've looked at basic watercolour techniques of wash, wet-into-wet, dry brush and calligraphy. They all have their strengths and weaknesses. Wash, for example, is the most positive way of indicating shapes. Its strength lies in its simplicity, but it can get a bit monotonous.

Wet-into-wet is the most spontaneous and exciting, but too much of it can be vague and look like candyfloss.

Calligraphy is decorative and descriptive but can look fussy if overdone, as can dry brush, but when used with restraint it can provide sparkle.

All these techniques when combined in one painting provide a whole armoury of textural contrasts. The combination overcomes the inherent limitations of each and they all complement one another.

In my own paintings I endeavour to contrast the character of stroke made by each of the three types of brush that I use—the enforced simplicity, softness and directness of the hake brush against the crisp, hard-edged precision of the flats and the fine delicacy of the rigger.

You could say it's rather like an orchestra with the big, bold, rich brass contrasting with the mellow strings and the clear tones of the reed instruments to form a complete and satisfying all-over sound.

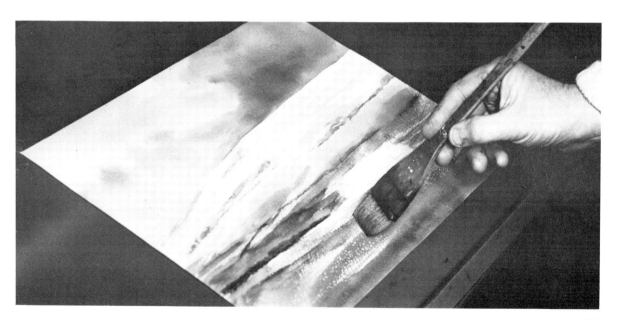

The first stage is to put the wet-into-wet sky and the main tones in with the hake, using dry brush in the foreground to get the effect of scattered snow.

Combining all the techniques

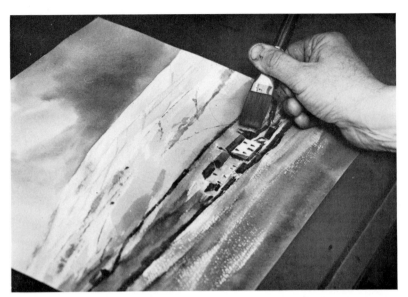

Left: Putting in the sharp details such as the walls, roofs, chimneys and gates with the flat brush.

Below: Using the rigger to put in the branches of the winter trees, etc.

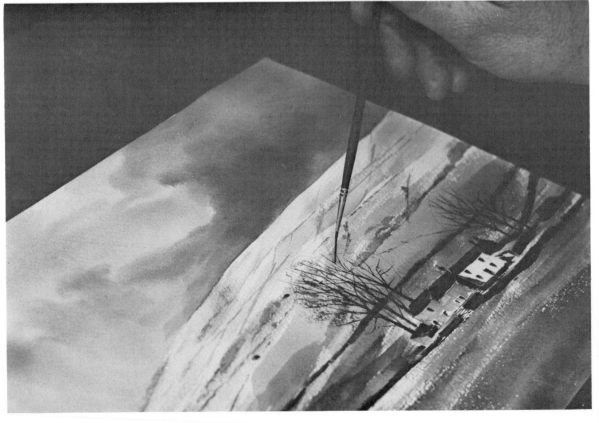

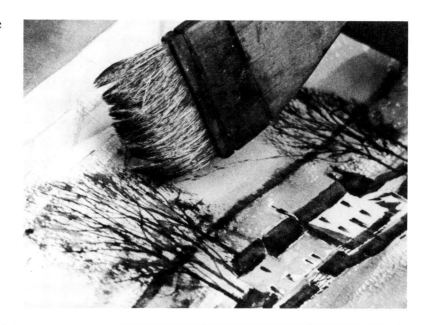

Right: Using the hake gently on the edges of branches, almost completely dry, to simulate twigs.

Below: The completed picture.

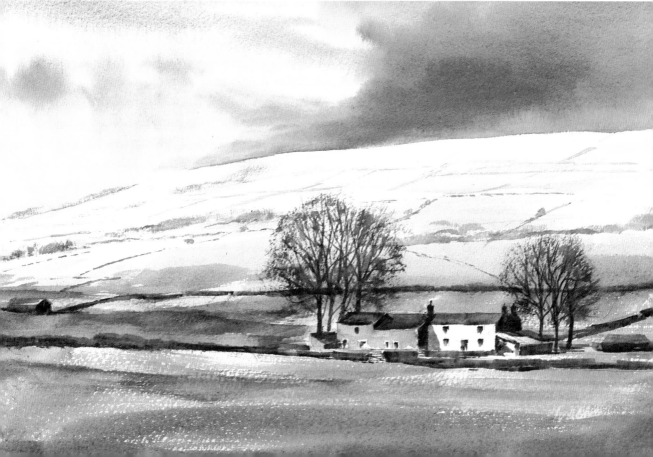

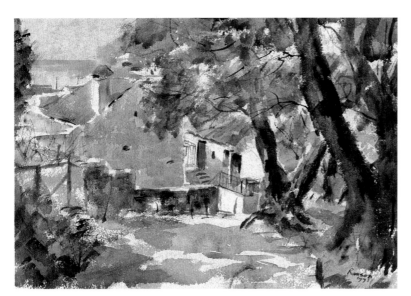

Left: Scene in a Paxos village looking over the roofs to the sea.

Below: Typical scene on the Wye.

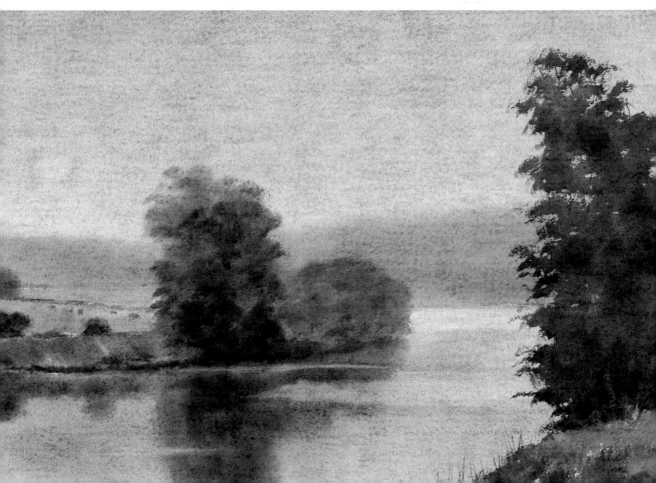

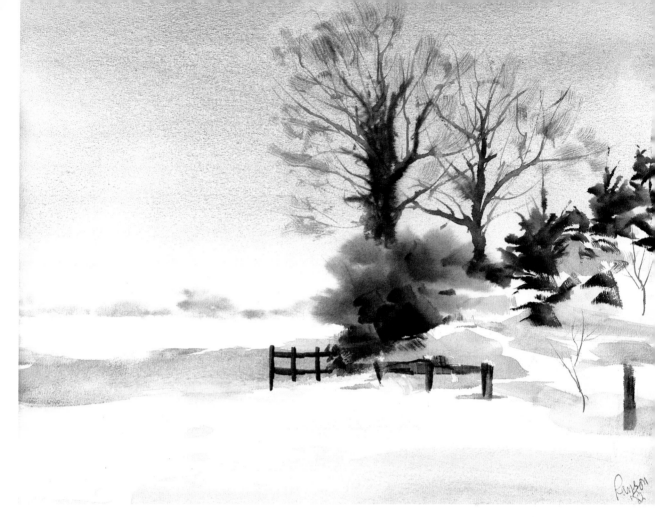

Above: Winter sun scene in our village.

Right: A simple river scene on the Thurne in Norfolk with wet-into-wet trees painted in before the sky had dried.

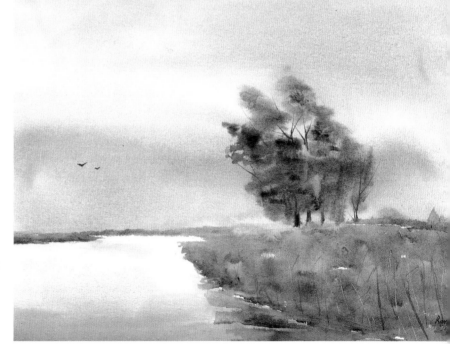

Overleaf: A painting of a windmill at Clay-next-the-Sea in Norfolk. This is one of the few paintings in which I used masking fluid, on the sails of the windmill to enable me to do an uninhibited sky behind.

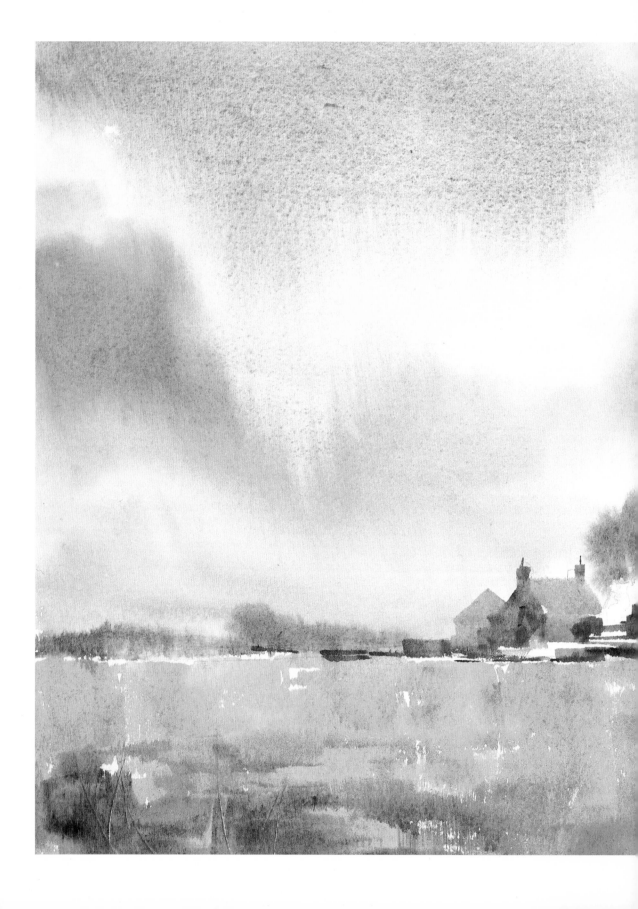

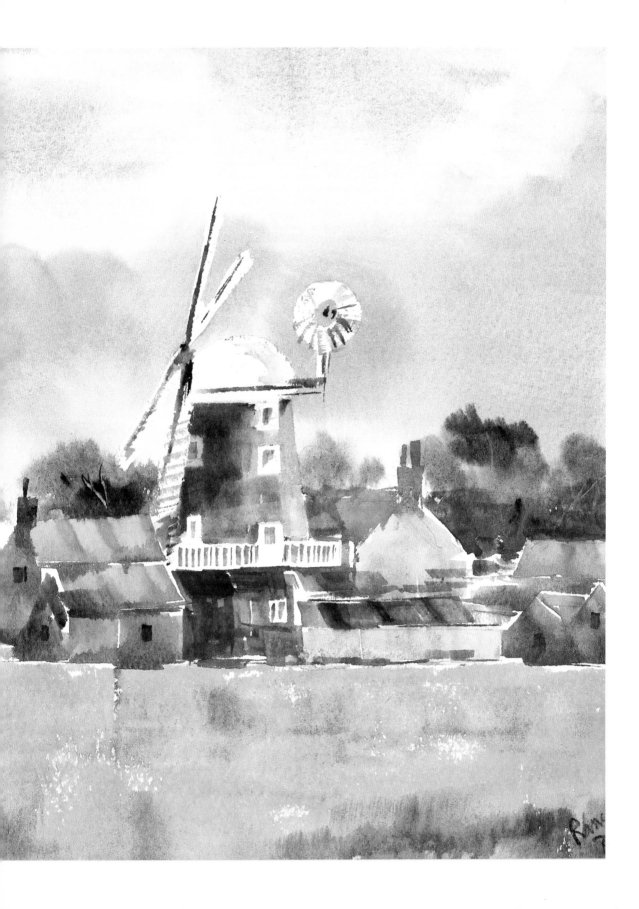

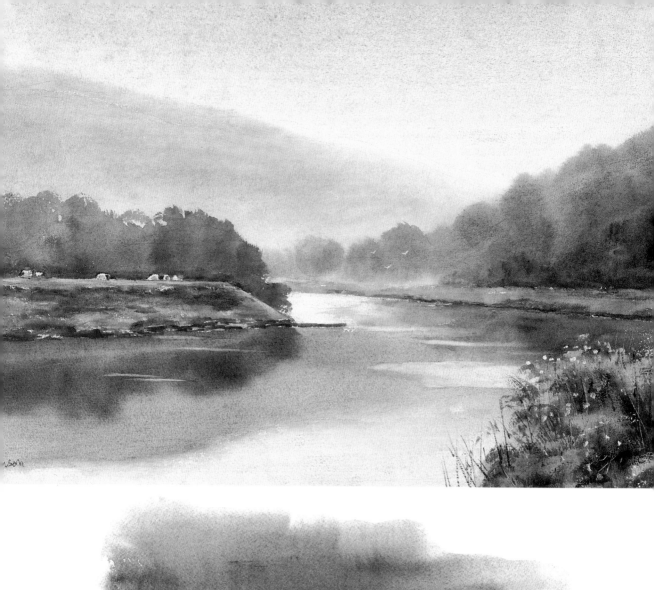

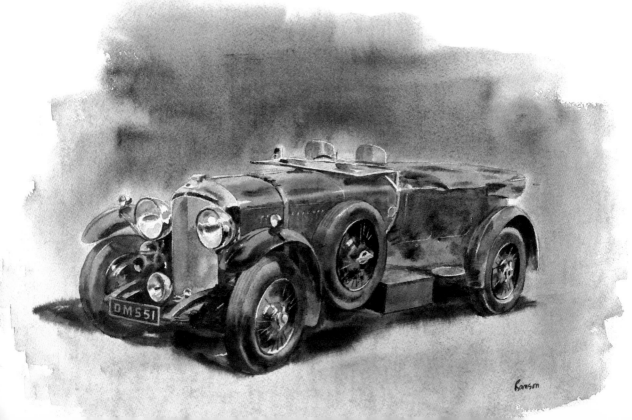

Opposite page: A painting of the Wye at Bigsweir, 800ft below my house.

Opposite page, below: A loose watercolour of a vintage Bentley.

Right: A quick demonstration painting of one of our meadows.

Below: Watercolour lends itself well to portraying steam trains. This is a typical example.

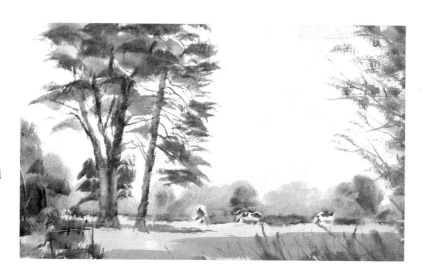

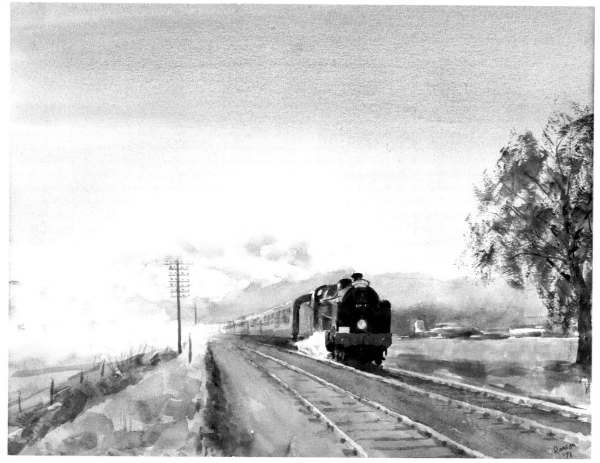

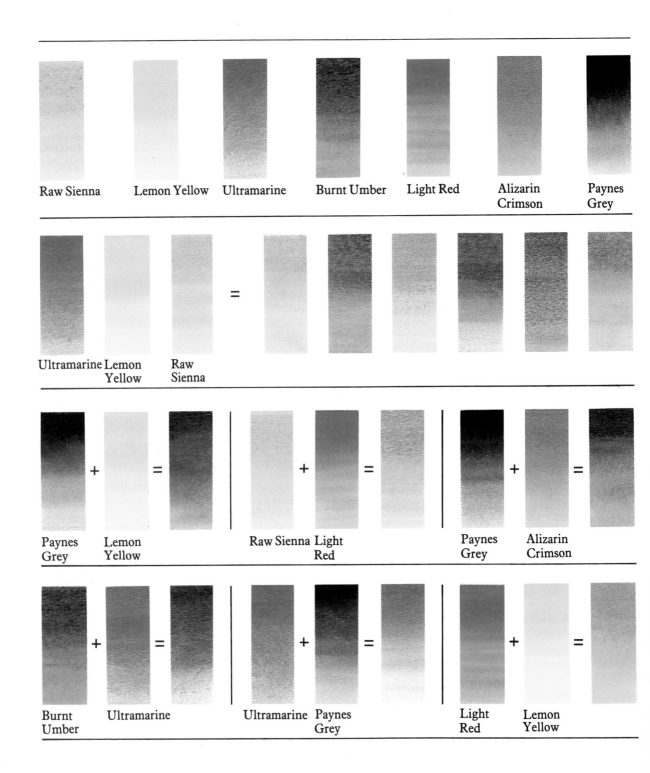

Raw Sienna Lemon Yellow Ultramarine Burnt Umber Light Red Alizarin Crimson Paynes Grey

Ultramarine Lemon Yellow Raw Sienna =

Paynes Grey + Lemon Yellow = Raw Sienna Light Red + = Paynes Grey + Alizarin Crimson =

Burnt Umber + Ultramarine = Ultramarine Paynes Grey + = Light Red + Lemon Yellow =

Colour

My complete palette of seven colours.

Some of the varieties of green obtainable by using raw sienna, lemon yellow, and ultramarine.

A few typical colour mixes.

I'm not going to start off this chapter with a talk on colour wheels, primary, secondary and tertiary colours, sunlight through prisms and the basic theory of colour. There are plenty of good books where you will find all this information. Personally, my eyes used to glaze over when I got to this section and I would turn the pages until I got to the more interesting bits, but by now you will have realised that I'm not much of a one for theory anyway.

First, the question of pans versus tubes. When I began painting I bought the usual paintbox with twelve to sixteen half pans. Whilst I was using smaller brushes it was fairly satisfactory. I soon found, though, as I began to paint more boldly and use larger brushes that the paintbox became completely inadequate. I couldn't get enough response from the pans or rich enough mixtures when I wanted them in a hurry. The palettes attached to the boxes were also too small so I soon moved on to tubes, and a larger palette to go with them, which gave me a completely new freedom. I'd never go back to pans again.

The next vexed question is the difference between the very best and expensive artists' quality paints, which most books insist that you buy, and the cheaper students' quality ranges. I found that so many people had the idea that the cheaper quality paints would somehow fade away that I went to the manufacturers, who of course make both ranges, and asked them about the difference. They said that provided you kept to the permanent colours (which I do) they would both last equally as long. The main difference in the two ranges is the time taken to grind a colour and, of course, some of the more expensive pigments in the artists' quality are replaced by reliable, modern substitutes, but your colours, under normal hanging conditions, will still stay bright and clear long after your great-grandchildren have gone. The important thing is to buy from an internationally known firm as it is unlikely that such a manufacturer would ruin their name by selling poor quality fugitive paint.

Let me say emphatically that I've nothing whatever against using artists' quality colour, except for that initial inhibiting factor which prevents so many people from actually squeezing out enough paint. However superb the quality, it's not doing any good in the tube. If you haven't got this problem use artists' colours by all means. However, I do enjoy using my colours with complete abandon and love squeezing out plenty of paint, some-

times using it almost neat on wet paper to get exciting soft, rich effects.

One important thing that I've realised is that most people, including myself, work better with a limited number of colours. One soon gets to know them intimately and to know instinctively how they react with each other, rather like having a few true friends as opposed to many acquaintances.

However, there's no magic selection of colours. Whenever I'm demonstrating and the subject gets around to colour there's always a wild scuffling noise as everyone searches for a pencil in order not to miss any. Later, so many people ask and make copious notes on exactly how a particular hue was obtained— notes which I'm sure are very little use to them afterwards. The secret is to cut the number of colours down to the bone and then learn to mix them instinctively, allowing the main part of your concentration to be devoted to solving the problems of the subject in front of you, not wondering which of your four yellows or three blues to use. This is similar to your behaviour when driving a car—your whole attention is devoted to the road ahead but at the first sight of danger your foot instinctively shoots to the right pedal without any thought on your part.

Having said all that, I'm still going to give you my own personal choice of colours which I use, year in year out, whether in misty, grey England or hot, sunny Greece. They fit me like an old pair of slippers. If you've already got your own palette which you have learned and it suits you, don't change.

Raw Sienna

This is one of the most important as far as I'm concerned. I certainly use more of it than any other. It's an earth colour made from the mineral oxides found in natural soil and is one of the oldest pigments known. Artists have used it throughout history. It looks a bit like Yellow Ochre but I prefer it because it's more transparent.

I use it in all sorts of mixtures and I feel it helps me to get a sort of unity in my pictures. I have got into the habit of using it very weakly as a first wash on skies. For a clear blue sky I would brush on Ultramarine at the top, while the Raw Sienna is still very wet, and graduate it almost to nothing at the skyline. For fluffy, partly clouded skies it gives a basic creamy colour around which I paint my blue. Surprisingly they don't combine to turn

green on the paper—I've never been able to explain why.

Ultramarine Blue

So many people say 'How do you manage without Cobalt or Prussian or Cerulean Blue?' The fact is—I do, and stick faithfully to my Ultramarine which is a permanent, warm, intense blue with excellent working properties. Mixed with Burnt Umber it gives a very wide range of greys by varying the proportions of each. It's sometimes inclined to granulate but personally I rather like the effect.

Burnt Umber

This is a permanent earth brown, on the cool side. Again it is an earth colour. The only other colour which I might add to this brown is Burnt Sienna, but I find I can approximate to this by adding a touch of light red to the umber to warm it up.

Alizarin Crimson

I don't use very much of this colour. It's a cool, intense red and a little goes a long way. It's the only one of my colours that is not really permanent. Used with plenty of water it makes a good pink, or mixed with Ultramarine a rich purple. With Lemon Yellow it will make orange.

Light Red

This is another earth colour and is extremely permanent. A sort of brick red which mixes with Raw Sienna to produce a lovely terracotta for tiles. With Ultramarine it makes a subtle mauve which is excellent for warm shadows.

One colour I haven't got is Chinese White which, of course, is opaque and to my mind alien to the rest of the colours. You immediately lose transparency and you can tell at a glance where it's been used. I don't want to be too adamant about it though, Turner sometimes used it but he was masterly enough to break all the rules.

Paynes Grey

This is a bit of a controversial colour. It's a cool grey—smooth and moist, useful for shading other colours to deepen them without losing clarity. However, never use it by itself—it looks horrid—but mixed with Alizarin it makes a lovely rich mauve or purple for dark storm clouds, or watered down in the same mixture is great for warm, transparent shadows which allow the colours beneath to show through. One warning though, remember that it does dry very much lighter than it appears when it is wet.

Lemon Yellow (or Cadmium Yellow Pale)
This is a straight down the middle yellow, slightly on the cool side and is again permanent.
Green
Now to the colour which seems to cause more trouble and strife than any other—green. Even before I myself, painted I used to go round art societies' exhibitions and look at some of the landscapes which had been ruined because of those awful greens. Bright green grass, bright green trees. I'm sure you've seen them too—I call them lavatory greens and was determined at least that I wasn't going to make that particular mistake.

I did, however, start out with one made-up green—Veridian—but my wife, Audrey, said I spoilt all my paintings with it and one day took it away from me and put it firmly in her handbag. I've never used it again and the only time I miss it is when I want to get a particular shade for the sea in Greece.

I always make up my own greens from the various colours on my palette and I think it's very important that you should master them once and for all. Some otherwise experienced painters seem to fall down here. I had one gentleman who was sound in every other department, his drawing was good and his painting was fresh and pure except for his greens which always came out in various shades of khaki. It took me a week to sort him out. Another time, quite a famous group of professionals, who specialised in portraying the Thames and its barges, wharves and warehouses, visited us for a week to use my home as a base while they painted the Wye Valley. They came back the first evening with long faces and said, 'How on earth do you manage all those greens?' It took another couple of days before they were happy.

Greens range from nearly blue right through to near yellow. There are cool greens and warm rich greens. The first thing, before you even start to mix paint, is learn to compare the various greens with each other. Look at various species of tree together. I've been amazed at how many students don't even attempt to match the various greens in front of them but use a set mix and just make it darker or lighter. The result is a flat, monotonous amateurish painting. Look hard at one variety of tree at about ten feet, then at about 200 yards, and again at two miles away; you will see that not only is the green paler in tone but much bluer as it recedes into the distance. Of course, exactly the same thing happens to grass as well. That is aerial perspective, and is just

commonsense, but is so often ignored once the painting starts and a rich, dark tree is portrayed two miles away on the horizon, sticking out like a sore thumb. It's of little use learning to mix the various greens until you first learn to separate them visually.

Put four colours out on your palette in a spaced out row; Ultramarine, Lemon Yellow, Raw Sienna and Paynes Grey. Put your brush into Ultramarine and make a patch of it in the middle. Then add just a minute touch of Lemon Yellow and you'll get a very cool bluey green. Paint that on some scrap paper then add a touch of yellow and the green starts to get brighter. By repeating it three or four times you've already produced a range of greens.

Try starting at the other end with a patch of Lemon Yellow and add a touch of Ultramarine. You'll get the green of sunlit vines and by gradually adding more and more blue you'll get back to the place you started. If you now add a touch of Raw Sienna to the mixes you'll richen them up, as opposed to making them brighter or cooler.

Now to the deep, rich olive greens that so many students are wary of because it's so easy to produce mud in the process. First, try various combinations of Raw Sienna and Ultramarine without the yellow. To get a really dark green try Lemon Yellow and Paynes Grey together but not too much of the latter. By now you should have produced a vary large range of greens on your paper. Now do it all over again. Learn to grade them down too, for misty scenes, by adding a touch of red.

Of course, if you use a different range of colours to mine the mixes will be different but the principle is the same. Learn to enjoy your greens rather than dreading them.

As far as the big palette itself is concerned the whole idea is to allow you more room to mix and move your paint around with complete freedom, whilst still leaving plenty of virgin space for other mixes. Some students sometimes complain that the colours run together but that's a sign that they're using too much water and, as I've probably said before, the cause of ninety per cent of all the troubles of amateur watercolourists.

Of course, you'll need plenty of water for the first washes but as you progress through the painting you should need less and less water. When I see students' palettes swimming with water I know even before I look at the painting itself that it's going to be weak and lacking in punch.

The studio

Hardly anyone starts with a ready-made studio unless they're very rich and can afford a purpose-built one. Mostly they just evolve slowly over the years. I'm a great one for finding junk and seeing the possibility of tarting it up to make something useful. I get so much more satisfaction doing that then ever I could from buying something new.

My studio started off as a large dining room but seemed only to be used once a week for Sunday lunch. Then we found dry rot there. Months and hundreds of pounds later we decided to turn it into a study/studio where at least it would be used and lived in most of the time.

From that point it has taken about four years for the room to grow gradually as the ideas have come and the various needs have dictated changes. It's a purely personal arrangement, tailor-made to my daily lifestyle. I spend many hours of the day and night in it so it has areas for writing, painting, duplicating, filing, also a library and lots of flat areas for just spreading things out.

The purpose of giving you a guided tour is that there may be a few ideas in it that you can adapt to suit your own requirements.

My main easel was a drafting table rescued, very rusty, from a scrapyard. Rubbed down, painted and with the top covered with laminated plastic, it's perfect. It can be easily wiped down at the end of a day and is instantly adjustable so I can work at it standing or sitting. I do all my demonstrations here as I've got space in the middle of the studio for about fifteen people to sit and watch. Above it is an 8 ft long fluorescent tube. I've got a second-hand plan chest on the right, the top drawer of which houses all my paints, brushes and framing materials, like hooks, tape and cord. The drawers below hold all my paper, mounts and sketchbooks. On top is the guillotine for trimming. On the shelves in front are all my other materials, inks, pastels, camera, hair dryer, art bin, etc.

Towering over the easel is the 'Optiskop', supported on a steel pole which stretches from floor to ceiling. It's Swiss and looks very impressive but it's basically just a posh vertical epidioscope. By putting a sketch in the instrument and fiddling the knobs it will blow up optically to any desired size on my drawing board. I use it mostly in my other capacity as a graphic designer.

I've found a very useful plastic-topped table in a furniture shop recently for holding my palettes and waterpot. It's just the right height and has castors so that I can push it around easily. The top

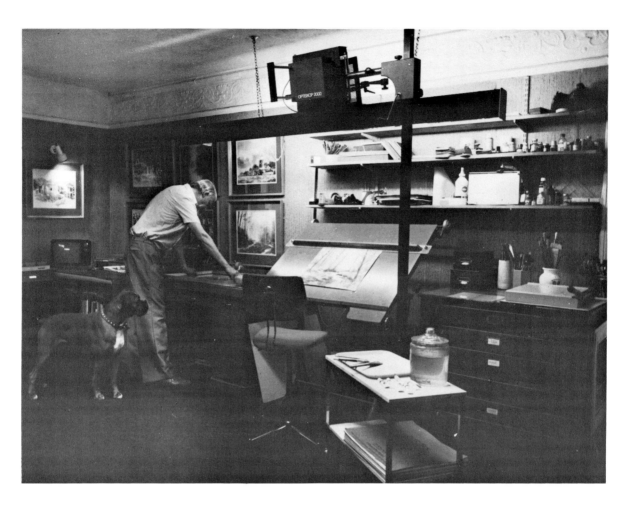

A view of the painting corner with my faithful assistant, Simon.

also serves as an extra palette when I run out of space.

On the left of the easel is a strange storage unit made out of a door, part of an old dressing table and a bathroom cabinet. I've painted them all the same colour, put some modern handles on them and covered the whole thing with a large sheet of glass. The end even holds my TV and hi-fi equipment.

What I've tried to do is combine reasonable comfort with essential practicality. It makes such a difference to your painting if you're relaxed in a warm, well-lit studio with everything at hand. I must admit I love working late at night or very early in the morning with everyone else fast asleep in bed, some nice soft music on the radio with Simon, my dog, snoring away in his chair and the phone silent for once.

The studio

In another corner are my desk, filing cabinets and library of art books, which seem to be growing all the time. Again the units are home-made and can be added to as the collection grows. I don't myself get much time to read but my students usually take armfuls of them to bed at night. I work them so hard during the day it's the only chance they get.

In yet another corner is a rather sophisticated photocopier and my year planner, showing at a glance all the courses, overseas trips, exhibition dates and Art Society demos. I'd be absolutely lost without it now.

Below the photocopier is my store of standard size frames, all still in their plastic bags and waiting for pictures to fill them.

On the floor I've got those rather hairy carpet tiles called

The writing corner showing the art book library.

40

A corner showing the photo-copier, year planners and stock of empty frames below.

'Heuga'. I think they're quite important because, although they look quite luxurious and I'm not ashamed to take potential customers into the studio, they're also incredibly hard wearing and forgiving. My students wince when I flick my brush onto them, however, over the last few years they haven't shown any sign of a mark at all.

Let your studio, like your paintings, express your personality, however small and modest the room may be.

Painting out of doors

There's no such thing as perfect conditions for watercolour painting out of doors—at least not according to all the complaints and excuses I get from all my students. These include;

The paint dried too fast.
The wind blew my easel over.
It was so damp the paint wouldn't dry.
Someone parked a car right in front of me.
The rain ruined my sky.
I couldn't find any shade.
People kept coming up and chatting.
The light kept changing.
These cows came up and sniffed at me.
It was so cold my hands froze.
I couldn't get away from the flies.
And so on, ad infinitum.

Right: My complete outdoor kit under one arm.

Below: A group of students painting on a misty morning at my favourite spot on the Wye.

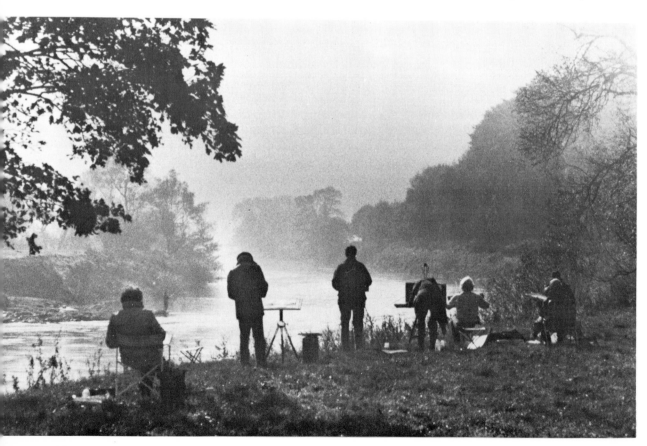

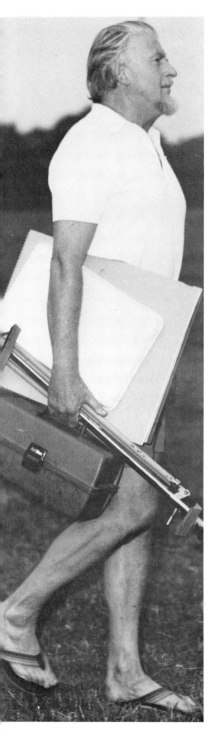

Seriously, though, I think I've painted outside in most conditions and I thought perhaps a few tips on how to cope with some of them might help.

First and foremost, keep your equipment simple. Over and over again I've been amazed at the enormous quantity of materials so many watercolourists consider is necessary to paint a simple picture. Quite elderly folk try to struggle up hills and over rocks with both arms full of quite inessential things, large heavy drawing boards, folding chairs, bags packed with enough paints and paper for months of work. They seem to think that the more they carry the less problems they'll have—nothing could be further from the truth. If they're with me, I never know whether to offer to take on some of their burden as well as my own or to try and ignore their heavy sighs, which makes one feel mean.

You should be able to carry the whole lot under one arm, leaving the other one for opening gates and fending off branches. My kit is generally much simpler than the ones of my students as they follow me around the countryside. I have my plastic art bin, which contains a soft pencil, my seven tubes of paint, my four brushes, collapsible water pot, plastic bottle of water, rags, spring clips and a couple of razor blades, besides my Bockingford pad with a hardboard backing, my plastic palette and metal easel. You'll see from the illustration how easily it fits under one arm.

Now, a big must. Before you set out check you've got everything with you. It's no good finding yourself a marvellous location and then discovering you haven't filled your water bottle, or you've left your palette or brushes behind. It's even worse when everyone is standing round waiting for you to demonstrate.

Windy conditions can be most trying to the temper when gusts make your paper flap and threaten to blow your easel over. I've often used strong words (when I've been on my own, of course). Spring clips are a must in these conditions and to hold the easel steady I've borrowed a tip from Angus Rands. He attaches a piece of cord to the easel where the legs meet and at the other end of the cord is a loop with a slip knot. On arriving on location he looks for a heavy stone, puts the loop round it and, hey presto, a solid easel. It's surprising, though, how much wind you can avoid if you find its direction and use a wall or building to shelter behind.

I try to use ergonomics when I'm painting outside, which just

Painting out of doors

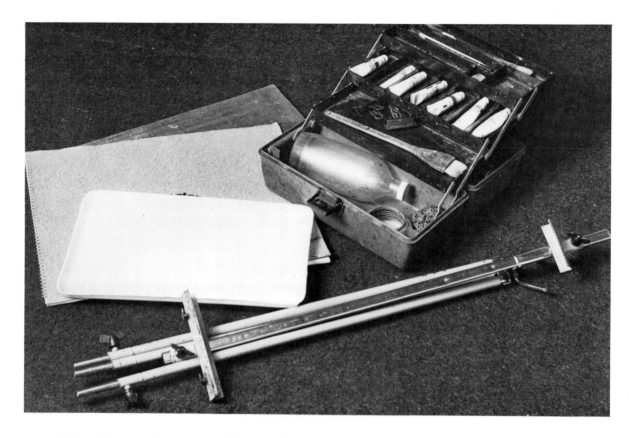

A complete outdoor kit of hardboard backing, watercolour pad, palette, easel, and box of assorted materials.

means that I try to have everything as close to the paper as possible so I'm not always bobbing up and down as this disturbs concentration. The water-pot is hung on a hook on the easel with the three brushes in it and I hold a plastic palette, with plenty of paints already squeezed out, in my left hand. I always paint standing up because I feel I have more freedom that way, but I realise that many of you will need a folding stool.

As to the problems of a sunny day, whenever possible try not to paint with the sun directly on your paper. I know it can't always be avoided—I've done many a demo in the direct sun when I'd rather be in the shade of a wall but then no one would have been able to see what I was doing. Apart from having to screw your eyes up against the light on the paper, the painting always seems to look washed out when one gets it home.

When painting watercolours in Greece in mid-summer there are obvious difficulties. We learnt to avoid working in the middle of the day with the hot sun directly overhead; it was not only

much cooler before ten or after five but the lighting and shadows were more interesting.

Talking of shadows, with a partly clouded sky the sun is alternately going in and coming out, so wait for a period of sunlight, leave the rest of the painting and concentrate entirely on the shadows. Once they're settled then you can continue the rest of the painting unhurried. The big difficulty with water-colour in a hot country is the speed of drying, even in the shade, and students are always moaning about this. After a time one learns to paint in a more staccato fashion, tackling smaller sections of the painting at a time. Luckily, the subjects often lend themselves to this technique, and if you're painting a misty river scene in England at five o'clock in the morning the fact that the paint almost refuses to dry can be a definite advantage in handling the scene before you.

Probably the easiest condition to work under is a bright but overcast light. There are no hard shadows or extreme points of glare yet there is plenty of contrast. Another advantage is that the light usually remains constant over a long period and you have a much longer painting time as the sun can travel for hours above thin cloud without any obvious change in the landscape. Of course the same light falls on the paper so you don't have to make any allowances, and the painting will look right under any illumination.

One problem that there is no answer to is rain. It can ruin a watercolour in ten seconds flat so don't try to brave it, turn the painting over the moment you feel the first spot. I don't know why but it always seems to happen just as I'm in the middle of an exciting sky.

Painting snow seems usually to mean numb fingers but you can help by painting the main washes with gloves on and just taking them off for the detailed work. Because the days are shorter an early start is important. The time I find most exciting is when the snow has finished falling and I wake up to a cloudless blue sky with the whole day ahead to paint—wonderful.

Painting out of doors

My other favourite condition is mist. It lends itself so well to wet-into-wet techniques. Try going out at about five in the morning before anybody else is up. You'll feel unbearably smug at the thought of what the rest of the sleeping population is missing. I always remember waking my wife up with a cup of tea one morning and showing her the painting I had just done. For once it was a beauty.

Finally, what to do about people. The one phrase that I seem to remember hearing over and over again is 'Are you a proper painter, mister?' Painters seem to be fair game for the rest of the world. I find that no sooner have I set up shop and start sketching than the kids arrive. They seem to vary a lot from country to country. In France they're fairly polite, whereas in southern Italy I've been the target for stones until I won them over, and after that they followed me around in a gang for days, applauding at the end of each picture and carrying my equipment.

Paint outside a Greek cottage, however humble and you'll be brought a succession of gifts including coffee, Ouzo and sweetmeats until the painting is finished—delightful but embarrassing. In Britain folk talk to you about their relatives—'I've got an aunt that paints,' or they run home to fetch you their childrens' work for approval. However, I've developed a technique for producing the occasional polite grunt which seems to keep the most talkative onlookers happy while at the same time reserving my entire attention for the job in hand—the painting.

Animals in the country are rather less trouble, they don't chatter, but cows, especially the young ones, have an insatiable curiosity and as soon as one of them starts to investigate they all come along, blowing loudly and wetly at you through their noses. Don't be scared of them though. One quick gesture from you will usually make them scatter for their lives and they soon become used to you and carry on eating.

Just a word or two about painting manners at home and abroad. The main thing to remember is that wherever you are you're almost bound to be on somebody else's property. Painting is a language that needs no translation and can easily jump any geographical and cultural boundaries. As an artist anywhere in the world you're regarded as someone a bit special in the eyes of the layman, no matter whether he's a Polish peasant or an English lord. The normal social barriers are often swept aside for you—you're in a privileged position, so don't abuse it. If you're

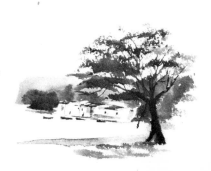

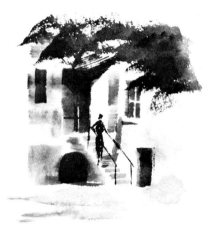

abroad try and learn the customs and taboos of the country, especially those based on religious beliefs. Some Middle Eastern people get very hostile if you try and portray them in your picture or, again, they may be delighted. One of the worst faux pas I ever made was in Paxos. My students and I asked permission to hold an informal exhibition of our work in the village square, and it was a great success with the crowds. Then the village doctor came up to me and asked if he could buy one of my paintings. I, of course, agreed and he handed over the money quite openly. That did it! One of the shop keepers got jealous and went to the police reporting that I was a foreigner selling pictures without a permit, the police arrived in force, the show was immediately dismantled and I was marched off to the police station, vainly protesting my innocence in English, which they couldn't understand anyway. I was very frightened and got into a lot of trouble all through my ignorance of their particular laws.

Just a few general rules. Anywhere in the world, when in the country, always be courteous and ask permission to set up and paint. You don't even have to know the language, your equipment is your passport and a few gestures and smiles will do the rest. It shouldn't be necessary for me to ask you to shut gates after you and not to trample over growing crops, but many's the time, with a painting group, I've had to run back and close a gate left open by the last one through. It can lead to chaos later and much bad feeling by the farmer. Always have a plastic bag with you to remove absolutely all your rubbish, including cigarette butts and cartons, dead matches, empty paint tubes and used tissue papers. Apart from the aesthetics, animals will try to eat practically anything.

When you're in the towns, try to be as unobtrusive as possible, and get into little corners away from the main flow of pedestrians. You're inevitably going to be regarded as a free show and a crowd will soon gather, like wasps round a jam pot. This is where a sketchbook and camera really come into their own. The sketchbook is much less obtrusive than an easel and a camera will fill in all the details you may have missed in the sketch. You can then paint the picture in seclusion back at the studio.

However, there's no substitute for the fun and adventure you're undoubtedly going to get outside with your watercolours, even if you do have to struggle with all the elements as well as your paints.

Pencil sketching

When non-painters at receptions turn to me and say sweetly, 'It must be wonderful to have a gift like yours', I'm always tempted to say, 'That's no gift, I've had to work bloody hard to get even this far.'

What I'm working round to is that so many students say, 'I can't draw', as if somehow they've missed out and the Almighty hadn't provided them with instant drawing skill on a plate. Believe me, it just isn't like that in real life. This skill has to be worked for. I feel that so called 'talent' is mainly the determination to work hard at your chosen subject for long periods, while others are out having fun and who then come back to you afterwards with this 'gift' speech.

Not that pencil sketching isn't fun in itself. A phenomenon I've always noticed is that for some reason everyone is friendly with artists and dog owners, as if one is taught to be suspicious and cautious about starting conversations with complete strangers but it's all right with those two types—even in cities. As I'm both, I make a lot of friends.

To get back to the point, there is absolutely no substitute for sketching to teach you not only skill in drawing but that even more important thing, observation, which is to record visual information intelligently instead of glancing mindlessly at things.

Sketch of a Welsh valley. The hills were put in with a soft, carpenter's pencil.

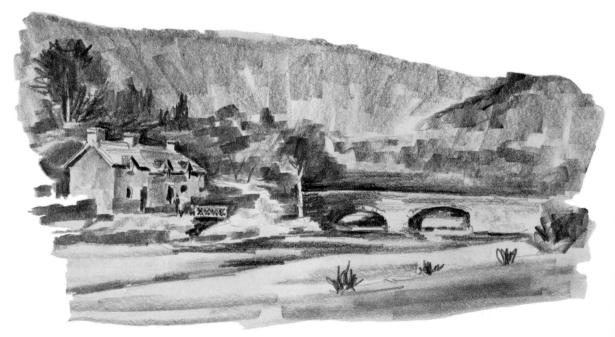

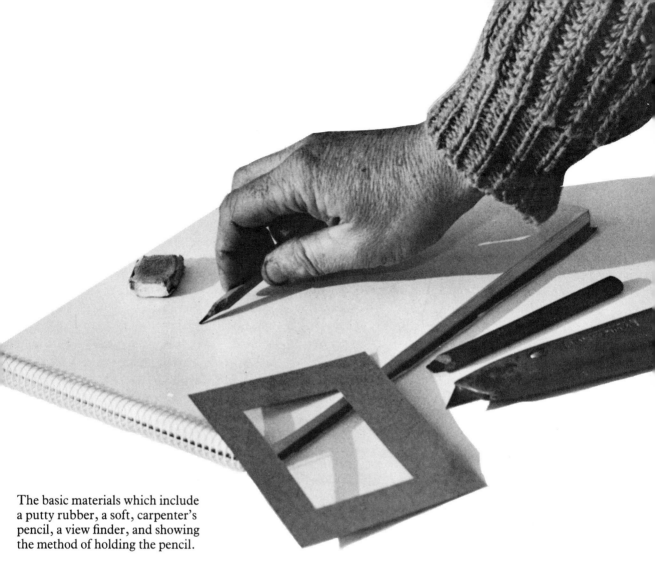

The basic materials which include a putty rubber, a soft, carpenter's pencil, a view finder, and showing the method of holding the pencil.

It will also teach you to select the essentials of a scene and reject the superfluous. As a bonus, it will provide you with a countless source of material for your future finished paintings.

The materials are cheap enough. All you need is a pad of cartridge paper, a 6B pencil and a Stanley knife blade to sharpen it.

A useful addition would be a postcard with a hole cut in it to form a frame. The hole should be in proportion to your usual watercolour paper size. It's enormously helpful, especially for beginners, in isolating the scene within the mount, enabling you to try various compositions. Afterwards, it will show you where the horizon meets the edge of the picture, how high up that hut comes and where that path meets the base—all the information that will help you put things down on paper with more confidence.

Now for the usual pitfalls. Don't try to put down everything you can see, filter out superfluous detail and look for the larger

Pencil sketching

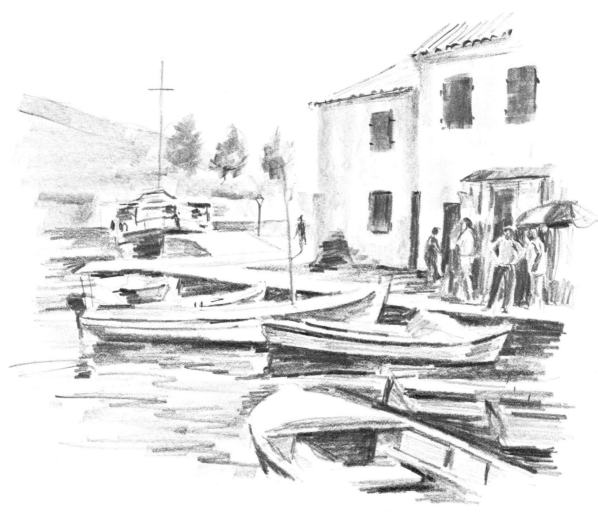

masses. Screwing up your eyes will help because then all you'll be able to see are the essentials without the clutter. This will also help you to find the main highlights and dark areas.

Once you've chosen your view through the card, feel free to shift things around to improve the composition. Simplify those buildings, put some clouds in, take out that ugly fence and the rubbish, move the tree a little to the left. Remember, the picture has to stand on its own feet, perhaps ten years later and a thousand miles away, without you being there to make excuses for it.

A lot of the above things I've said elsewhere in the book about watercolour painting itself, so you can see what good practice it is. The pencil, as with the brush, should be used with as few strokes as possible, making each one count, and without covering the paper with meaningless scribble.

A sketch of the little village of Logos on the Greek island of Paxos.

A 6B pencil has enormous power and intensity when used with emphasis. Don't hold it like a pen but sideways as shown. It's much better used unpointed, as a wedge shape. Do remember that a 6B is very soft and breaks easily, so sharpen it gently.

Basically, as a watercolourist, you need just as much practice with your pencil as you do with your brush, but your growing skills in both will cross fertilise each other.

Start off your sketches by drawing single objects, like a cottage, a boat or tree. As you progress and go on to full scenes this will do wonders for your confidence as your work becomes stronger and you draw with more authority. Drawing practice will also help you solve many of the problems of composition and light and shade that you'll encounter in your watercolour painting.

A sketch of one of the little backwaters in Venice.

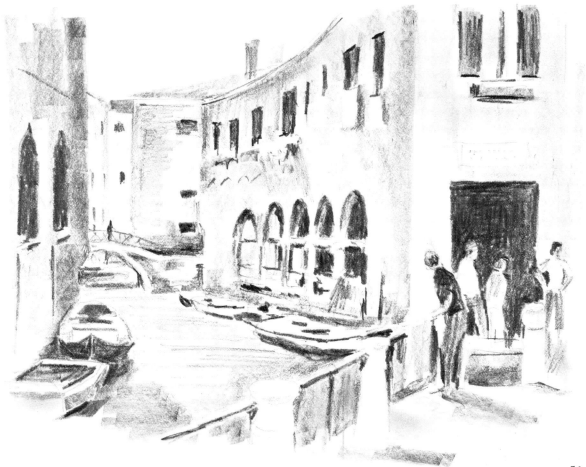

51

Tone

Painters often get confused between the terms colour and tone. Tone is the lightness or darkness of an area irrespective of its colour. You might have two balls on a snooker table, one red and one green, but both would be exactly the same tone. In fact, probably the best way to explain the difference is to turn the knob of your colour television set until the picture goes black and white and you've converted everything into tones.

A normal landscape is composed of scores of tones ranging from white to black. What you must do is to try and simplify these into just a few. Screw your eyes up until you can only just see through them. You will then eliminate nearly all the detail and colour leaving you free to distinguish better the various tonal ranges.

If you can then break down what you see into four tones, you've more or less solved the problem. These tones extend from what in watercolour is the unpainted paper, to the darkest pigment. The middle tone is local colour, while highlights and shadows are at the two extremes.

However, in watercolour, unlike oils, you have to decide where your whites are to be before you start your picture and either paint round them or mask them out. You usually start by painting the light tones first and work through the middle tones to the darkest.

I find I'm continually screwing up my eye to check on the tones of my painting, and if the adjacent tones then tend to run together I know that I have to increase my contrasts. If these are not present enough in nature itself they have to be deliberately exaggerated.

But why bother with this business of tones? One reason is to create a sense of unity and contrast in painting. Before you actually begin your finished painting you should do a small tonal sketch in pencil in which you can test and organise your placement of lights, middle tones and darks. Don't bother in the sketch so much with the objects themselves but more on the tonal relationships. Once this is done to your satisfaction and propped up in front of you, it will do wonders for your confidence. It will mean that you will be able to work directly from light to dark with less repainting and patching. Your finished painting will then not only hang together better but it will be fresher and more in control.

Right: The actual scene with some
rather confusing tones.

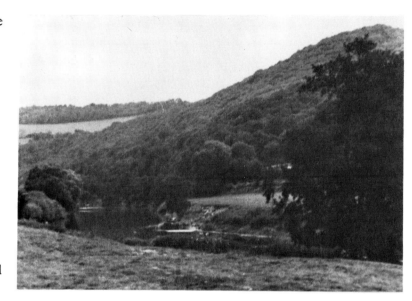

Below: In the painting I have tried
to simplify the tonal values.

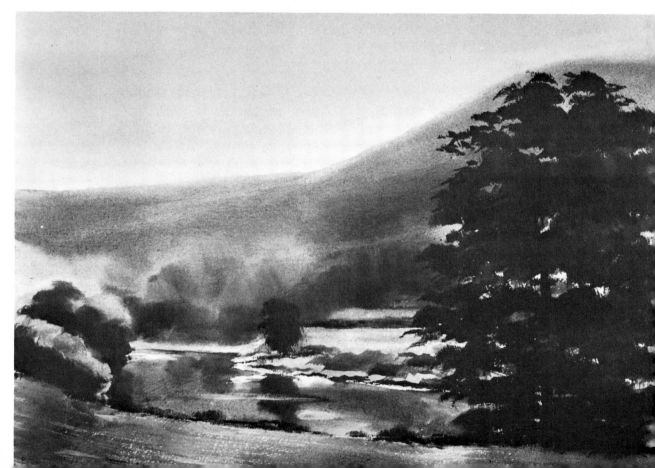

Composition

What is composition? It is simply the means of arranging the parts of your picture so that they add up to a harmonious whole. A badly composed picture will look bitty, disjointed, and faintly irritating, but a well composed picture fits together in a satisfying way even though we may not be able to explain exactly why. Whilst there is no foolproof way of composing a painting you will learn mainly by experience, but some of the more obvious pitfalls are shown opposite.

First, you must provide a way into the picture, usually at the bottom, the eye is then led over the foreground to the main part of the painting, resting at the centre of interest and exiting in the distance or out of the side.

The worst thing you can do to a picture, and I've seen it done so many times, is to put a wooden or even a barbed wire fence right across the front, as if the artist was deliberately trying to keep the viewer out rather than inviting him in. 'But, it was there', says the artist, not realising that unlike a photographer who has to accept everything that's put in front of him, the artist can and should edit and reject things that he doesn't want in his painting.

Secondly, division of space is important—this is the way a picture is organised. There are lots of ways of doing this with triangular, circular, radiating and rectangular divisions, to mention a few. They are much more exciting visually if they are asymmetrical. The old masters were billiant at this and a lot can be learnt by analysing their paintings.

Third, always provide a centre of interest—the most important thing and what a picture is really all about. It is very important that this centre of interest should be placed correctly in the picture where everything can lead the eye to it.

The complete master of this was Rembrandt. You are absolutely compelled to go where he wants you to go. Your own paintings should try to do the same thing, which is to guide the viewer gradually to the centre of interest. You can emphasise this centre in all kinds of ways, with dramatic counterchanges, as I mentioned on *page 59*, or it can be one spot where the colour is most intense, or even the only place where the paper is left completely white. A single boat on a beach can be very dramatic, however small it is, particularly if the curve of the coastline points the eye directly to it. If it doesn't you can change the coastline or move the boat.

1 Too many horizontal forms in a painting are liable to look monotonous so compliment them with some vertical feature. The same goes for too many verticals without a horizontal.

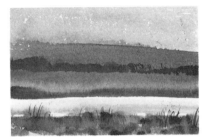
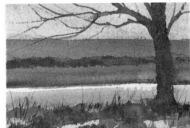

2 Make sure you have a centre of interest in your picture. It is the point around which the whole painting revolves.

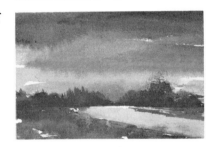
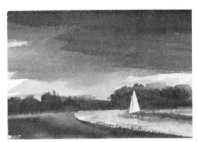

3 Never get two objects of equal interest and weight vying for attention. Make one of them dominant and diminish the other.

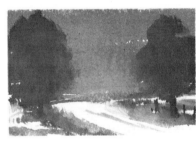
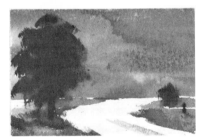

4 Don't divide your painting into two equal halves by putting the horizon in the middle, either raise or lower it depending on whether you want the sky or landscape to dominate.

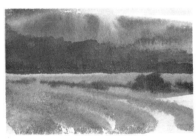
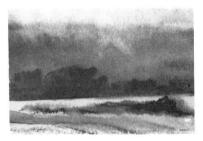

5 The main object of interest should never be in the exact centre of your painting, move it to the left or right.

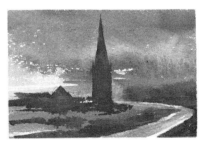
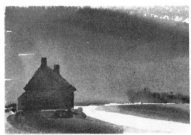

Composition

Now to some of the don'ts. The main object of interest should never be placed dead in the middle of the picture but set to one side. This is a very common fault with students. The other places to stay away from are the outside edges and the corners. The worst faux pas of all is to put two objects of equal interest in the painting. The eye tends to bob backwards and forwards between the two. For example, if you have to show two boats or trees, make one bigger or more dominant than the other.

You see, then, that you have the power once you know how to use it, of controlling your viewer's eye. Begin to look at good paintings with a fresh mind, it's very easy to find the centre of interest in most of them but it's much more important that you see and understand how the artist has helped you to find it.

Finally, keep plenty of variety in your painting. Contrast softness and wetness with crisp, sharp strokes. In a mainly horizontal picture, put at least one vertical object. Vary your textures as much as possible; put plenty of depth in your work. If part of your picture is very busy, don't be afraid to have peace and quiet and emptiness in the rest of it. You can have low-keyed painting where you can afford to add a spot of colour, rather like putting an orange cushion on a fawn settee.

An example of contrasts in texture; softness and wetness in the background with crispness and sharpness in the foreground.

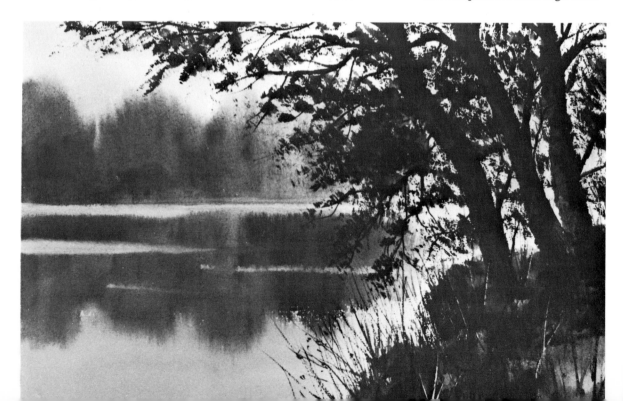

Aerial perspective

This is one of the most useful techniques in watercolour and gives the illusion of depth better than anything else. It's based on the basic principle in nature that light tones seem to recede into the distance whereas darker tones seem to come forward.

If you look at the work of the masters of watercolour painting, such as Turner, Cotman and one of my own favourites, Edward Seago, you'll find they all used aerial perspective constantly, indeed, they seemed to have deliberately searched out and painted subjects which ideally lent themselves to the technique.

The other important thing to realise about recession is that objects also appear to contain more blue the further distant they get. The greens in grass and trees, for example, are quite pale and bluey at two miles away and they get richer and warmer as they get nearer to the viewer.

If this all seems to be stating the obvious you would be surprised how many students seem to be unaware of it or, at any rate, forget it as soon as they start painting. They see what is obviously a dark tree on the horizon about ten fields away so they paint it in a strong dark tone, forgetting that there are still about five layers of trees before the foreground is reached. In other words they've used up their tonal 'big guns' in the background and have nothing more powerful left for the foreground. The same applies if too rich a green is used for a far distant meadow which should have been held in reserve for a nearer one.

I always paint, and advise my students to paint, from the furthest distance, gradually moving forward in planes to the foreground. I aim to start off, as it were, in a whisper with pale bluey colours, possibly soft, out of focus wet-into-wet and then raise my voice with stronger, richer colours containing a little more detail (not much!) until the foreground is reached which should be stated crisply, strongly and decisively but without fuss.

A typical example of aerial perspective.

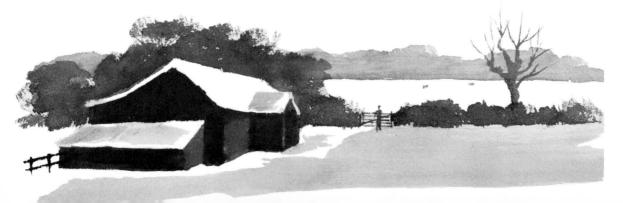

Aerial perspective

The first plane that goes in after the sky is the distant hill.

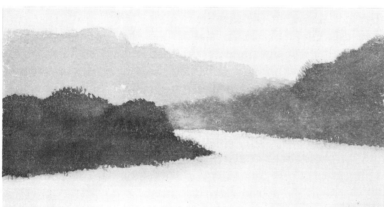

The two banks of the river are painted in ascending tones according to their distance.

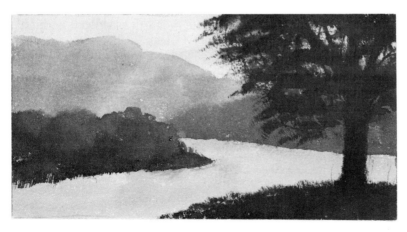

Lastly, the foreground completes the picture with the strongest tone.

Counterchange

Counterchange is the placing of dark shapes against light ones, and light shapes against dark. Basically, this is contrasting areas of dark and light as on a chess board. This principle should be locked in your mind all the time when you're painting, almost like a fighter waiting for the opportunity to use his favourite punch. All the great masters used this principle when they composed their work, but unless you're aware of what's going on you probably accept it without appreciating it.

You only realise how important it is when you see a painting done by someone who hasn't yet learnt about counterchange. A house may be put next to a tree, both with the same tone, even though they may be a different colour, and the only way they can be separated is by having to draw a line on top to show up the edges. This I call wire—it's an admission of defeat. What they should be doing, instinctively, is to darken the tree to show up the edge of the house or darken that bit of the house where it comes in front of the tree.

The most obvious way of stressing the main centre of interest can be achieved very dramatically by putting the darkest dark in the picture against the lightest light, such as the pure white sail of a yacht that just happens to be passing in front of a very dark tree, or a horse and cart coming over a hill being silhouetted against the lightest part of the sky.

The same principle should be at work in a less obvious way all over the picture, but these things don't just happen by accident in a painting, they have to be thought out beforehand.

Let me emphasise this again, put the idea of counterchange into your brain permanently and use it at all times as part of your armoury.

With this in mind you can even begin to see new patterns in nature itself, where so often in a landscape objects seem to be set one against the other in sharp tonal contrast. If nature doesn't always do it for you, rearrange the adjacent tones yourself. It's up to you, after all, you're in charge.

Notice the silhouetted figures against the light in the arch and the light figure placed against the dark part.

Counterchange

The sunlit church is shown against a dark part of the sky. The dark tree at the far end of the church also helps with the counterchange. The foreground tree on the right is silhouetted against the light sky.

Here the white sails are shown against the dark tree. The figures are silhouetted against the light river, whereas the tones of the mill are reduced to give distance.

The foreground bridge is thrown up by the darker background and the castle is dramatised by being placed against the lightest part of the sky.

Linear perspective

Now we come to the boring bit, but bear with me, please, don't hurry on to the next chapter.

I've heard so many students say, almost defiantly, 'I don't know anything about perspective', somehow implying they don't want to either. They seem to feel it's a subject that will always be beyond their comprehension. I think the word itself puts people off.

Often on a painting holiday I've gathered together all those folk who've professed ignorance or fear of perspective and we've had a short session working out the basic facts and learning how to avoid the more obvious pitfalls. Within an hour or so most of them have had a much better grasp of the subject and their paintings have improved considerably.

Any fool can point out that you've made a mistake in perspective but it's not always easy to be able to put it right.

Whole books have been written about the laws of perspective but, as with legal laws, you need only enough knowledge of them to be able to keep out of trouble.

In your paintings the houses should sit soundly on the ground, their walls should not threaten to fall over, or their roofs to slide off; trees, figures and even clouds should all become smaller as they recede into the distance. Roads should become narrower and boats should float serenely on the surface of the water, but all will rely on your basic knowledge of perspective for them to look convincing.

The first thing we need to establish is the artist's eye-level which will determine the horizon line in the picture. For most people the horizon is where the earth meets the sky, but for the artist, the horizon is at eye-level, intersecting with an imaginary eye-line running straight ahead from the eye. Therefore, if the artist is sitting, the eye-level will be lower than if he or she was standing—so too is the horizon.

The various elements in your painting will be partly or fully above or below your eye level. In most cases the main part of the picture will be above eye level.

Having understood that, the next thing to discover is the vanishing point. This is always on the horizon and is the spot where all the parallel lines seem to meet. In many cases the vanishing point will actually be outside your painting.

Now to perspective itself. There are three different sorts but they're all quite easy to understand. There is one point perspec-

Linear perspective

tive which is where all the parallel lines seem to converge to a single vanishing point. This occurs mainly when you're painting interiors but the drawings will show you what I mean.

Two point perspective is the most common, which is when the parallel lines seem to converge on two points on the horizon, as when you're painting a house and can see two sides. Again, the drawing explains it.

Last is three point perspective but not much used unless you happen to be painting a sky-scraper from above, or a church tower from close to its base. This is when parallel lines seem to converge on two points on the horizon and another vanishing point either above or below the horizon line.

A useful thing to know is how to divide a plane in half, for example, if you want to find out the position of the top of a gable on a house. Draw two diagonal lines from the corners of the plane, as shown, and where they meet will be the halfway point in perspective. Using the same idea you can get most divisions that are needed (*see page 65*).

Regarding the drawing of figures or animals in perspective, imagine you are standing on a flat plain looking into the distance:

Opposite page, top: An example of one point perspective outdoors where one might be looking at a garden from a bedroom window.

Opposite page, below: This shows a two point perspective with objects above and below eye level.

Below: An example of one point perspective in a room.

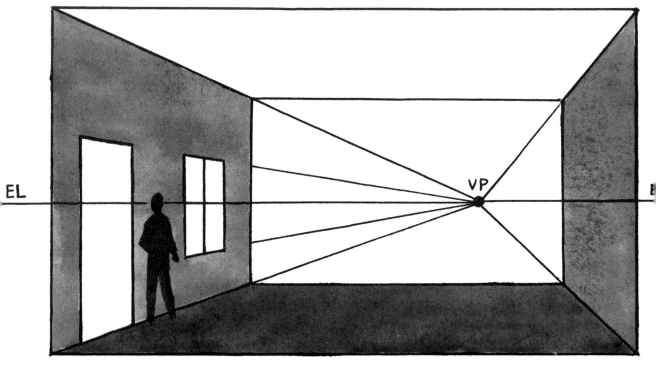

EL

VP

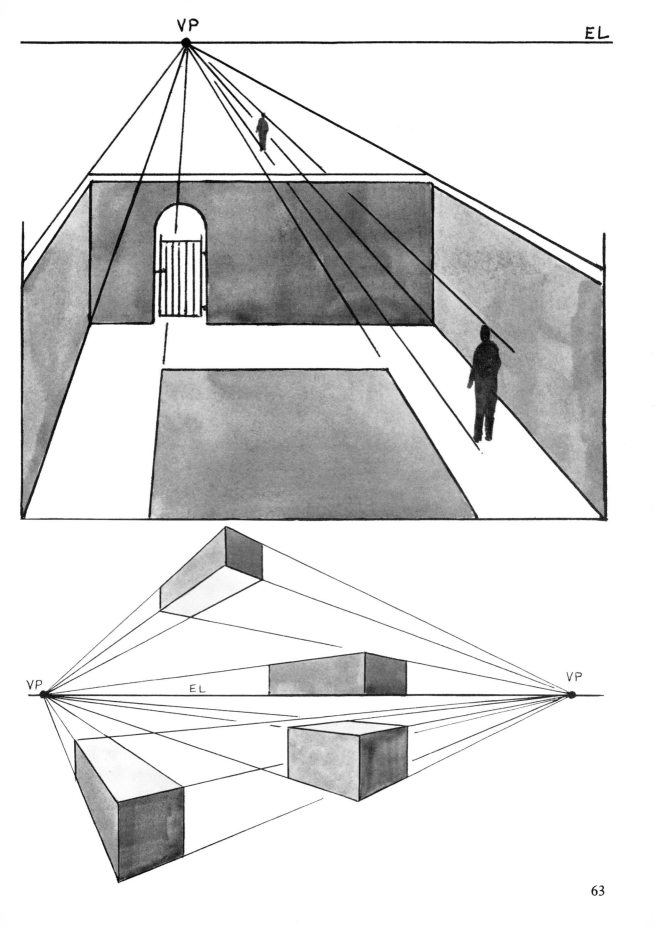

VP

EL

VP

EL

VP

Linear perspective

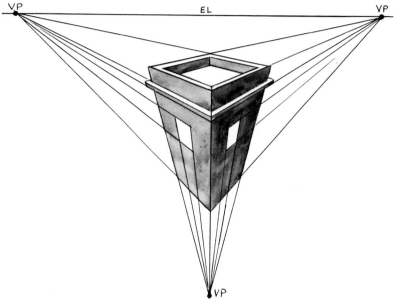

An example of three point perspective as if one were looking down on a tower.

A painting showing vanishing point and lines of perspective.

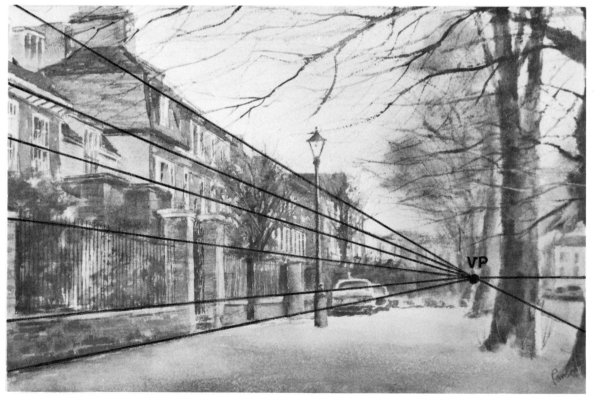

A cottage seen at the eye level of a child. Notice the eye line half way up the door.

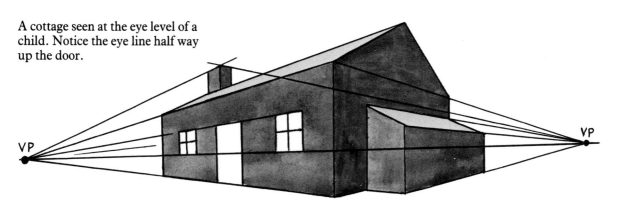

The same cottage seen from the eye level of the chimney. Notice also the way of locating the top of the gable.

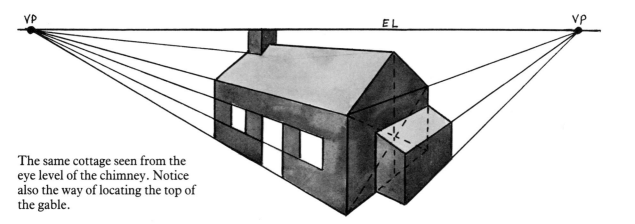

The placing of figures on the eye level.

there are figures in the foreground, middle distance and in the distance. You will need to draw them so that the horizon cuts them at eye level with sitting figures a little lower.

Do try to think of perspective not as an adversary but something that's always with you so can be studied at any odd moment. You don't even have to have a pencil in your hand. From where you're sitting look at the line of the wall where it meets the floor and the line where it meets the ceiling then try and place in your mind the spot where the two lines meet. The perspective lines at the top and bottom of the window would also both meet at the same spot, so would the top of the shelf.

You see, the whole thing is mainly common sense and the more familiar you become with it the less mysterious it seems.

Skies and clouds

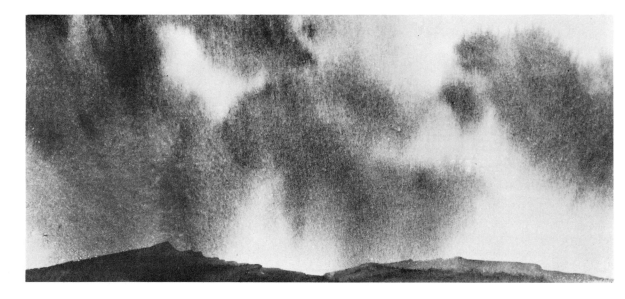

With skies the chief fault is nearly always timidity. I'm so often shown a painting with a weak anaemic looking sky and the usual excuse is 'It looked quite strong when I first put it on but it seemed to fade back.'

The answer is that when it was first painted, the rest of the paper was white and the contrast gave it a false value, then of course the rest of the landscape was put in, with perhaps a few dark trees, and as a result the sky looked half strength. Although the same thing happens time after time the student still seems surprised and disappointed.

The only way is to start by taking your courage in both hands and paint it that much stronger and richer than you think it ought to be—then it will probably be about right when the whole picture is finished.

It's amusing to hear the gasp that often goes up from my audience when I'm painting a sky. They're sure I've ruined it but by the time the whole picture is finished everything has dropped into place tonally.

Another thing people tend to do is play about with their skies—pushing the paint around too much, sometimes painting a blue sky all over and then jabbing out their clouds with loo paper. I don't like using loo paper in painting—not even the super soft kind! My own feeling is the less you touch and torture the surface the fresher and more professional the painting looks.

An example of wet-into-wet nimbus clouds.

Opposite page: Part of a painting, reproduced actual size, of a scene at Southwold.

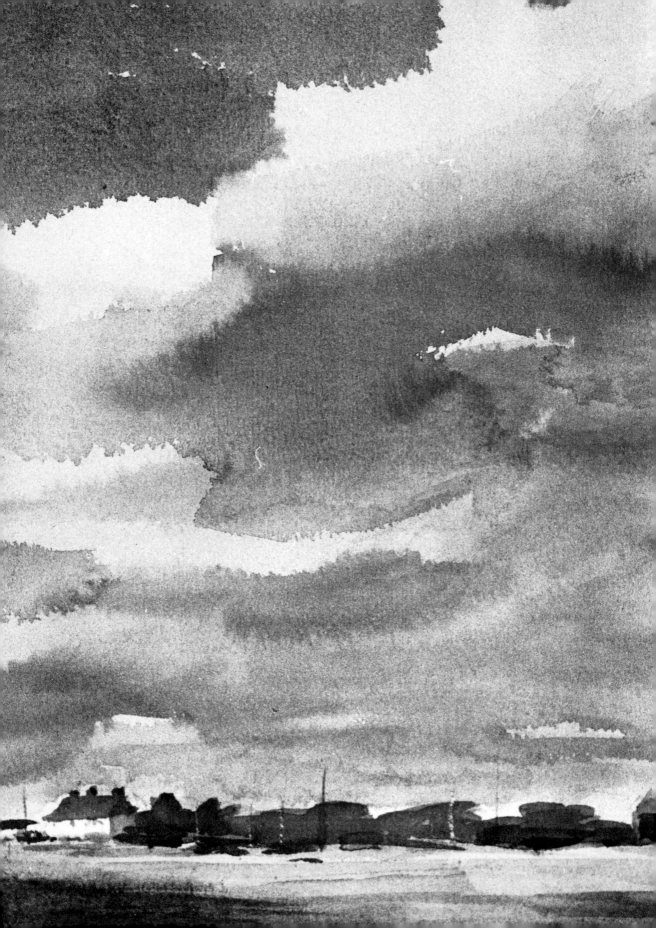

Skies and clouds

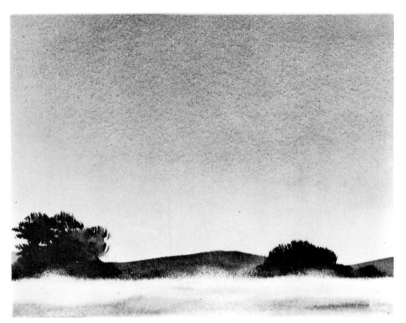

Left: Even a clear blue sky should graduate in tone with the colour at the horizon being weaker.

Below: Showing how clouds, too, obey the laws of perspective, appearing to get smaller as they reach the horizon.

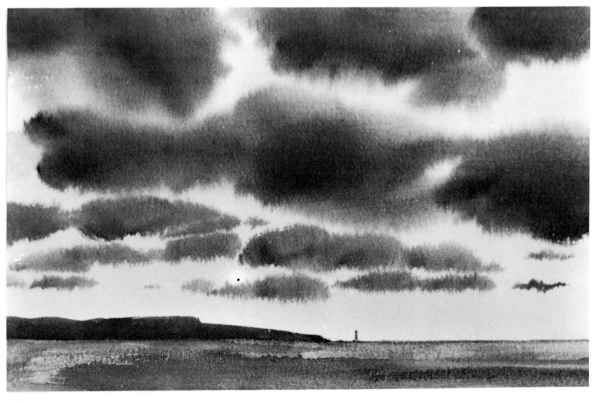

A sky with a mixture of cirrus and cumulus formations.

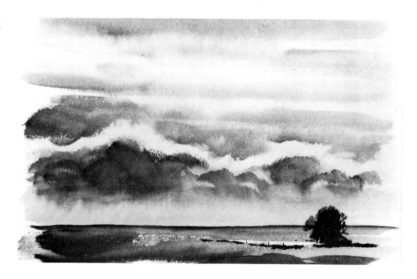

The whole sky should be planned beforehand—what sort of weather conditions you are going to have, whether it's a windy, sunny day with lots of fleecy white clouds, or an approaching storm, or even a clear blue sky.

The worst thing you can do is to paint some water tone over the area and drop some darks in, trusting to fate and luck that they will look like some sort of clouds and fool somebody.

I'll try to show you in the next few pages some of the ways of tackling the various conditions.

In general, painting skies is rather like going off a high diving board, it looks scary before you do it. But take a deep breath, paint quickly and decisively; after a few successes you'll begin to enjoy that mixture of skill and luck that combine to produce a fresh watercolour sky that works.

Here are a few basic facts about skies which will make them look more convincing. First, clear blue skies should never be flat but are darker above, and lighter as they approach the horizon. I always put a very weak wash of Raw Sienna all over my sky just to give a creamy tint, then paint my blue strongly across the top, while the first wash is still very wet, and then graduate it so that by the time it reaches the horizon it's almost non-existent.

It's important to realise that clouds have their own perspective too, in as much as the big ones are always at the top of the picture and they gradually get smaller and weaker as they approach the horizon.

Skies and clouds

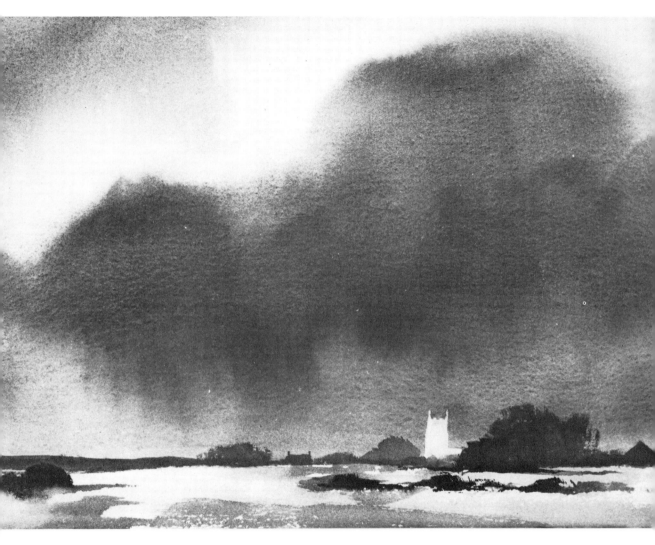

Going back to the high diving board simile, the more you practise the more confident you'll get. Try doing at least one sky every day. You don't need to do the whole picture, just look out of the window any day of the year and work out quietly in your mind, before you actually get the brush in your hand, what sequence of washes you're going to use. Select the essential features and simplify by using the big brush only and working quickly and decisively—you can even give yourself a time limit of say, ten minutes—you'll be amazed how quickly you'll be working with increased authority and pleasure.

A dramatic sky with threatening nimbus clouds. Notice the opportunities for counterchange.

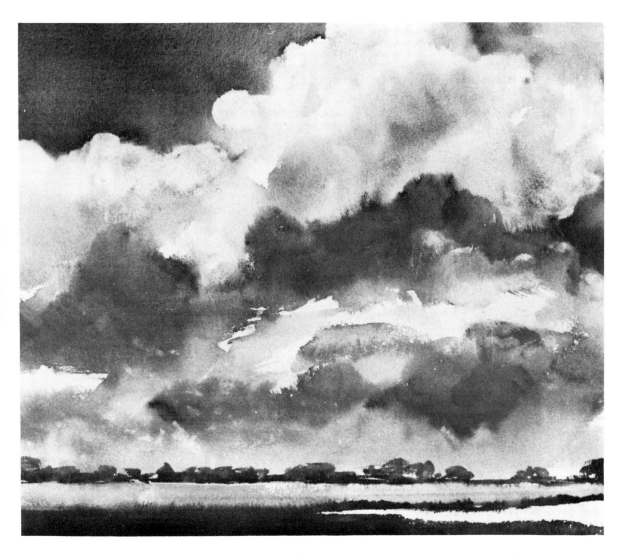

A strong and vigorous sky with cumulus which needs to have a simple landscape as contrast.

Another simple rule to remember is that if you have a complicated landscape give it a simple sky, but if you want to paint an elaborate sky, set it against a relatively simple landscape.

Being very simplistic, as this isn't a book about meteorology, there are three main families of clouds: *cirrus*, a thin, wispy high cloud; *cumulus*, a white, woolly type which has a light top where the sun catches it, with a shadow underneath; the third type is *nimbus*, which is a rain cloud and usually means business. Of course, in reality, things are more complex. And you get the various types overlapping. A plain layer of low cloud is called *stratus*.

Trees and foliage

I'm convinced that most of the faults that so often occur when painting trees are not basically because of a lack of skill but a lack of observation. In so many cases it's a quick glance at the actual tree and it's eyes down to get on with the painting, with scarcely a second look. The result is often a stereotyped cardboard cut-out of a tree with little thought of light and shade, and branches that are silhouetted in front of the foliage rather than feeding up into it.

So many times I've sat down with a student afterwards, compared the painting with the actual tree and pointed out that most of the branches can only be seen through the gaps in the foliage masses. They've then looked hard and long and said, 'You know, I've never noticed that before.'

Whole books have been written about drawing and painting trees, but what I want to do is give you a few of the basic facts about them, some seemingly self-evident but so often ignored when the painting starts.

Opposite page: Part of a painting reproduced full size showing the treatment of a foreground tree and other trees at various distances.

Below: A quick sketch of a river bank done entirely with the hake.

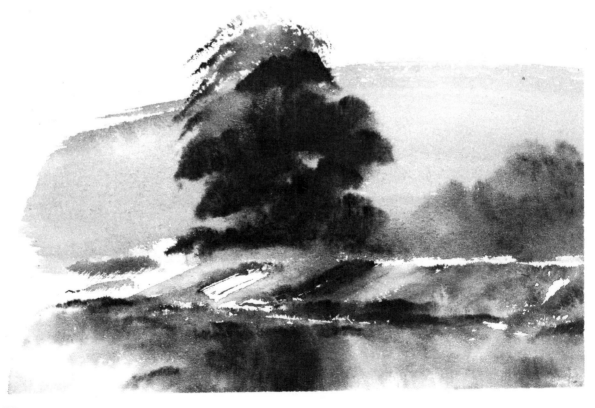

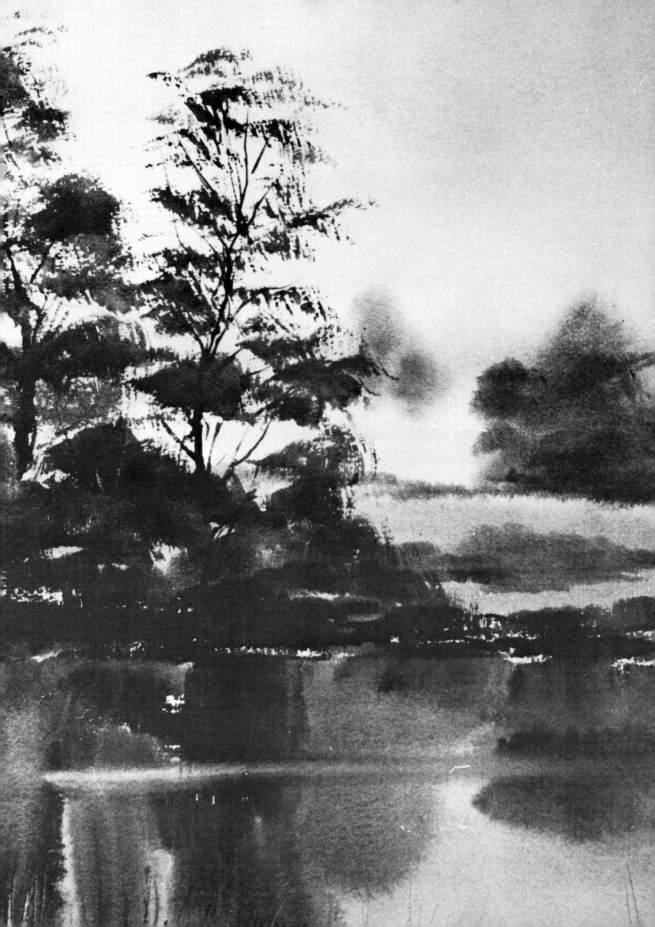

Trees and foliage

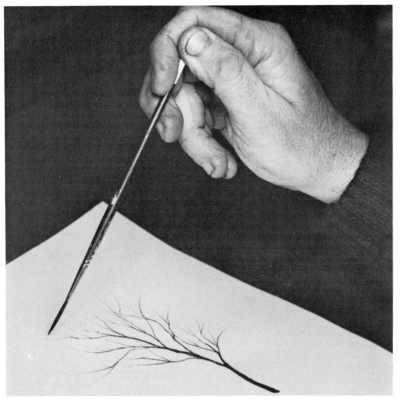

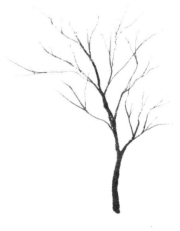

Left and above: Method of portraying a winter tree with the rigger.

Below: A branch produced with the rigger and with dry brush twigs added with the hake.

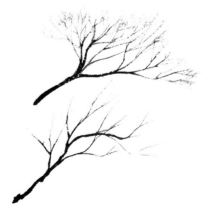

The structure of a tree tapers gradually upwards from its trunk to twigs. The important word is gradually. I've so often seen students putting in the main trunk and then adding a few twigs to support the rest of the tree, which would all collapse in the first breeze. This is where brush control is very important, being able to take the pressure off gradually, until you get to the really fine twigs at the edges. Again, because of this lack of control, the branches even seem to taper and grow thick again, something that couldn't possibly happen in reality and looks very amateurish, so do practise with that rigger!

In all cases when you're painting trunks and limbs, start from the base of the tree and work up, after all, that's the way it grows.

Each species of tree has its own characteristic silhouette or basic profile. Branch structure is different too; elm trees branch in a characteristic 'Y' fashion, oak branches in an erratic sickle shape. Willow often have a 'U' where the branch joins the trunk. Pine branches leave the trunk at right angles and the lower, heavily weighted down ones even bend under their own weight.

Right: A typical tree produced with a hake and added rigger.

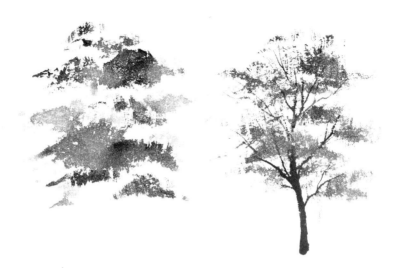

Below: The method in progress. Basically trees are moulded by light. Branches should not be placed over foliage.

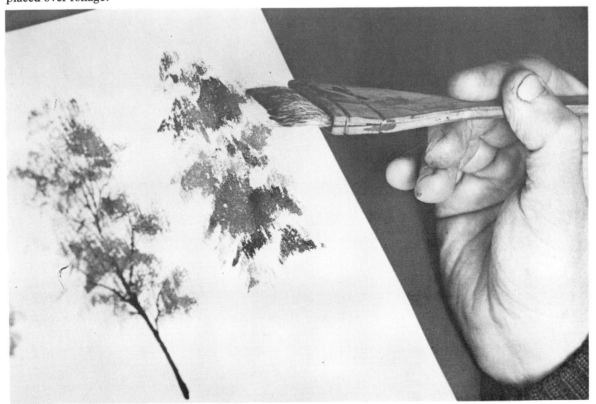

Trees and foliage

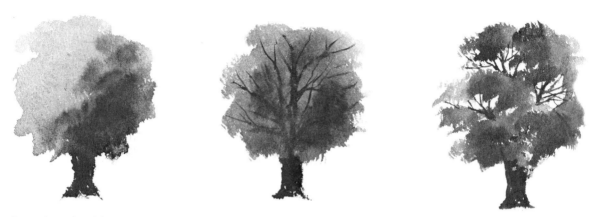

Branches should generally be seen only through 'sky holes' as shown on the right.

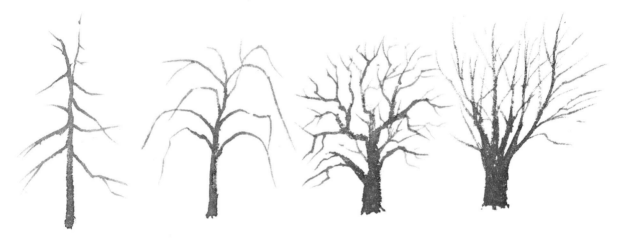

Look for the pattern of growth in the various trees. Above is a pine, weeping willow, oak and horse chestnut.

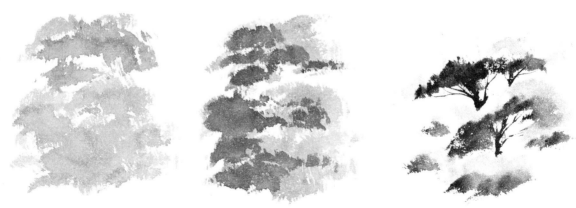

Painting of foliage in two washes. Strong sunlight can produce the effect of caverns in the tree, (*right*).

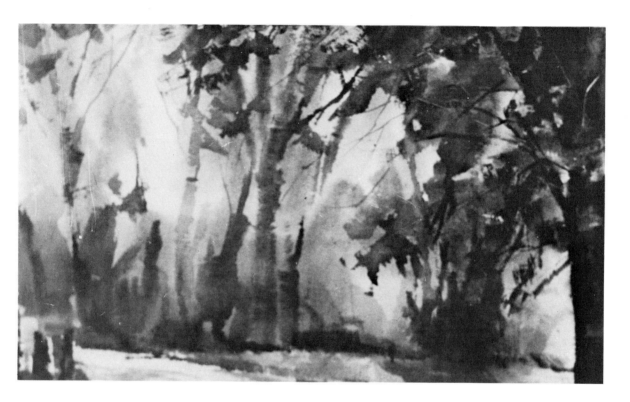

Above: A quick impression of trees in my village. The trunks are produced by a succession of side strokes with the hake.

You don't have to remember all this, it's more important that you get into the habit of looking at trees analytically with these points in mind before you even get your brush out. On my own courses, after I've made sure they can handle their brushes properly, especially the rigger, I send students out into the garden and get them to do half-a-dozen 'tree portraits,' each of a different species. The object is for them to observe carefully for at least two minutes then work quickly and simply, not bothering with fiddly details but focussing on the peculiarities of that particular tree. It should be possible for someone to go back and identify each tree among all the others afterwards.

Do try to get into your mind that a tree is three-dimensional, it's not flat as it's so often portrayed, its branches not only spread from side to side, they also come towards you and go away. This is just as important but more difficult to portray in a winter tree with all its leaves removed.

I'm often asked, 'Do I paint the foliage first and add the trunk and branches afterwards, or paint the trunk and branches first and add the leaves afterwards?' Look at the tree first and decide

Trees and foliage

which is the more dominant. In a full, lush, summer tree it seems all foliage and you can only see a branch or twig through the occasional sky-hole. There's no point in painting all the branches first just to cover them up—it's surprising how few branches are really needed, in this case, to finish the tree.

Let me remind you at this point of that common fault of drawing a lot of conventional branches on top of the foliage 'just for luck', even though they're not actually visible at all. This really is lack of observation.

In an early spring tree, or where the structure is dominant and the foliage light, paint the trunk and branches first and add the leaves later.

Sky-holes, or 'spaces for the birds to fly through', are often completely ignored. These are very important and occur especially round the edges of the tree. Often quite a lot of sky can be seen through even the thickest foliage. Putting these in also avoids that cardboard cut-out look.

Groups of trees together lose their own identity and unite to make one shape. The common fault here is to overdo the detail on individual trees and foliage groups. The further away a group or a wood, the less elaboration is needed. There seems to be a dreadful temptation to add some fiddly trunks which usually ruins things, when all that is needed is a single flat tone.

In general, I try to resolve trees into two basic tones, putting the lightest tone first and adding the strong darker tone while the first is still damp, keeping in mind where the light source is.

Whenever I'm painting trees I use only the hake for foliage which forces me to eliminate fussy detail and concentrate on the

Below and opposite page: A few sketches of various varieties of tree showing their general characteristics. *Left to right*: oak, silver birch, Scots pine, plane, weeping willow, lime.

basic masses. The direction of the strokes depends on the basic character of the tree itself but a glance at the illustrations will show you what I mean.

I find the rigger indispensable for putting in the branches and twigs. By pressing hard down on the paper it spreads enough to portray quite large middle distance trunks of trees. By gradually taking the pressure off the brush it will draw tapering branches, and by flicking it lightly off the paper fine twigs can be shown.

Another potential problem is that of painting a light tree branch against a dark background. The method depends on the width. For fine branches I usually flick my finger nail into the damp paint. For wider branches or trunks one can paint the background in vertical strips leaving the trees as white paper where possible. I've even carefully pushed the end of the hake gently through the still damp background. Another way is to use a kitchen knife or a Stanley knife blade. Timing is important though. If the paint is too wet the stroke will fill in and it will finish up darker rather than lighter. The lesson is to experiment on scrap paper with all these ideas to see which suits you. Do things lightly and directly and don't torture the paper. Another solution of course is the use of masking fluid (*see page 123*).

If you get a tree with light foliage in front of a darker tree, put the light tree in first and then paint the darker tree round it.

To sum up then, the best advice when painting trees is to look, look and look again. Simplify the tones and colours, especially as they get further into the distance. Do the absolute minimum of characteristic detail and then stop before you over work them.

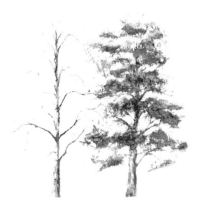
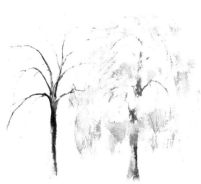
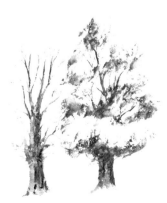

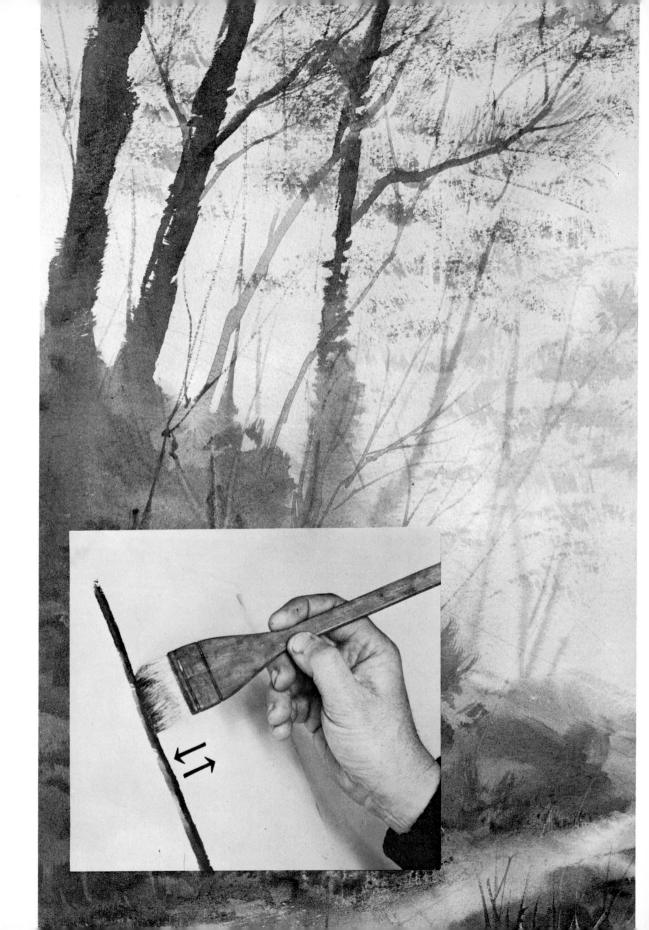

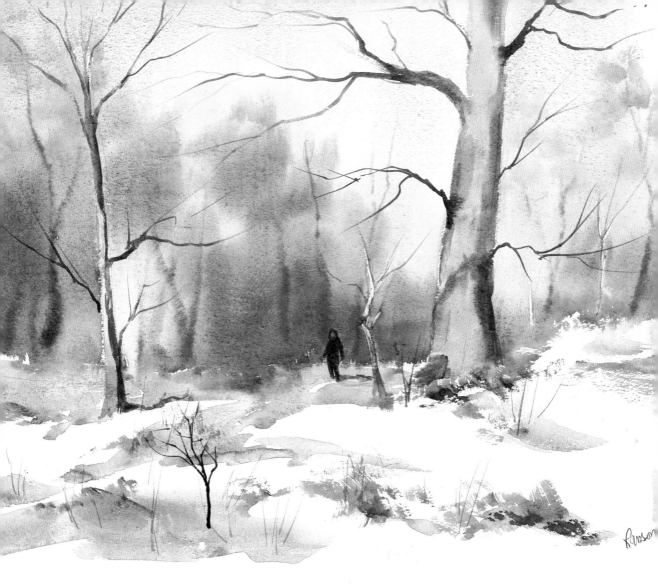

Above: A sunlit snow scene in the woods with an extensive use of the paper surface itself and wet-into-wet distant foliage.

Right: Another winter scene with just the last remnants of snow left.

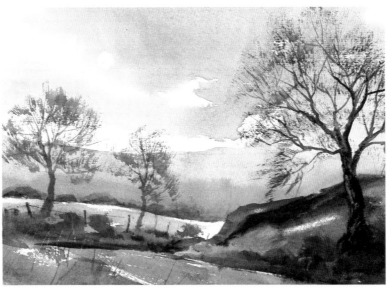

Opposite page: A method of painting foreground trees with a series of side strokes of the hake. The shadow side is indicated with strong paint touched in whilst the first wash is still wet.

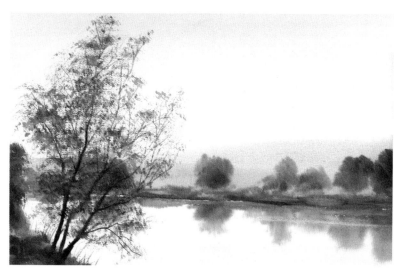

Left: A quiet scene on a French river with distant trees in a wet-into-wet technique, and the foreground tree in dry brush.

Below: My favourite painting (I wish I still had it) – a very quick impression of a wild garden done in a moment of complete abandon!

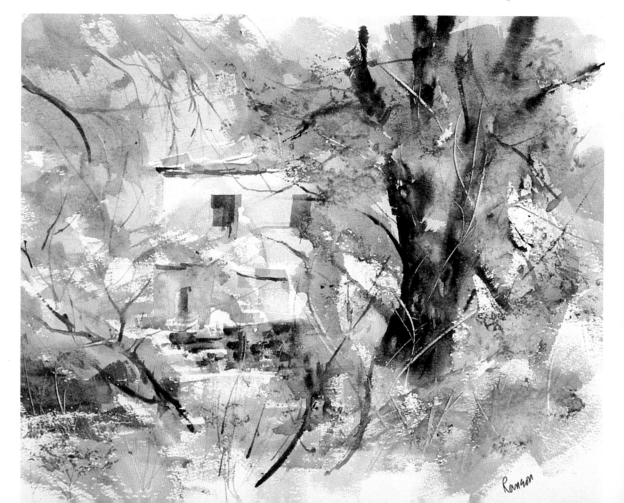

Ranson

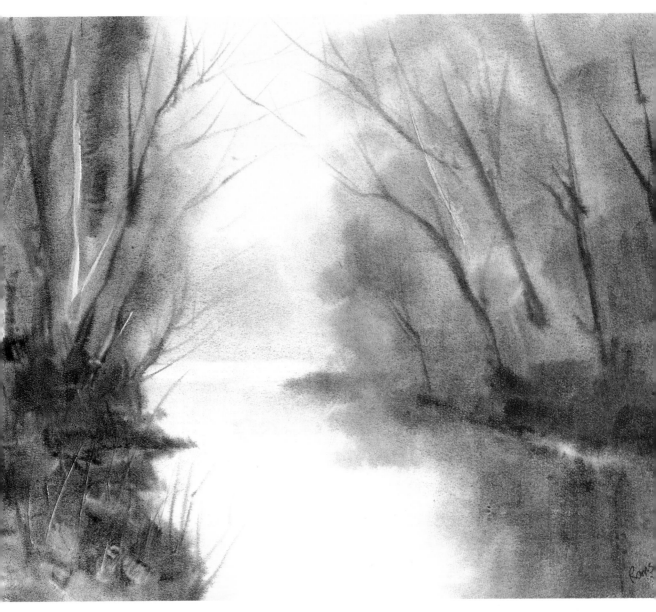

Above: An impression of a misty
river scene painted on damp paper
using raw sienna, Paynes grey and
ultramarine.

Overleaf: A painting of a street scene
in Highgate, London. Notice the
use of flat brushes to indicate
windows and railings, with the
rigger for the overhead branches.

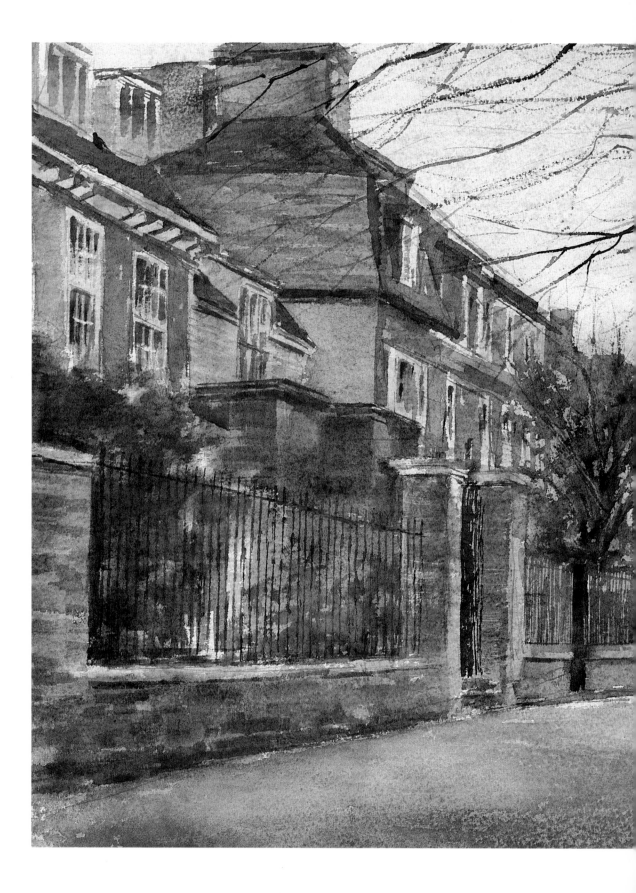

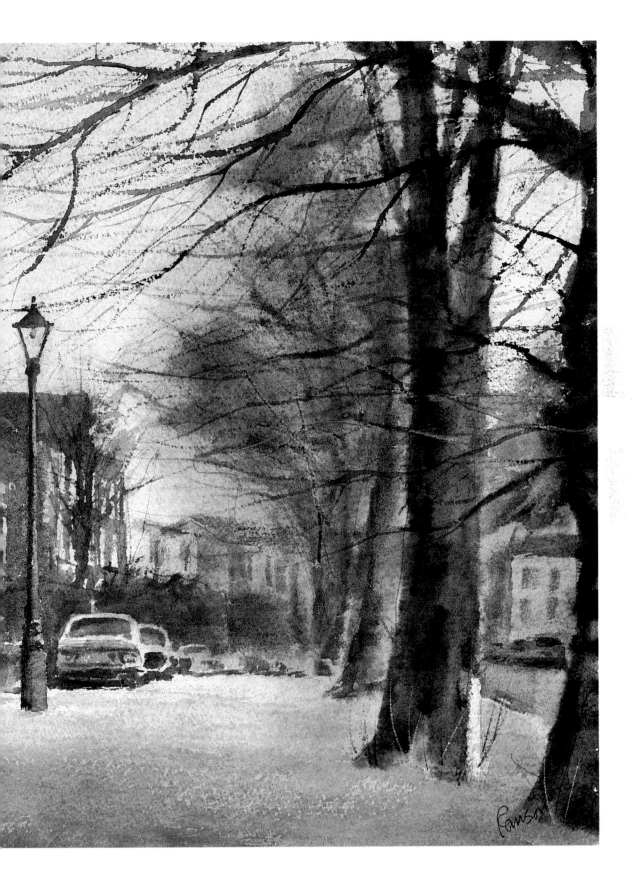

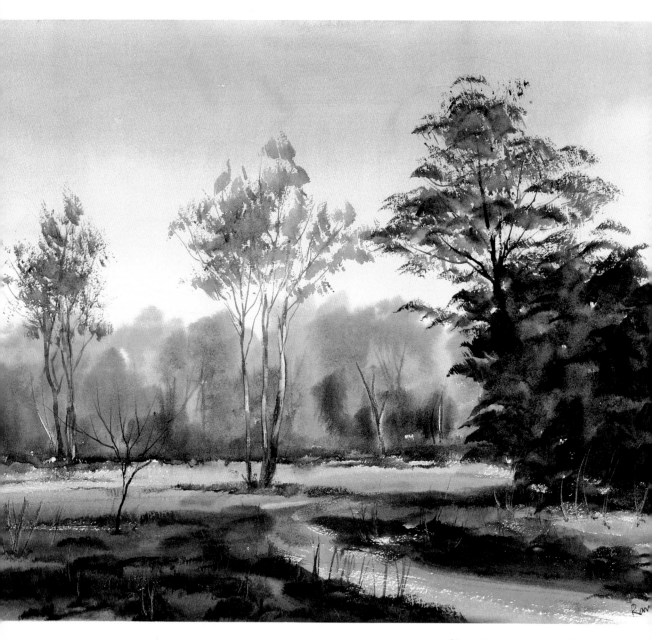

Above: An autumn woodland scene with wet-into-wet distant trees and some dry brush in the foreground. Notice the use of the paint handle in damp paint to indicate the silver birches.

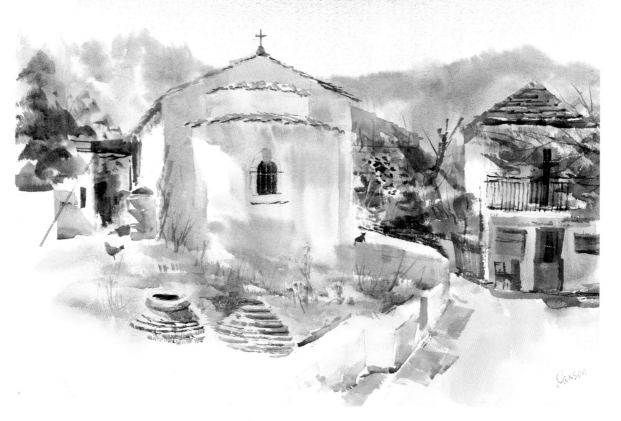

Above: A tiny Greek church painted as a demonstration.

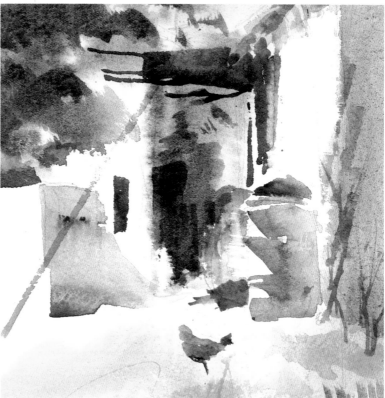

Right: An enlarged section of the painting showing the simplified brush strokes. The object on the right was a petrol drum painted white.

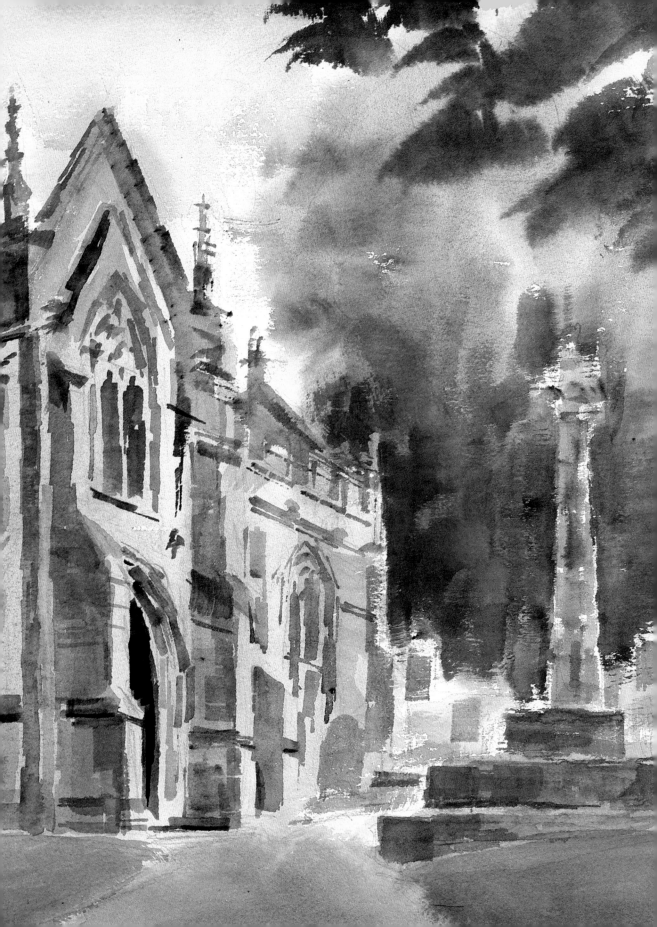

Painting buildings

You cannot avoid buildings for long if you are painting landscapes. You must learn to make them look convincing and be able to portray the texture of their materials—stone walls, thatch, tiles, bricks or clapboards. One of the most common faults with texture is overworking. Students often believe it necessary to indicate every brick in a wall or to show every tile on a roof. They take hours painstakingly, and needlessly, painting row after row of these. It is difficult to convince people that suggestion is the key, that it's only necessary to show details in small portions of the wall or roof, and the viewers will fit in the rest themselves. They accept this principle without thinking when looking at someone else's picture but as soon as they start painting themselves everything has to go in.

But let's start with the basic construction of the building, be it a cottage or a cathedral. You've got to mentally strip it of all its trappings, decoration and detail, and regard it in its simplest form. However complex and daunting a building looks at first sight, once it's broken down into geometric shapes such as cubes and cones with squares, triangles or oblongs attached to them, it's not so daunting. Combine this thinking with the basic rules of perspective covered in a previous section, and you're in business. Once you've got these simple shapes looking right you can start adding the details, like windows and doors. But so many people seem to want to do these first, like a builder trying to paper the walls before he's finished the foundations properly. I know why it is—it's the desire to see how at least one bit of the painting will look when it's finished, but there's nothing more disheartening than spending hours on the details only to find that the basic shape or perspective is wrong and the whole thing is ruined.

Once having got your basic drawing done, the next thing you've got to think about is the light and shade. The usual fault here is that not enough thought is given to the lighting, and the result is that a building looks flat and anaemic. It seems fairly obvious that if you can see two sides of a building one should be darker than the other to give it solidity and depth. This fact often seems to be forgotten once a painting is in progress. Try putting a little pencilled cross on one top corner of your painting to remind you of the direction of the light. It will also help you to get right the angle the shadows are cast.

Opposite page: Section of a painting of a churchyard in the village of Crowcombe. The church details were painted in very rapidly using a 1 in flat brush on dry paper whilst the foliage was painted wet-into-wet.

Painting buildings

Using very dark areas on a building would always make it look dramatic and the use of counterchange, as described previously, is very important. Putting a dark tree behind a light roof to throw it up tonally, or placing the lightest part of the sky behind a dark building, are both effects you should be using in your pictures.

Don't neglect the use of smaller incidental shadows—the shadow under the guttering to show up the edge of the roof, under the window openings to give them depth; a chimney can be made to stand out by emphasising its shadow on the roof. Remember the darker the shadow the brighter the adjacent parts appear. If the light, at the time you are painting a building, is not very bright you can use your imagination a bit and intensify the shadows, as long as their direction is consistent. And that cross I mentioned earlier will make sure you don't slip up.

Among the favourite buildings painted by watercolour artists are windmills and they can look very attractive, but they are often let down by the handling of the sails. Students hardly ever devote enough care and attention to their construction, and they're often stuck on as a badly drawn afterthought, looking crude and spoiling the whole effect.

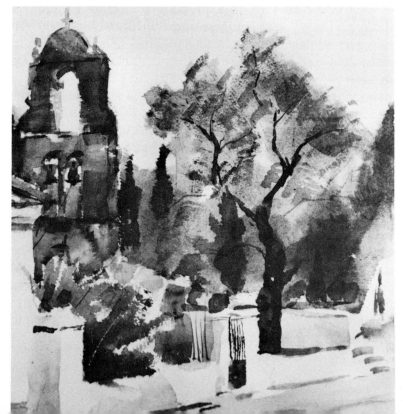

Part of a painting of a little church on the island of Paxos, where the bell tower is separate from the actual building. Notice the way the white wall in the foreground is indicated only by the dark surroundings.

A painting of the Spaniards Inn near Hampstead.

Other popular subjects, of course, are cottages. Apart from the emotional appeal of the subjects themselves they give the watercolour artist the opportunity to use his skill to portray all the various materials involved, such as thatch, tiles, timber and stone against the surrounding textures of trees and shrubs.

Now to consider churches and cathedrals. Obviously, village churches are the easiest to tackle, with their simple construction and pretty settings. But don't be put off from trying a really massive cathedral. It may seem impossibly complex at first glance but, as I said before, resolve it into its basic shapes and add the decoration later. Try to suggest in as few strokes as possible the buttresses, windows and spires, with a 1 in flat brush. You'll be surprised how economical you can be and still portray all their grandeur and magnificence.

I am lucky in so far as I have five castles and an old ruined abbey within a ten mile radius of home so I have a plentiful supply of material of this kind. I find it always pays to look at them in different weather conditions and at different times of the day. Tintern Abbey, my nearest, is wonderful in the evening light when it's lit up against the darker woods behind it; but not so good in the mornings because it blends so much into the hillside. Chepstow castle, though, is definitely at its best very early on a sunny morning. However, mist is my favourite weather condition for buildings as it gives them mystery and dignity without having to put in so many details.

Opposite page: A few thumbnail sketches showing architectural detail painted with the flat brush.

A painting of Wyeholme done for the front cover of our brochure, painted in the late afternoon showing the strong shadows cast by the trees.

Another interesting and potentially lucrative sideline is house portraits in watercolour. I remember a period when I was almost inundated with requests from various country gentlemen to portray their residences, and great fun it was too. It all started when the managing director of the company I was working for at the time asked me to paint his place, a beautiful Georgian house with a grand curved drive sweeping up to the front door. I did a full 'imperial' of it and it came off well. He was pleased with it and decided to put it over the fireplace in his entrance hall and to ask all his friends to a cocktail party to see it. That did it—almost immediately I was invited to country seats and mansions in the surrounding counties and had a brief unaccustomed taste of la dolce vita. Again, I learned a lot from the experience and perhaps I can pass on a few tips.

Painting buildings

The setting and the lighting are very important. Have a good preliminary walk around and find the best, most flattering view of the house. If it's a country house don't come in too close, and show some of the surrounding scenery. Use your imagination—a strong dark sky behind will dramatise a white house by counterchange. House owners, like yacht owners, can be sticklers for detail. Not that they want a tight picture—most of them don't—they just want the roof angles to be right and the proportions correct. Of course, not being artists themselves they don't understand some of the difficulties. I have been faced with drawing a large house from about 20 ft away because it was impossible to get any further back. One interesting commission was to produce an artist's impression of a house before it had actually been built, using the architect's drawings and a lot of imagination!

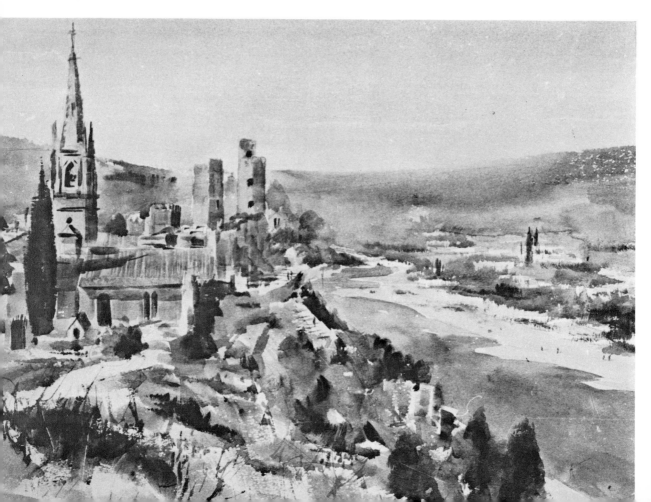

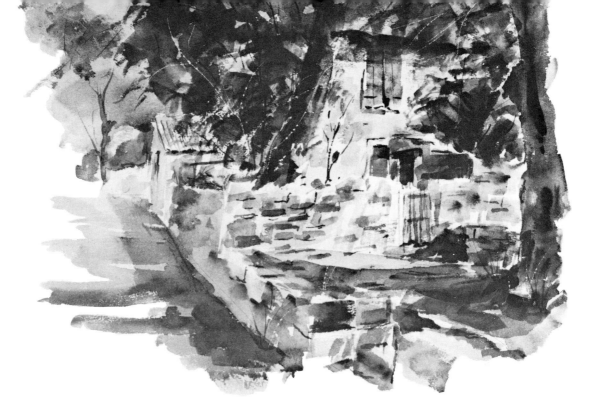

A loose painting of a rather neglected Greek villa.

I'm often asked what colour I use for a Cotswold stone wall by a student seeking a ready-made formula. The answer is that there is no such colour. I know you can get it superficially with a watered down Raw Sienna but as you progress along the wall you should add touches of blue, light red, burnt umber—just tiny amounts but enough to take away the monotony and give it life and warmth. When it's more or less dry you can add the texture of the stones—not all over but in various areas. As soon as the effect becomes apparent—stop!

One common mistake made by students is to try and build a wall stone by stone with flat strokes. Always put the general overall tone in first. The same applies to roofs. Put in the general tone first and then add the minimum of texture. You can get into a lot of trouble trying to paint in every tile or slate.

One thing I urge you to do with textures is to try them out on spare pieces of paper first. This way if you're not sure how to tackle a certain surface, and if you find a potential technique doesn't work you haven't ruined your precious painting. Remember, golfers practise strokes before putting a club to the ball.

One watercolourist I feel was supreme in his treatment of old textured buildings was Sir William Russell Flint, perhaps best known for his nudes on the shore and scantily clad Spanish girls. I've heard some art snobs sneer at his work but like theatre critics they're often, thankfully, ignored by the public. I've yet to see anyone who could portray both exteriors and interiors of buildings with greater authority and skill. You will do well to study the many prints of his work—you'll learn an enormous amount.

Opposite page: A demonstration painting of the River Ardèche in France with the ancient village of Aiquèze in the left foreground.

87

Boats, harbours and beaches

This is not a chapter about surf and waves breaking on rocks. First of all, I haven't painted many seascapes and wouldn't presume to try and tell anyone else how to do them. I think they're very much a specialist subject, better left to people who live by the sea and have time to study wave action day in and day out. I think the sea is more of an oil subject anyway.

However, harbours, boats, beaches and boat yards I find an endless source of material for watercolour. Luckily for me, a lot of the art societies where I demonstrate are on the coast and I always try and arrive a few hours beforehand so that I can explore and sketch.

After thirteen trips running painting holidays on the Greek island of Paxos, I've developed a great love of their fishing boats called *caiques* and the visiting yachts.

One of the things I've discovered is that so many people have a deep fear of drawing boats, their normal intelligence seems to desert them and they produce some awful monstrosities. 'I can't draw boats', and 'I don't know anything about them', is such a common cry from students, especially, I'm afraid to say, from the ladies, who seem to think that, as females, they should be excused.

If you go about it in a logical way, boats are no more difficult to draw than anything else. First, get to understand the basic form of the boat, which is the same whether they're big or small.

A Greek caique or fishing boat, reproduced actual size, painted mainly with a 1 in flat brush.

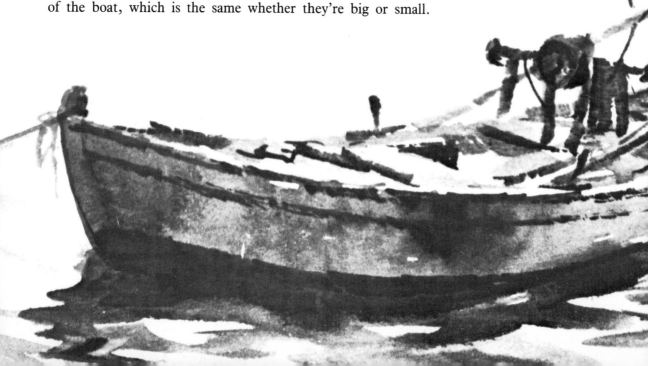

Right: The village of Lakka
painted before breakfast.

Below right: A sketch of the beach
at Shaldon in Devon.

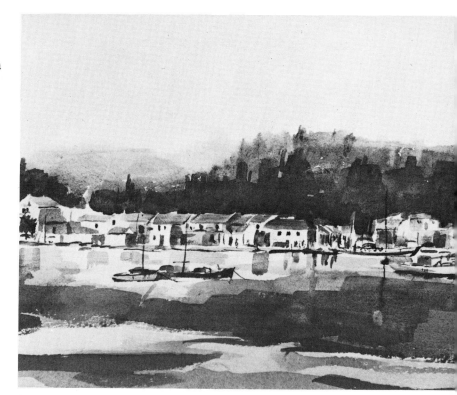

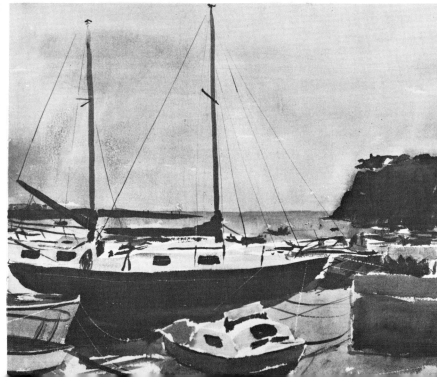

Boats, harbours and beaches

Learn to draw the basic form of the hull and do think of it as a 'shape'. Keep looking at your drawing and back at the boat itself, over and over again. I've often watched students drawing boats, one glance and it's eyes down. They just haven't got this habit of constant critical comparison, which is the only real way to draw accurately. Lightly draw in the centre of the boat from bow to stern. This will stop you drawing bits of the boat, such as the mast, off balance. If it helps, draw a box as shown and put the boat within it, it will certainly help to get your perspective right, especially such things as seats or thwarts in a dinghy.

Opposite page: Low tide at a mooring in Cornwall.

The method of drawing a boat within a box framework.

90

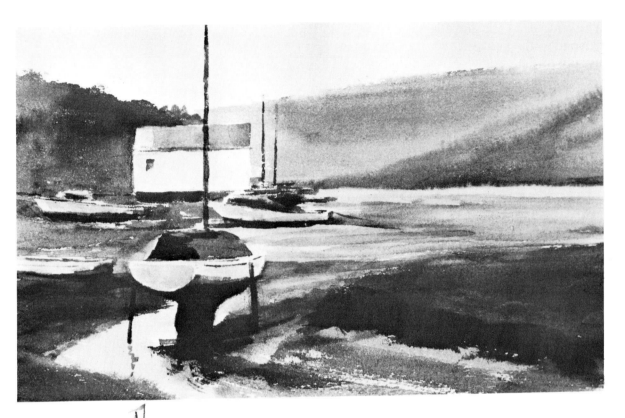

On my Greek island I used to play at being Gauguin and keep myself in food and wine entirely from selling boat portraits to visiting yachtsmen. It taught me to be very observant though, there's no one more critical of the exact angle of a bow, the shape of a stern or the exact curve of a deck than the proud owner of the boat himself.

As usual, don't worry yourself with small details, concentrate on the proportions. How far is the mast from the bow? How long is the cabin roof compared with the length of the boat? Just use your observation and commonsense and don't think of them as difficult.

Try to draw the main essential curves of the boat, using your whole arm rather than little jerky lines with a tightly held pencil, it gives more of a flow and rhythm.

There are two natural hazards in painting boats. Moored dinghies swing about a lot so that they seem to be constantly changing their shape, but you've got to be patient, the one you are painting will soon come back again to the angle you want.

91

Boats, harbours and beaches

The other hazard is that boat owners are sometimes very inconsiderate to the needs of the artist and want to sail off in them, usually in the middle of a painting. When painting waterfront scenes with a row of yachts, one learns to keep half an eye open for signs of preparation for off and quickly paint the potential absentee in first before returning to the rest of the picture.

In and around the harbours you'll find boats of all shapes and sizes divided roughly into two classes, working boats and pleasure craft. I love the old fishing boats, which have character and dignity, and the yachts with their graceful curves. I avoid the plastic dinghies and the big cabin cruisers, uncharitably known as floating gin palaces.

If you're painting more than one boat, make sure that they're not all the same size. Nothing looks worse, compositionally, then two boats of the same importance both vying for your attention at opposite sides of a painting—make one more dominant than the other.

There's always something going on in harbours, figures doing all sorts of interesting things like painting boats, lowering buckets, carrying oars, climbing ladders or just standing around in groups gossiping. You must learn to put them in simply and directly without any detail. Get the essential movement or silhouette of an action.

Maintenance seems to play a disproportionate part in the life of a boat owner. I'm sure I spent a lot more time with a paint brush in my hand than I ever did with a tiller when I was sailing. However, it makes a very good subject for painting when the boat is pulled up on the hard, you can see the whole boat not just the part that is above the waterline. The keel of a yacht, for example, is given an entirely different and more dramatic appearance out of water and in the yards there is so much fascinating junk to paint, rusty oildrums, piles of rope, old propellers.

Little harbours are always much more interesting and paintable when the tide's out. The boats are tilted on their sides and the harbour bottom exposed, with its fascinating texture of sand, rock and seaweed puddles of water making good opportunities for reflections, and there is an assortment of anchor ropes and coloured floats.

When you're painting the harbour wall itself, don't try to build it up by painting individual stones but indicate it as a solid mass in good rich colour and then just suggest the texture of the

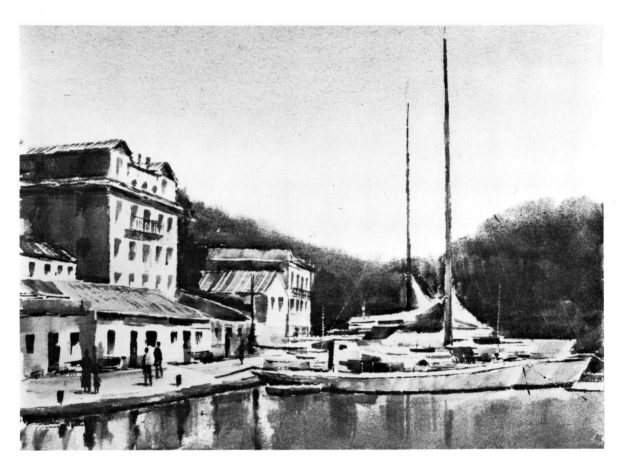

The waterfront at Gaios on the
Island of Paxos.

stones here and there—the viewer's imagination will do the rest.

Unless you really know how to draw them don't ever try to put in a boat quickly from memory in an otherwise empty lake or seashore—I've seen so many otherwise well painted scenes ruined by badly drawn boats, obviously done without knowledge or reference material. The problem is made worse because it usually becomes the object of interest, that's why you put it in. Work from a good sketch or photograph and then draw it in with care. The most common and glaring mistake is to draw a yacht sideways with its mast in the dead centre. It should always be well forward towards the bow otherwise it looks as if a child of five has drawn it.

Don't forget the seagulls. An hour or two of sketching them in pencil, as they pose on masts and harbour walls and in flight too, will give you a lot of material to call on for years of painting.

Boats, harbours and beaches

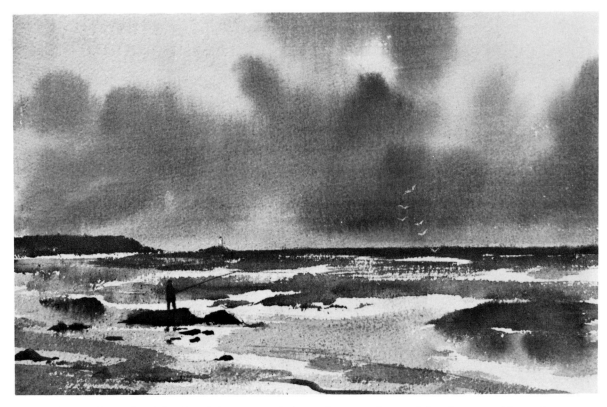

A beach scene with wet-into-wet and dry brush in the foreground.

Don't forget that when they're flying around they often overlap each other in a group so don't always do them as separate birds.

When you're painting beach scenes the main thing to avoid is being boring. Most student paintings fail because of poor composition and we're back to the picture of two equal rocks or sand dunes one on each side of the paper, and the panoramic view of miles of beach which might look breathtaking when you're actually there but deadly dull as a painting. Try and compose your scenes with a simple foreground which makes it easy for the viewer to enter your picture and be led to the centre of interest.

Don't clutter your beaches with too much fiddly detail. Clean up the beaches and put in the changes of tone with wide swinging sweeps of paint using your whole arm; put on the paint with authority and leave it fresh and transparent. As for pebbly beaches, for goodness sake don't try to paint the individual stones, it's impossible. Suggest them with a little touch of dry brush or spatter but the important word is 'suggest'.

Boats, harbours and beaches

A few simple figures on a beach give life and scale, but be careful where you place them and keep your strokes to a minimum with no detail.

Don't make the sand too yellow on the beach and sand dunes are really a mixture of warm and cool greys.

A word about rigging on boats. To most of us this is just a confusion of ropes, especially if you don't know their functions. It's much better to leave most of it out of your painting rather than clutter the whole thing up. Put in the main lines of the rigging very lightly, the usual fault is to put in the ropes too thickly because of lack of brush control. With boats at a good distance away, forget about rigging lines altogether rather than ruin your painting.

I've been asked so many times, 'How do you paint rocks?' The first thing to remember is that rocks are solid, they have bulk and weight. The top of the rock faces the sky and gets the most light, the sides are darker and the part of the rock that faces away from the light source is darker still.

There are all sorts of tricks you can use to texture the rocks, like dragging a flat razor blade or the edge of a flat card over the damp wash but beware of overdoing these. None of these things will help you unless you understand the basic tonal values which give a rock bulk.

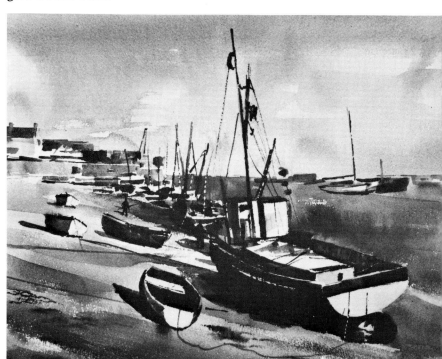

Fishing boats at low tide on an east coast beach.

Shadows and reflected light

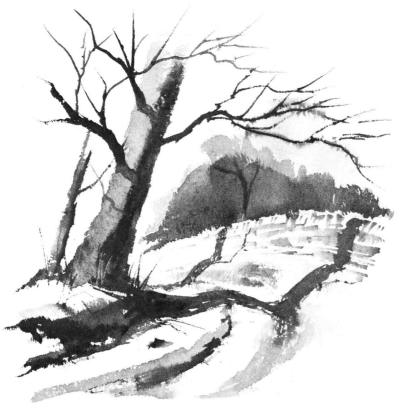

Left: The way that shadows can be used to indicate the profile of the ground. Notice the way the shadow of the trunk moves over the path, up the bank and wall.

Below: This shows how a shadow from a possibly hidden tree can be used to dramatise the picture.

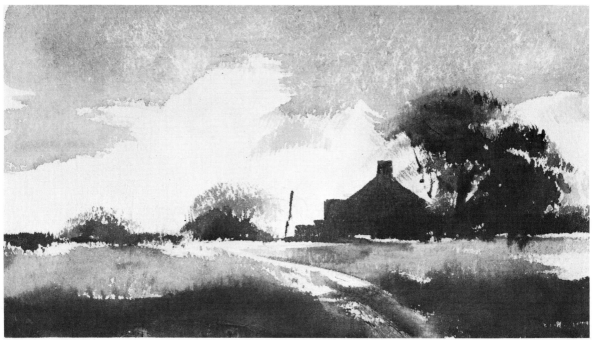

Shadows are so often regarded as a necessary evil to be stuck on at the end of a picture, without very much thought and with even less observation. In a sunny landscape they are a very important part of the picture. That feeling of strong light you're trying to portray is impossible without strong contrasting shadows.

They are also very useful in indicating the form and texture of surfaces. Imagine the shadow of a tree falling across a smooth road, it might show a curve to indicate the contour of the road but if it's cast over a rough cart track with a hedge at the side, the shadow would go up and down each rut of the track, change direction completely as it hit the hedge and would then show the shape of the hedge at a glance by the way it fell.

Finally, shadows can be used to help build up or strengthen a composition. You can, for example, put one completely across the base of a painting to frame and contrast with a well lit centre of interest.

Of course, because they're dark, shadows are prone to get muddy. Then it's the usual tale of two or three coats of paint to try and get the right strength of tone. This is caused by timidity and indecision.

The best way to put in a shadow is to first observe very carefully where the shadow comes from and how it changes direction as it goes over various contours it covers, so that your plan of attack is rehearsed before you take up your brush. This is something no more than about one in ten students seem to do properly.

The next stage is to mix up a good shadow colour, be it warm or cool. My own favourite mixtures are Paynes Grey and Alizarin Crimson, or Ultramarine and Light Red. It's very important that you mix up enough paint before you start, it's hopeless if you run out of colour half way through a shadow. Try it out for strength first on a piece of scrap paper, take a deep breath and work quickly and decisively. Then for heaven's sake leave it alone— don't start poking it about and touching it up. Nothing looks worse than an opaque or over-worked shadow. If it's been left transparent, it will then show the other various colours through it as it crosses say a cream path or a green lawn.

You may think it goes without saying that you should first establish your source of light and stick to it, making sure that all the shadows lie in the same direction, but I've seen very confused paintings where the student has forgotten this half way through.

Shadows and reflected light

Reflected light is something which is associated with shadows but is so often ignored or unnoticed when painting a hot, sunny scene. Once the principle is understood and you know what to look for your paintings will improve considerably. Basically, all sunny areas surrounding shadows bounce light back on the objects casting the shadows. You can see this particularly on the shady side of a boat where the colour of the water is reflected into it. Another thing you'll notice if you really study a sunlit tree trunk is that the darkest area of shade is not at the back edge, where you would logically expect it, but about two thirds of the way towards the back. At the back edge in shade can be seen a lighter area with some of the light and colour reflected from the ground surrounding the tree.

Again, on a wall in shadow there is a lighter area at the base where the light from the surrounding ground has bounced up into it. This happens on the underside of rocks too and under the eaves of houses. Notice the actual colours of the shadows. A green tinge in a shaded wall would probably be caused by colour bouncing off the tree nearby; glass windows reflect light and colour from objects opposite them so don't always portray them as dark holes or they'll look very dead indeed. In a sunny street scene, particularly, you get a ricocheting of light and colour. Shadows on the street itself will have some of the blue of the sky reflected in them. A shadow cast on a white house on one side of the street will be warmed by the colour of the pink house opposite.

Of course, it becomes even more pronounced in sunlit snow scenes where the sun's light makes the snow appear a creamy colour and the shadows are really quite a distinct blue, again reflecting the sky above.

Train your eye to search out these things—the more you practise the more exciting subtleties you'll discover. Get out of the habit of thinking of your shadows as just grey things to be put on at the end of a picture. I hope this chapter has made you realise how subtle and important they can be.

Light bounces off the water
surface and illuminates the
shadow side of the boat.

Notice how the light bounces up
under the eaves and off the
ground onto the shaded wall.

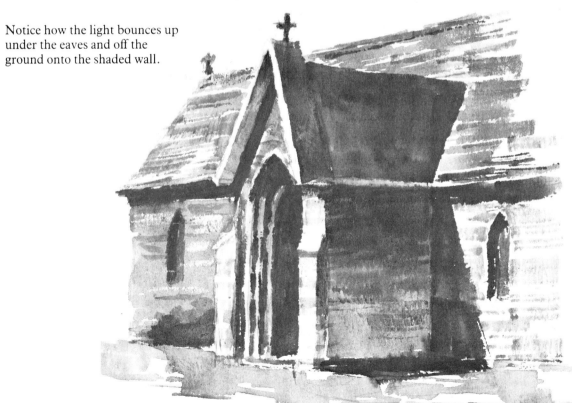

Mist

There can be few atmospheric effects more fascinating and mysterious. Mist lends itself ideally for portrayal in watercolour. It is composed of fine particles of water suspended in the atmosphere, virtually a cloud on the ground. These particles are like a series of veils between you and what you are looking at. The greater the distance away the more veils and the less you see. Don't make the mistake of painting everything woolly and soft. Use a strong interest in the foreground and always paint it strongly and richly so that your picture will have a firm anchor to it.

Start your picture from the furthest point you can see. There's probably no horizon visible and the sky will be brighter and lighter at the top than at the bottom; this is the opposite to a normal sky. Paint from light to dark.

Moorland mist.

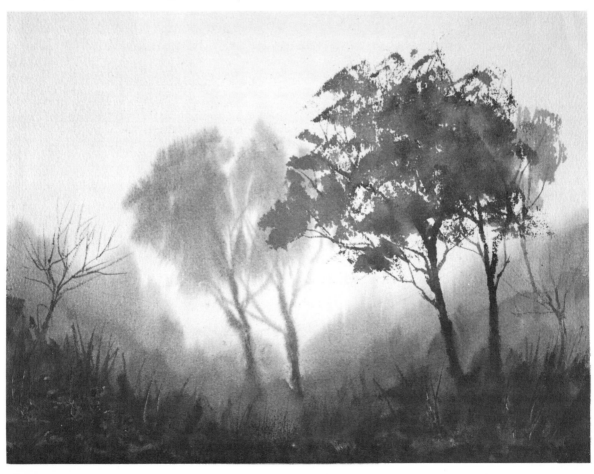

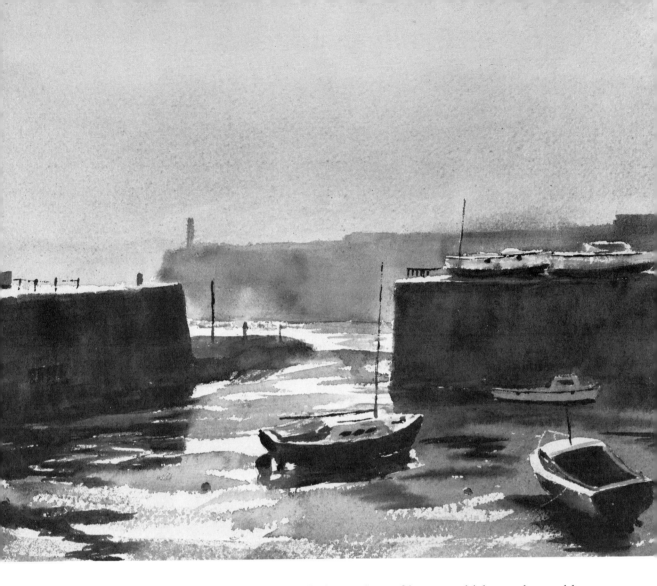

A misty morning in Porthcawl Harbour South Wales.

Mist has a distinct colour of its own which may be a cold grey or even have a yellow tint. The local colours of individual objects will take on some of this mist colour. For example, when the sun is struggling to break through a morning mist everything in the picture is in various tones of this golden colour. Nearly all modelling is eliminated in mist and you will mostly be painting silhouettes, so the objects in your pictures should have interesting contours retaining their crisp, sharply defined outlines.

Remember to make the near objects warmer in tone than the distant ones which will then increase the effect of contrast.

I've often painted outside on the river bank in early morning mists and, believe me, I've needed plenty of patience. With all that moisture in the air the washes seem to take an eternity to dry. You may find this a good time to try out a smoother paper.

The fact that you're forced to simplify your tones and details in misty scenes may suggest to you that you could well use some of these properties in your normal paintings. Think about it.

Figures and animals in landscape

Why does everyone always draw the heads too big? All right, I'm exaggerating, but I've seen so many otherwise satisfactory landscapes ruined by what looked like little gnomes wandering about them. It is by far the most common fault when putting figures into landscapes.

Figures can make or mar a landscape. So many people know this and are afraid to take the risk—far better to assume that the street scene is painted at five o'clock in the morning before anyone is up.

We've all looked at pictures where the painting of the landscape is fresh and direct but the figures are stiff, awkward and tight. They might even have been done by another person.

It's always a big decision as to whether to put figures in a landscape or not. That great watercolourist Turner nearly always used them. If you go through a collection of his prints and cover up the figures you'll see how much his landscapes depended on them.

Be sure that whatever figure you do put in is an integral part of the picture and not just a small afterthought. They can be used in different ways to give life, movement and scale to a scene.

Below and opposite page: A few examples of simplified figures, drawn mainly with the rigger.

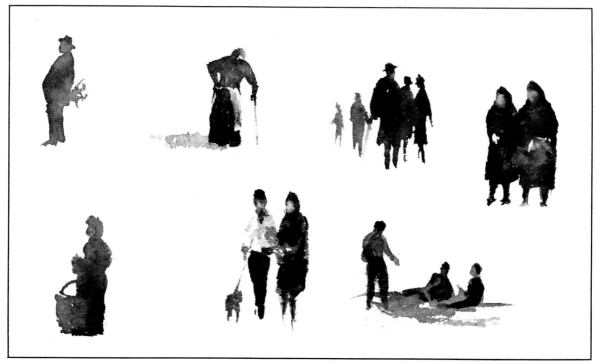

Opposite page: A few examples of animals and birds for judicious use in landscapes. The figure with the donkey, for instance, might be useful in a Greek scene.

Nothing can quite indicate the vastness of a cathedral or open country quite so convincingly as a tiny figure dropped in the right place.

But how can we be sure it is going in the right place or even if it improves the painting or not. I always draw a figure first on a piece of tracing paper and then push it around on my landscape until it looks completely in scale with its surroundings. Then I trace one or two location points on the tracing paper, and turning it over scribble some soft pencil behind the figure. Replacing it on the landscape it is just a matter of going over the figure again with a ball point pen which transfers it ready for painting.

Remember the business of counterchange. If you want them to show up properly, put a dark figure in front of a light background and a light figure against a dark patch. The first is no problem but the latter can be achieved by cutting out a little stencil of the figure from the tracing paper, placing it in the correct position and by quickly using a damp sponge leaving a light silhouette in the landscape, to be completed when dry.

How can you get your figures to match your landscapes in freshness and liveliness. I'm afraid there's only one way — practice. A sketchbook in your pocket and a soft pencil, say a 2B, is the answer. Take it around with you in your pocket and make rapid sketches of people in parks, cafes, trains, bus stops. Keep them small and simple, the most important thing is the action and the gesture. Don't bother about putting in any details like fingers, features or feet. You don't need to know anything about anatomy just that the parts should relate together correctly and are in the right proportion — keep those heads small. Your figures will soon start to have life of their own and will be useful for years afterwards as a source of reference.

Of course, when I talk of sketching figures I should mention animals like chickens, sheep, cows and horses. Again, avoid detail but try to get the silhouette right. The pose of a hen as it stops to peck up food, the shape of a sheep, head on, sideways and three quarter view.

Finally, when you put figures into your picture be sure they're in the correct scale to each other and to the buildings near them. For example, make sure that the figure next to the door can get through it without going down on its knees, also that the style of execution is similar in style to that of the rest of the painting. Don't suddenly tighten up.

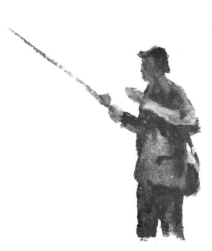

Portraying water

I must admit I'm a complete addict when it comes to painting water. If when I'm out driving I pass a river, a stream or even a pond I have this irresistable urge to stop and set up my easel, rather like my dog Simon who can never pass a lamp post without having an investigation, but there the similarity ends!

Pictures of water sell very well too and titles like 'Mist on the Wye' or 'The Lake at Dawn' have bought me many a good dinner.

So what are the main faults that crop up? There's no doubt at all about what is the most common fault, it's over-elaboration, trying to put in every ripple and patch of light that momentarily catches your eye, most of which move around with the breeze anyway. It's even worse with flowing water. It's easy for me to say 'simplify' but much more difficult to know where to begin.

A typical river picture, reproduced actual size. It was painted very quickly on a damp surface, simplifying the scene as much as possible. Note the harder reflections of the hut and tree on the right.

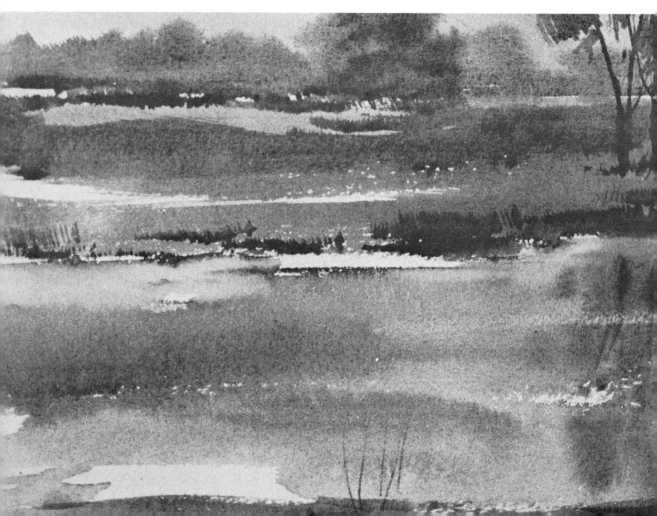

Let's start with the river. Imagine you're standing with me on the banks of my beloved Wye. It's a fairly smooth river and the main reflections are broken completely by those moving patches of light which confuse things badly. Don't be led astray by these but try to build in your own filter system, rather like those clever things in hi-fi that filter out all the crackle and hiss and allow you to hear pure music. Always try to imagine the river as a soft mirror, reflecting everything above it.

Apart from when it is muddy and in flood a river firstly reflects the colour of the sky, be it blue or stormy grey. But many's the time I've seen even that fact ignored and a conventional blue river has been depicted, bearing no relation to the colour of the sky above it. Secondly, it reflects the things that surround it, trees, earth and bridges, all of course upside down.

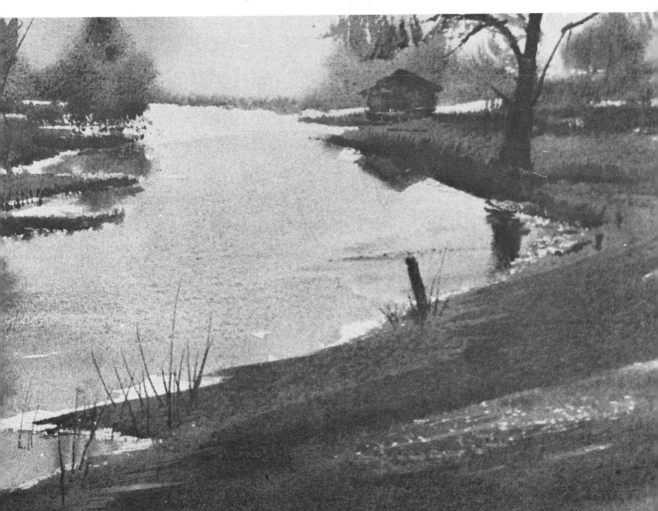

Portraying water

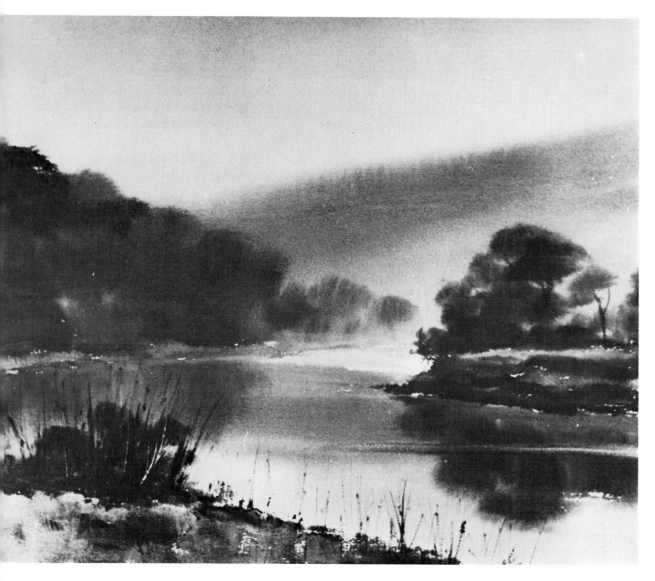

One thing that has dawned on me over the years is just how little you need to do when you are painting a river to make it look authentic—whole areas can be just left as a flat wash. The student distrusts this though—it seems too easy—there must be something more to it. Perhaps they should add a few ripples for luck or odd streaks here and there but all the time, however, the work is getting more and more bitty and amateurish. As for ripples, I always think they're sudden death to a watercolour.

A simple river technique with a light patch 'round the bend'.

Below left: The wrong way to paint a river bend.

Below right: A more satisfactory result with less of the distant water in view.

There are a couple of tricks which I always find most effective when I'm depicting rivers. One is that where the river goes round the bend I leave a little patch of light which seems to give a little air of mystery. You will find this on some of my paintings in the colour plates. Another process which is quite good for putting depth into an otherwise fairly flat river is to turn the picture upside down, wet the whole river area with clean water and immediately put a strong dark across what is now the top, graduating it down to nothing as it comes to the end of the river. When it is dry, turn the picture upright and you get quite an exciting illusion of depth.

While we are talking about faults in painting rivers, I've found a very high proportion of my students seem to make the river flow up hill. They know they've done it wrong once they see the finished picture but they have little idea of how to correct it.

As the river gets to the bend it seems to bank over rather like the old Brooklands race track used to. The trouble here of course is the lack of observation, they don't draw what they see but what they think they ought to see. I've shown in the illustration the right and wrong way of putting in a river bend.

Reflections in general obey certain laws. It is much easier to understand them if you try this simple experiment. As I've said before, smooth water acts like a mirror, so put a mirror on the table and put a box of matches upright at the furthest point of the mirror at right angles to your vision. Now, look at its reflection. See how the reflected edges of the box are in a straight line with the edge of the box itself and if you stand up and move your head above the box, the reflection shortens. If you replace the matchbox with a pencil held upright, then lean the pencil at various angles to the mirror, you will see that the angle of the reflection of the pencil is always the same as the angle made by the surface and the mirror.

Portraying water

If you imagine the box to be a house and the pencil a pole in the water you will get a much better idea of how they reflect in the water. It will also help you to understand how reflections of things that are leaning towards you extend outwards and become longer than the objects themselves appear in their foreshortened position. Conversely, where the pole slopes away from you the reflections are shorter than the objects themselves seem.

On large stretches of water the surface is made very light where it's farther away and dark in the foreground. This is because the horizon reflects the low, lighter part of the sky, but close to the shore the water picks up the darker colour from the sky above. Also, because we're looking down at it, the foreground water transmits some of the colour of the bottom. With a

Above left: Reflection of a post in completely still water and in disturbed water. *Above*: A post sloping away will produce a shortened reflection, while one sloping forward will produce an elongated one.

Opposite page, top: A typical boat reflection. The dark reflections should be done as quickly and decisively as possible.

Left: Rapid water simplified.

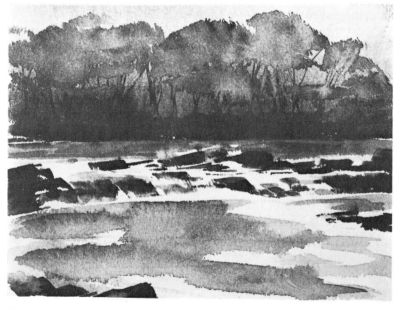

Opposite page, right: A misty river scene.

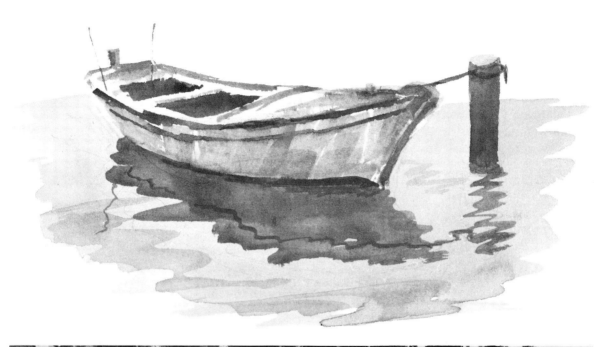

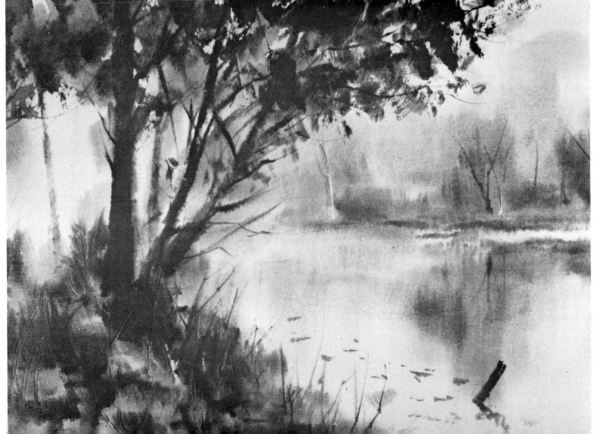

Portraying water

large body of water some parts of the surface are smooth while others are ruffled by wind. Smooth water reflects the sky like a mirror but rough water picks up and relays the light from many directions, either darker or lighter than the sky depending on the prevailing conditions.

Water in a stream tumbles in some parts and flows in others. Watch its movements very carefully for quite a long time and then try and paint a generalisation of this movement. Brush strokes should follow the action of the water. Don't put down every ripple because rushing water looks much better when it's understated, and the absence of detail gives an impression of rapid movement.

The Wye at Wyndcliff.

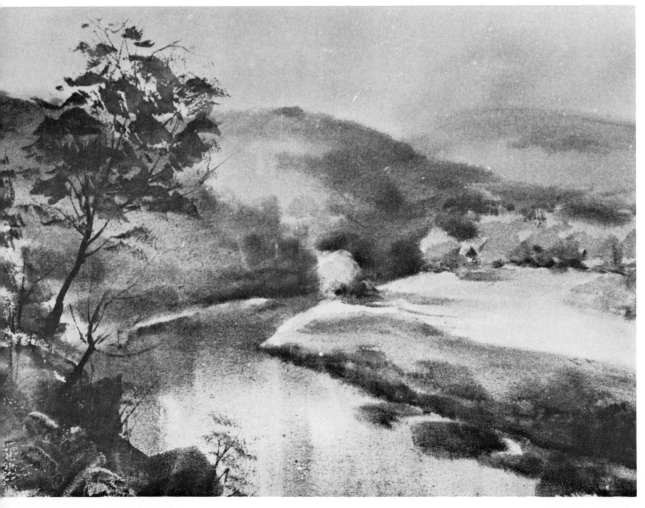

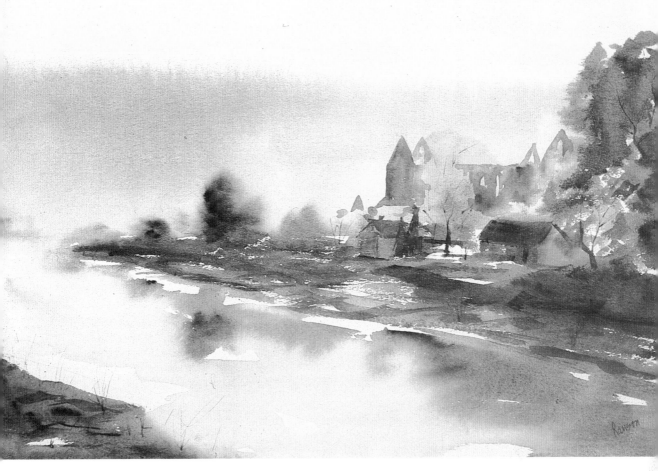

Above: A mainly wet-into-wet painting of Tintern Abbey on the Wye. Notice how the crisp lines of the abbey are contrasted with the general softness.

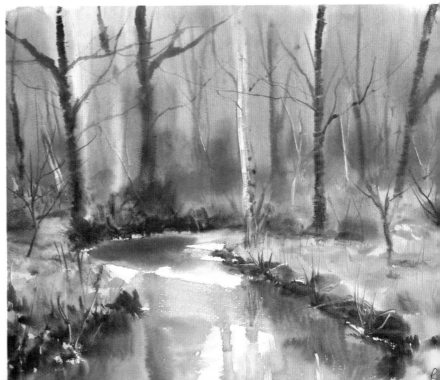

A woodland stream in Cornwall. The background is wet-into-wet with the brush handle pushed into the still damp paper for its light tree. The water is part wet-into-wet, part dry brush, with white paper left for the lights.

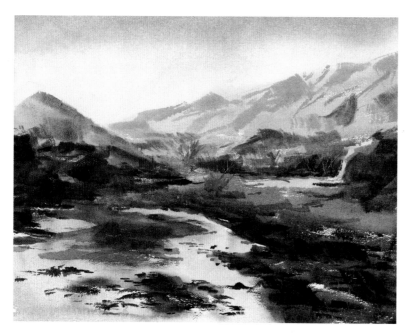

Left: A scene in the mountains of Oman.

Below: A bend on the River Windrush in the Cotswolds. The nimbus clouds were painted in with a mixture of Paynes grey and alizarin crimson.

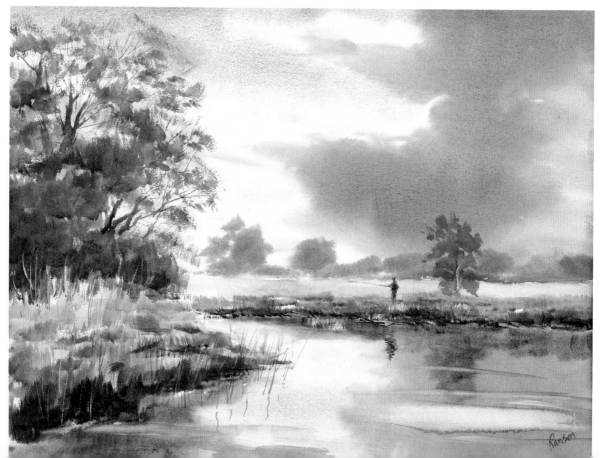

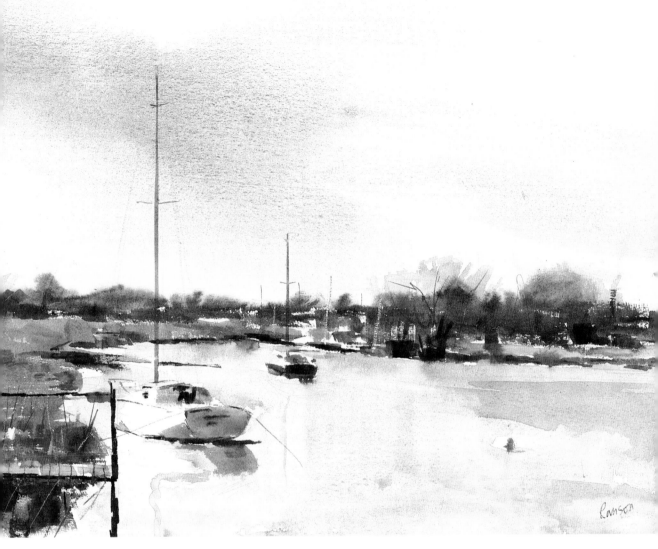

Above: A painting of yachts on the
river at Wareham in Dorset.

Right: Detail of the painting
showing the use of the paper itself to
portray the white yacht.

Overleaf: A view of the Wye in
winter with wet-into-wet hills and
trees in the background, contrasting
with the fine rigger treatment of the
foreground trees.

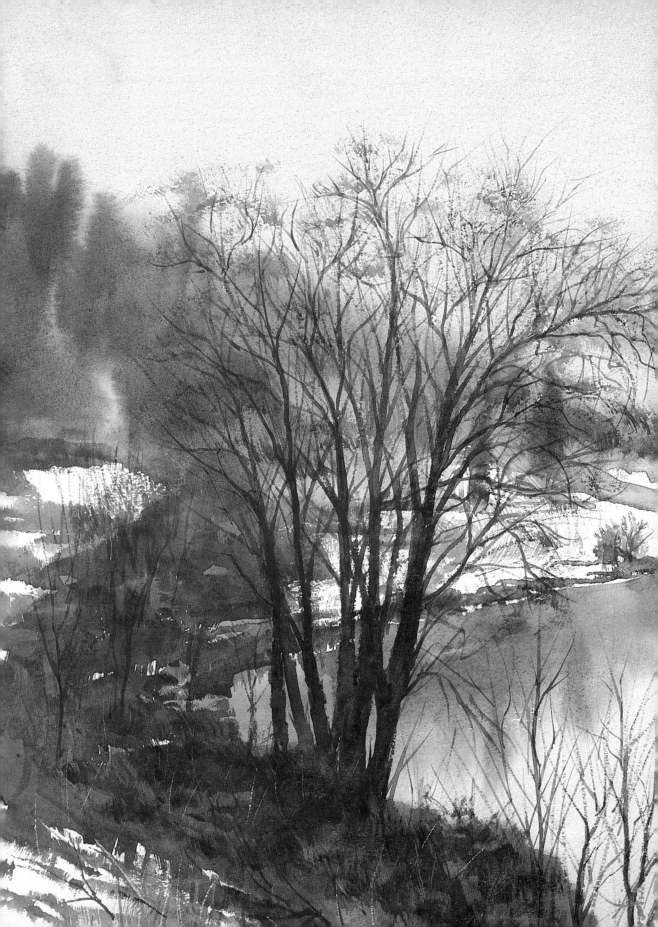

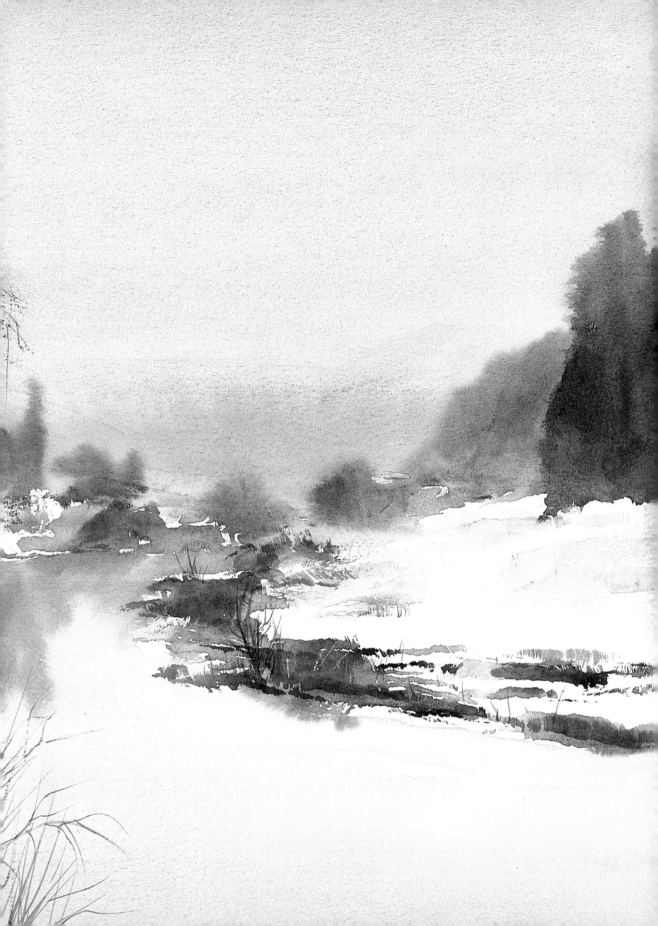

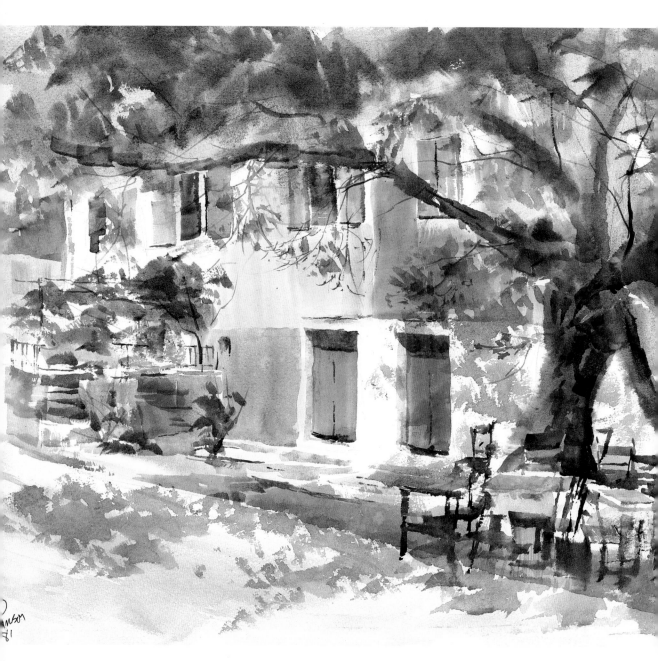

Above: A painting of a Greek
taverna done as a demonstration.

Right: Detail showing the foliage contrasting with the sharp shutters.

Below: Detail showing the loose impressionistic way of indicating tables and chairs.

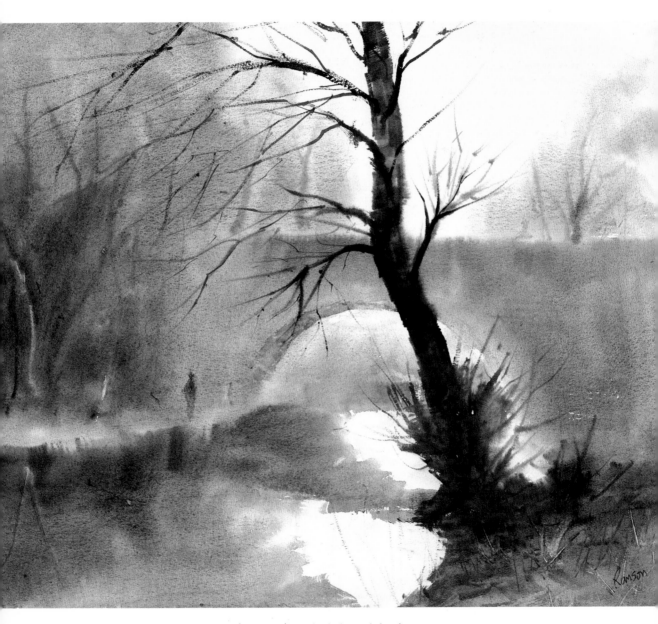

This misty river scene was done with two brushes, the hake and the rigger,
and three colours, raw sienna, ultramarine and Paynes grey. I put a weak
raw sienna over the whole paper. While the paper was really wet I started by
dropping in the distant trees on the right, then with thicker mixture I
painted the trees on the left, using the rigger for the branches. By this time
the paper was faintly damp – just about right for the bridge. Then finally I
put in the foreground with really 'gutsy' paint. The main tree was put in last.

A simple river picture with wet-into-wet background and foreground applied with the rigger.

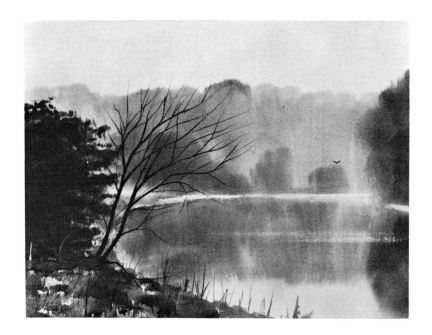

A winter scene near my own village of St Briavels.

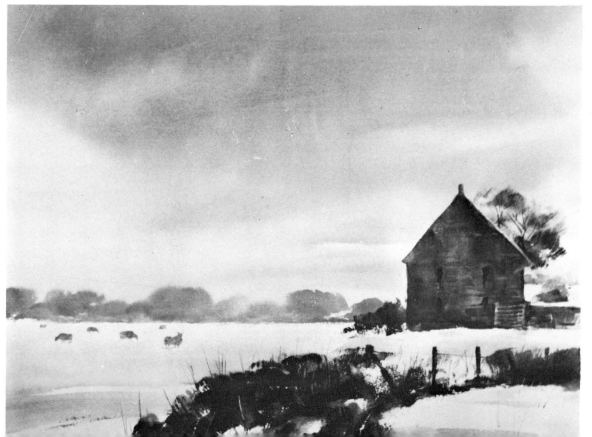

Winter landscapes

I think that winter is when the medium of watercolour really comes into its own. It's the season of warm and cool greys and subtle browns. I must say I enjoy painting winter scenes more than any other, as one of my students said, 'It's nice to get away from those wretched greens.' I use an even more restricted palette for winter work: Raw Sienna, Paynes Grey, Ultramarine, Burnt Umber and Light Red. Most of the greys are made with Ultramarine or Paynes Grey mixed with various proportions of Burnt Umber.

In winter, too, you can really see the anatomy of the trees and they make beautiful subjects to draw. You can learn how the parts progress from the trunk right up to the twigs. Go out with your pencil and paper and do some tree portraits—pages of them. You'll never regret it and when the summer comes you will paint them with that much more authority. As in figure drawing, the work is much more convincing when the artist understands the bone structure beneath the flesh. I find the rigger is even more important in winter and is used to portray the subtle tracery.

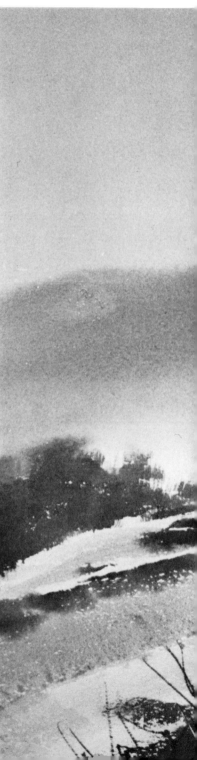

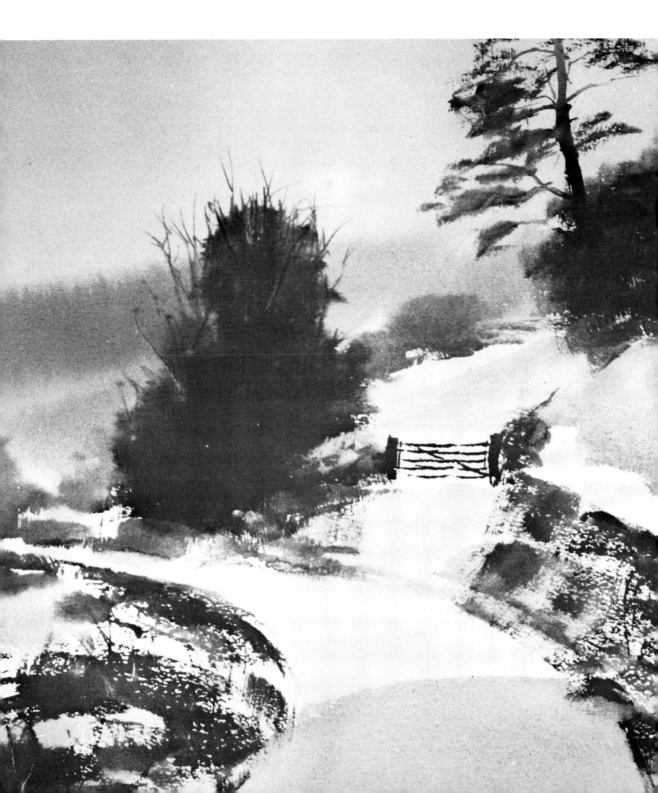

Winter landscapes

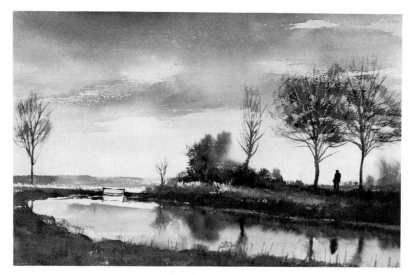

Previous page: A typical snow scene in the Wye Valley.

Left: A river scene painted in January.

Below: An ivy-covered winter tree in the foreground contrasting with the wet-into-wet distant trees.

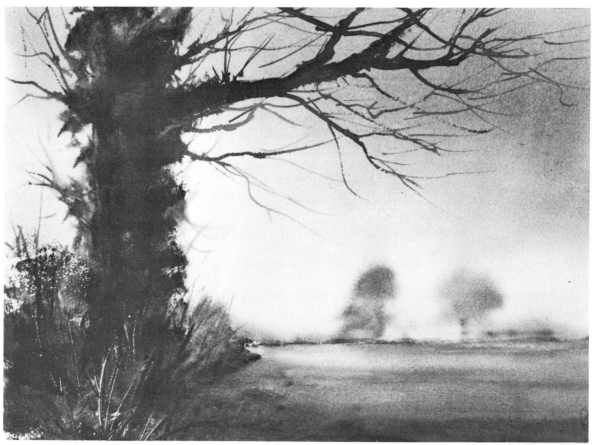

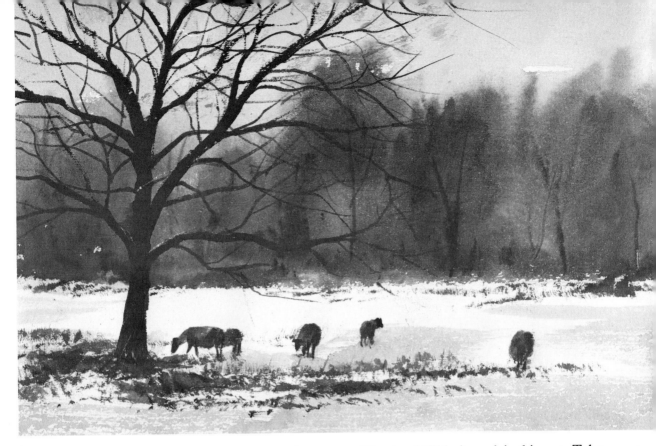

Above: Snow in the Forest of Dean.

Below: Sketch of a farm in February.

Have a look at some of Rowland Hilder's work in this area. Take the fine branches as far as you can, then finally finish off the lacy mass of fine twigs, which form the profile of the tree, with very light dry brush strokes of the hake, having a definite direction.

Now to snowscapes. These can be a thing of beauty or they can be nothing more than a Christmas card picture where all you need is a robin (not that I've got anything against robins). It all depends on the composition and the balance. Compose your picture in terms of light and dark pattern and take advantage of the whiteness of the paper. Don't let the dark and the light be equally important—let one or the other dominate. The whiteness of the snow, however, is reflected light from the sun in various weather conditions; a warm glow of sunlight might give a tinge of yellow or gold at sunrise and even pink at sunset. The shadows catch the blueness of the sky, and a contrast of warmth and coolness seems to intensify both of them. Don't always paint sunshine on snow. Do try it on a cloudy day; I find a really threatening sky in a snow scene is very effective. Of course, this too modifies the colour of the snow beneath it.

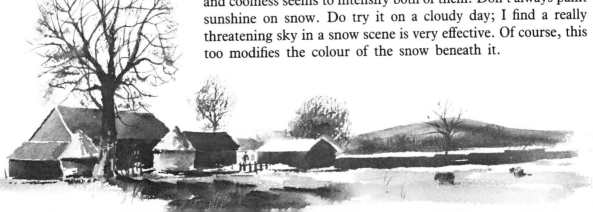

Winter landscapes

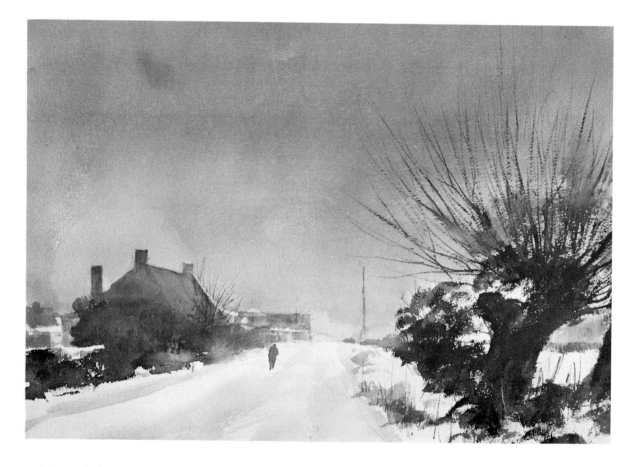

Most of the snow surfaces are, of course, smooth but often broken up when grass and stony earth shows through them. Shadows are very important in snow scenes as they describe clearly the contours of the surface they fall on. The white of the paper will be very important in your pictures, many times you can leave it absolutely untouched and other times you'll have to add a slight tinge of blue or warm yellow to suit the weather conditions.

Dry brush strokes are very useful for portraying the way the snow clings to the limbs and trunks of the trees.

To sum up then, remember that the grey days of winter are studies of edges, masses and values. If you've gone wrong it will be because you haven't handled these three elements properly. Remember, if you want a peaceful mood, keep your masses large and simple and don't break them up too much.

A rather bleak painting of the road between our house and the village.

Additional techniques

I've deliberately left this chapter until later in the book because I didn't want to confuse the issue. These various techniques you should learn, keep up your sleeve, and bring out at the appropriate time. The real purists will hate them and call them 'gimmicks'. I suppose you could say they are rather like swear words—known about but kept in reserve until you hit your thumb with a hammer. If you're continually using them they just become boring.

Take masking solution. I suppose I use it in about one in twenty of my paintings, when it really does fulfil a useful purpose, like painting it on the intricate white sails of a windmill to enable me to put a juicy thundercloud behind it without inhibitions. But to find a use for it on every picture would be, I feel, like the tail wagging the dog.

The same would apply to the sponge; a little touch occasionally might be appropriate for such things as a light tree, but to base your painting style around it would be disastrous. You'd finish up doing hundreds of crude, identical pictures for seaside gift shops.

I have a little trick of flicking my fingernail into a damp wash which is useful occasionally for such things as sunlit grass against a dark tree. But you have to do it sparingly. I've only got to do it once at an evening demo and I can see people's eyes light up, and next day these flicks appear everywhere in rows of students' work looking dreadful. They've learnt the technique but not the need for discretion and restraint.

Here then are a few ideas, but watch it, they're no substitute for talent.

Washing out

The legend is that watercolour once put on the paper is there for good and can't be altered, which is why so many would-be watercolour painters don't try it. The truth is of course very different. Whole areas or sometimes the whole painting can be washed off and repainted without anyone being any the wiser. I call it 'the sink treatment' and it is first regarded with amazement and then delight by my new students. If you think watercolour is like walking on a tight-rope, this is a safety net. You will often get troubles with foregrounds. The top half of the painting may be fine but something awful comes over people when they put in foregrounds. They are unsure of themselves, and it shows. It so often turns out to be a tired, over-worked, muddy mess. First let

Additional techniques

the whole painting dry completely, this is very important, then put the paper in the sink and turn the tap on gently until the whole thing is immersed and the water is flowing over it. Surprisingly, nothing happens to the colour until it is touched and then it flows away. I use my hake brush gently to take away the ruined portions. It often happens that distant hills or trees are painted in too dark, bringing them too far forward. A gentle touch of the hake and they gradually fade until they are about right. Of course, if the whole painting has been overworked and is muddy you can remove it, just leaving a faint image of the original. Lift the paper out of the water and put in on a drawing board to dry. When it is dry you can paint over it, but if you want a wet-into-wet treatment you can recommence the painting before it dries. Some colours leave a stain on the paper that no amount of washing can remove.

Don't wait until you have crucial problems though, get out one of your old failures and experiment with it. I have found various watercolour papers respond differently to the treatment—I know just how my usual Bockingford reacts but I might have to treat Fabriano or Arches in a different way. Do try it—Turner did.

Hair Dryer

This is a very useful tool and I've always got one plugged in at the side of my drawing board. It certainly speeds up the drying process if I'm in a hurry or especially if I'm doing a demo. Students often show me paintings with fuzzy roofs which obviously should have been sharp. 'I couldn't wait for the first wash to dry, I got impatient', is the usual excuse. This is where the drier is the answer. We also use our studio heater and the wash dries in a few seconds if held about 6 in away from it.

White paint

I never use the stuff myself because it's opaque, I always try to keep watercolours transparent if possible. I feel its use sticks out like a sore thumb but many artists I admire use it, like Rowland Hilder and even Turner himself, so who am I to say? But it must be used sparingly and with discretion, I've also seen white spattered on a snow scene looking very effective.

Hog's Hair Brush

A small hog's hair oil painting brush is an excellent tool for removing small areas of paint. It seems to have just enough

Opposite page: The various stages of washing out the foreground of a painting.

Top left: The actual foreground which was too muddy and overworked.

Top right: Wetting the whole paper.

Bottom left: Gently removing the unwanted colour with a hake brush.

Bottom right: Lastly, the result with the rest of the painting unaffected.

The hairdrier in use.

120

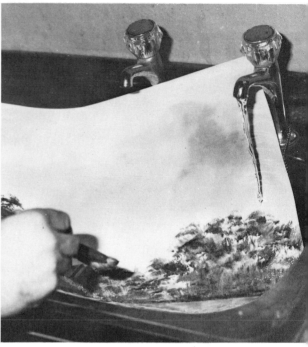

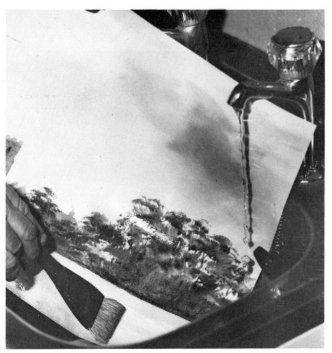

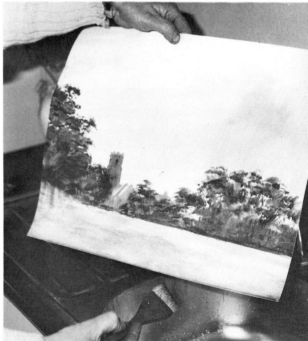

Additional techniques

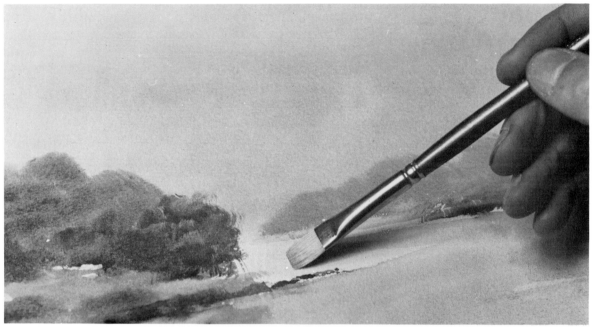

A clean, hog's hair brush being used to remove paint.

abrasive quality without damaging the paper if it is used very gently. It can be used with or without a stencil. For example, if you want a soft fuzzy sun or a misty morning, wait until the main wash is completely dry and then dip the brush into clear water and move it around in a small circle, gently blotting the paper occasionally and your sun will gradually appear. It's useful too for getting that patch of light at the end of the river which you may have forgotten to leave.

Sponges

I usually keep a small natural sponge in my painting box for all sorts of purposes. It can be used to lift almost any colour clean while the paper is still moist, such as wiping out light clouds in a darker sky. My own feeling is that it's always better to paint around your clouds—sponged out clouds always look exactly that. However, it's often saved my bacon in emergencies, which seem an everyday part of watercolour. As to its more productive uses, it can of course be used to apply a wash, making sure that neither the sponge nor the paint is too wet. But its main use is to produce texture by dabbing it, loaded with paint, gently on to paper. Experiment for half an hour and you'll find endless possibilities.

Try it with various consistencies of paint and even with

The effect of dabbing paint on the damp paper with a sponge.

122

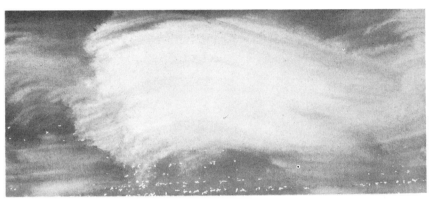

Above: The effect achieved by moving a clean, damp sponge over a freshly painted surface.

Above right: Using a sponge on dry paper.

Right: Actual size, effect of sponge for foliage and, on the far right, with added rigger work.

synthetic sponges, which come in coarse and fine textures. I'm sure you'll find plenty already around the house. Learn all you can about sponges and then put them away until a legitimate use presents itself like texturing a large rock where it can be used on top of a dried brush-laid wash. It's also very useful for putting in foliage.

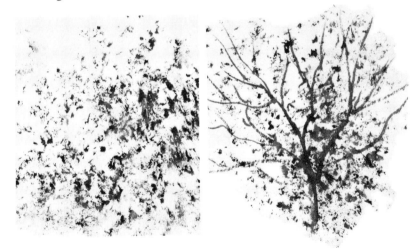

Masking fluid

One of the problems that watercolour has compared with oil painting is the white areas. With oil painting you just use white paint but with watercolour you normally leave the paper blank and paint round the space. This is fairly straightforward with large simple areas, but with complex shapes, like white boats, windmills and houses against dark backgrounds, it's sometimes almost impossible or at best inhibiting. The answer, of course, is to cover the area with masking fluid.

123

Additional techniques

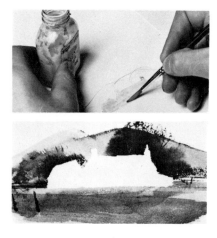

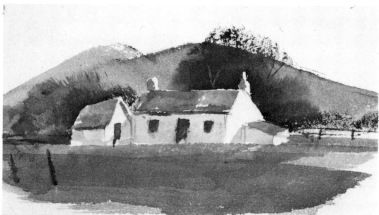

Masking fluid is a pale yellow liquid you buy in bottles. It is a colloidal suspension of rubber solution in water. You have to decide before you commence the picture where your white areas are to be and then paint them with the solution. The yellow colour is to show where you've applied it. You can then paint over it with confidence and once dry it can be removed by gently rubbing with the top of your finger and the virgin white paper appears where it's needed.

A word of warning. When you've painted the masking fluid on, wash the brush out immediately in warm soapy water to remove all traces of the rubber solution. However, if you've been careless or lazy, as I often am, you can remove it later with petrol.

Stencils

Using a stencil is a very useful technique for lifting out such things as sails, seagulls and light figures (I believe Russell Flint used this method). Say you want to put a white seagull in front of a rock or sky. After painting the background normally, draw your seagull on separate tracing paper overlay, cut out the shape with a Stanley knife and lay the stencil carefully in position, scrubbing through the hole with a damp bristle brush or sponge, and lifting off the moist colour with a tissue. Do it gently and patiently so as not to damage the paper and don't use too much water or it will creep under the edge of the stencil. Another effect useful for creating white masts on waterfront scenes is achieved by putting two sheets of paper on the painting with only a narrow gap between them, a quick rub with a damp sponge and you have

Top left: Painting the silhouette of a cottage with masking fluid.

Left: The result after the background has been painted in and the masking fluid removed.

Above: The finished result.

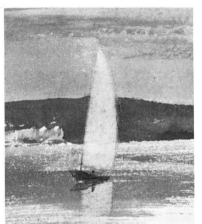

Above: Cutting out a mask.

Right: The finished result after sponging out.

Far right: The effect of salt on a wet wash.

a mast. The width of the gap of course is very critical to the size of the mast.

In many ways this method is often better than masking fluid as it doesn't stick out quite so glaringly, also you may decide near the end of your painting you need something extra, whereas masking fluid areas have to be pre-planned.

Salt

There are rare occasions when this too is useful. Experiment by dropping a few salt crystals on a damp wash. A little star forms round each crystal as the salt soaks up the paint—it looks exactly like snowflakes.

Spatter

First the warning—don't be led astray and overdo it. It's very simple and can often be used legitimately to indicate pebbles on a beach or give interest to a foreground but to see it on painting

Right: The effect of spatter on dry paper. Try it also on damp paper.

Far right: The method.

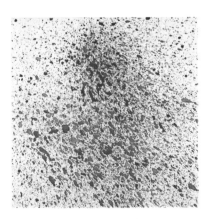

Additional techniques

after painting is a bore. One method is to tap a brush loaded with rich paint and not much water on the handle of another brush held in your left hand. A shower of spots will fall on the paper, the size of which can be varied by changing the distance between the brush and the paper. The other way is to dip an old tooth brush in paint and then draw a pencil across the bristles, thus spraying the paint on the paper.

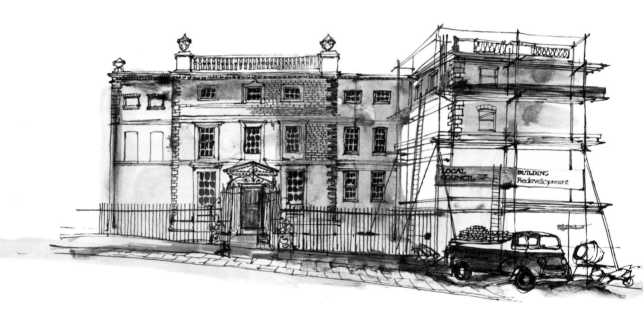

Line and Wash

This is a perfectly legitimate technique, that of drawing your picture first with a pen and waterproof ink. Many famous artists have used it through the ages and we've all seen superb examples. The real danger of its use by beginners is that the pen can be used as a crutch and the student becomes afraid of doing anything without it because of timidity. I started this way myself but I soon realised its restrictions. I've often sensed this dependence with students who seem to finish up merely doing tinted pen drawings so I deliberately take their pen away from them for a few days, and after this their progress is often quite dramatic.

Above: Line and wash drawing, by Graham Byfield, with the line work being put in with waterproof drawing ink and being allowed to dry before the various watercolour washes.

Right: The effect of knuckles and fingernail flicks in damp paint.

Far right: The use of masking tape before putting in the washes. It could be used for keeping a flat horizon on a seascape when painting the sky.

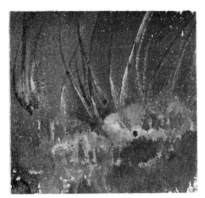

Fingernails and Knuckles

I use these quite a lot myself, where appropriate, especially on foregrounds perhaps because I've always got them close at hand as it were! The occasional flick with the fingernail in a damp wash can be quite effective for sunlit grass or branches. The knuckle can create textures like rocks but as I said before—not too much.

Masking Tape

This is a strong adhesive tape which attaches itself to the paper but is easily peeled off afterwards. It can be cut or torn to mask out uncomplicated shapes or to give you a sharp straight edge to a wash.

Candle Wax

This too can be used as a resist and gives a sort of batik effect. It should be used very sparingly to suggest light sparkles on a lake or to create texture. Remember, the wax cannot be removed afterwards—it becomes part of the picture itself.

Right: Use of the candle before painting and the finished result.

Additional techniques

Pointed Sticks and Cardboard Strips

Pointed sticks dipped in watercolour can be used to draw branches and cracks in stone walls, for example. You should try it on both dry and damp paper. Cut out some assorted strips of heavy cardboard from $\frac{1}{2}$ in to 3 in wide and long enough for you get a good grip. Again, try them in various ways.

Painting Knife

Before you try this technique you must remove every trace of grease or varnish or oil paint by using a household cleansing powder, otherwise the watercolour will not stay evenly on the knife. If this doesn't do the trick, stick it in a lemon and leave it overnight. There are all sorts of ways of applying watercolour with a knife and, again, experimenting will show you how. You hold it as if you were going to cut the paper with the tip and produce fine lines for twigs, weeds and ships' rigging. You can use the edge of the knife laid on precisely to indicate distant walls or short sideways strokes to paint birch trees. By scraping already applied paint in a sort of spreading butter motion you can produce interesting textures. It can also be used to apply masking fluid either in precise strokes or by dipping the knife in the fluid and flicking it onto the paper with your finger. Again, this produces interesting foreground textures.

Above: The effects you can get with pointed sticks and cardboard strips.

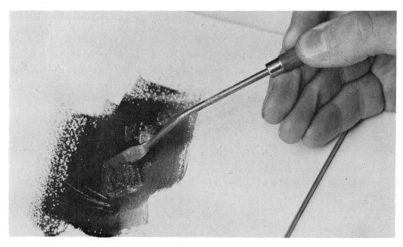

Left: Using a painting knife on a damp wash.

I realise, after all my dire warnings, just how many possible techniques I've given you. Warnings still hold good but I'll leave it to your own good taste and discretion not to overdo things.

Right: A watercolour portrait showing the extensive use of wet-into-wet technique on the hair (*below*) with the more detailed treatment of the eye (*above*).

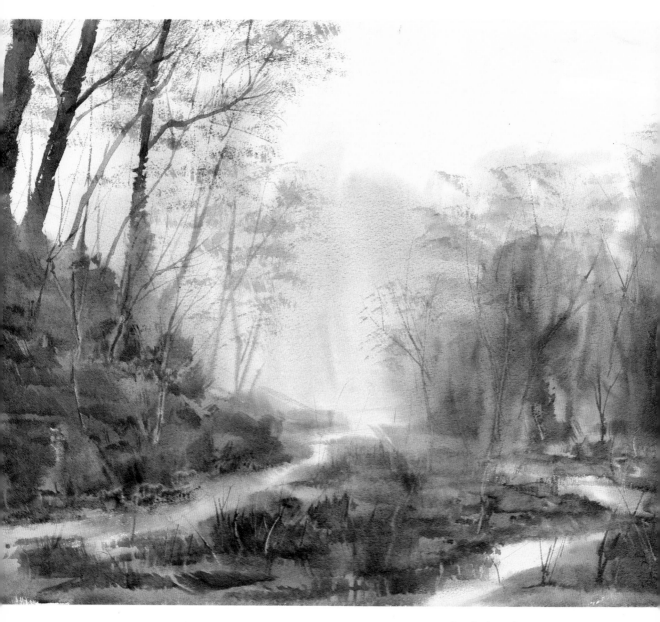

A painting of a misty woodland scene in the Forest of Dean using Paynes grey, raw sienna and ultramarine.

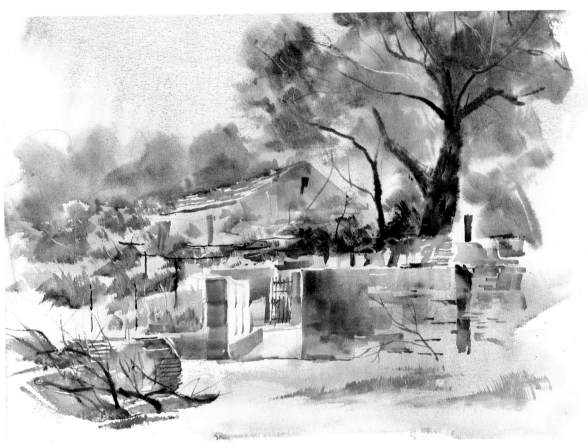

Above: A demonstration painting of a Greek island villa.

Right: A detail of the painting showing the impressionistic rendering of the water pots and branches.

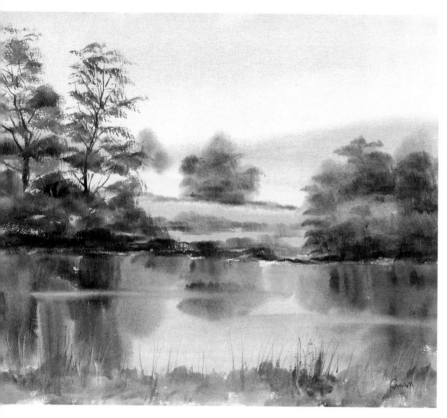

Above: A painting of trees with wet-into-wet reflections on the banks of the Wye.

Right: A winter scene on the River Thurne in Norfolk with the sky, trees and river in wet-into-wet and the grass and figure added with the rigger.

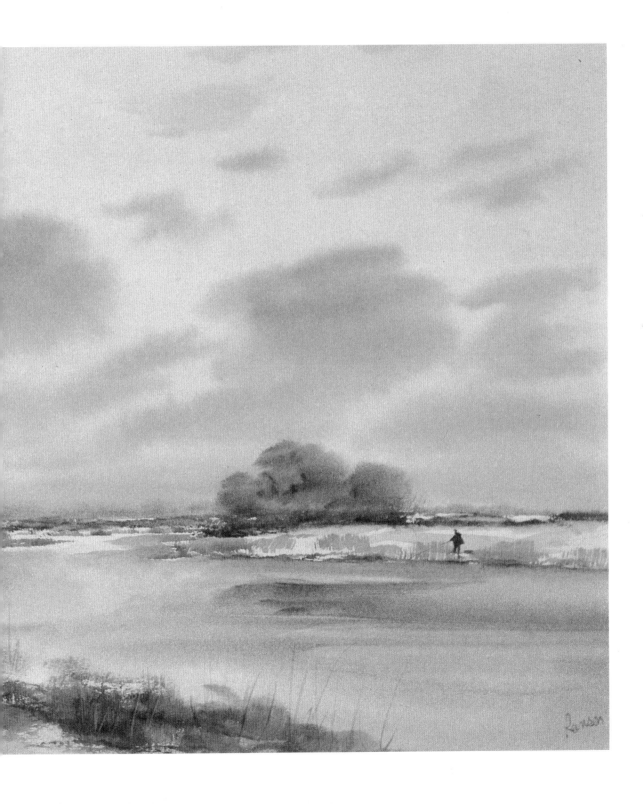

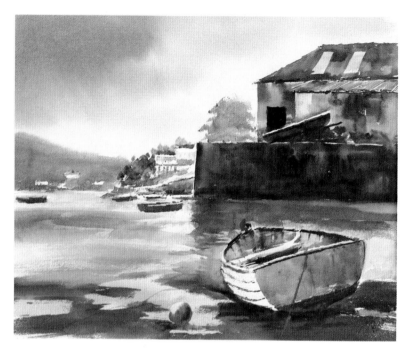

Left: A painting of Salcombe harbour in Devon.

Below: An early morning scene on the Wye.

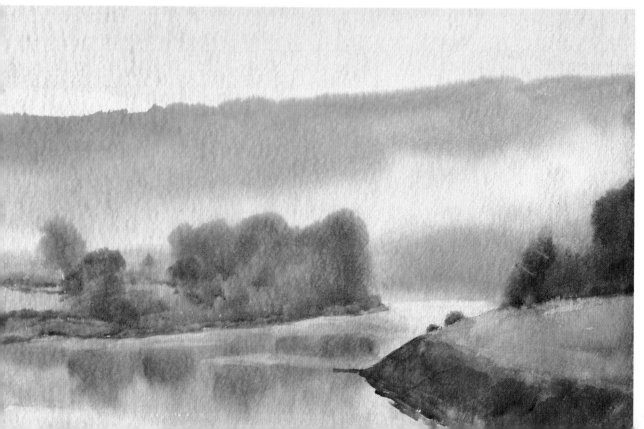

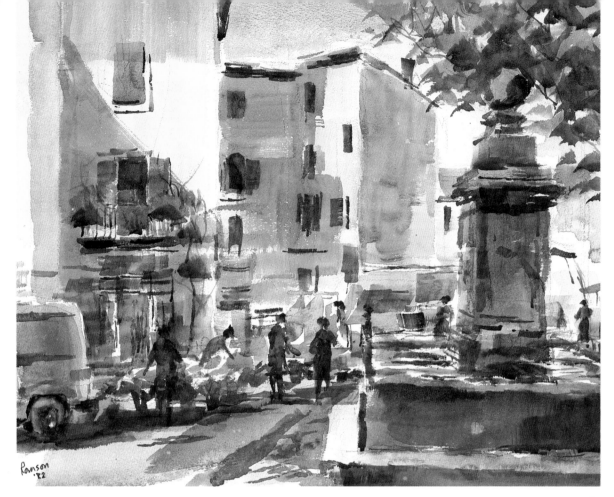

Above: A demonstration painting on a market day in the Provence village of Gourdes. This took about half-an-hour working very quickly.

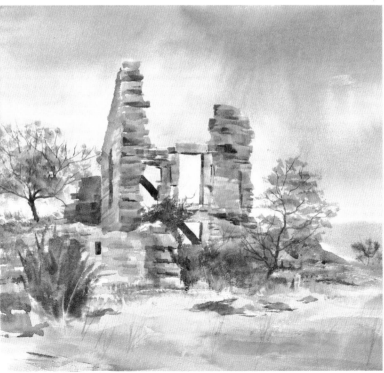

Right: A ruin I found in Provence.

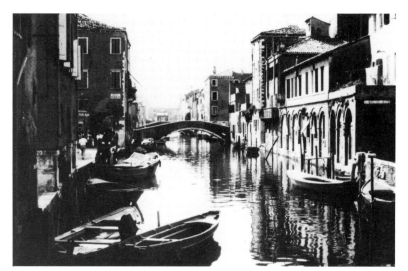

A photograph taken in Chioggia – a little town near Venice.

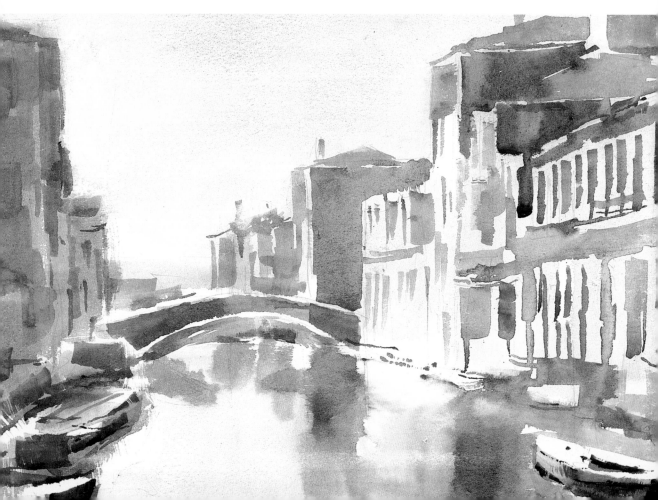

Using photography properly

This is going to be a controversial chapter. I know most painting books sternly and piously advise against using photographs at all, and some of the purists among us regard the camera as a form of cheating. But let's not be hypocritical about this though. Both you and I know that thousands of painters all over the world work from photos anyway, so we might as well learn to use them creatively and responsibly.

Since the camera was invented in the nineteenth century great artists like Degas, Corot and Sickert all used photographs as a source of reference; the great thing was they knew how to use them properly.

What has given the process a bad name are the amateurs who sit and copy photographs slavishly and mindlessly and in every detail. It becomes a kind of crutch that spares them from the trouble of having to observe carefully and draw skilfully.

So how should you use them? Basically, by making the camera your servant rather than your master. First learn to take your own photographs inventively and don't rely on magazines and calendars. By this I don't mean just learning which knob to press, but how to compose your pictures well.

Of the thousands of photos which students have shown me not one photo in twenty has been produced with any real thought for composition.

That view from the hilltop where you can see three counties is breathtaking if you are there but deadly boring as a photo. So many people just point the camera and click rather than move round, getting down low or high, to the right or left, looking in that viewfinder to get the most exciting composition. My own basic rule is to try to get a good foreground subject, a middle distance and a far distance, in other words get depth into it. All the rules we talk about on *pages 54–56* apply equally to photography. Don't just waste film, use it intelligently.

I feel that painting has helped me to become a better photographer. I travel about the country by car and I always keep a camera permanently in the glove box. Countless times I've gone over a humpback bridge and seen a lovely stream out of the corner of my eye. Pulling off the road I have run back, climbed down the bank, and composed and taken four or five different views in as many minutes and I'm off again to meet my appointment.

Opposite page, below: Part of a painting using the photograph as a guide. By adopting the flat brushes only for the buildings and boats I forced myself to simplify the scene.

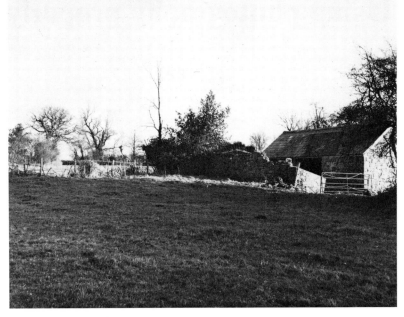

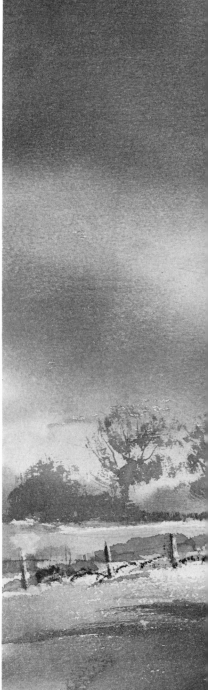

Above: A straightforward photograph of my barn. Tonally it is confusing. The sky is too light and uninteresting; the roof and one wall are too similar in tone; and the field is rather boring.

Below: In the pencilled sketch I tried to make the sky more interesting. I lightened the roof to counterchange it against the trees behind and used the existing lighting direction to make the foreground more interesting, adding a couple of sheep for the same reason. Notice also the difference in tone between the dark wall and the roof.

Right: The finished result. Compare this with the original photograph.

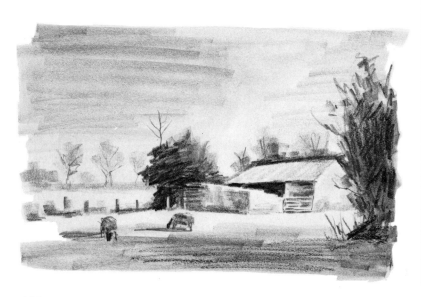

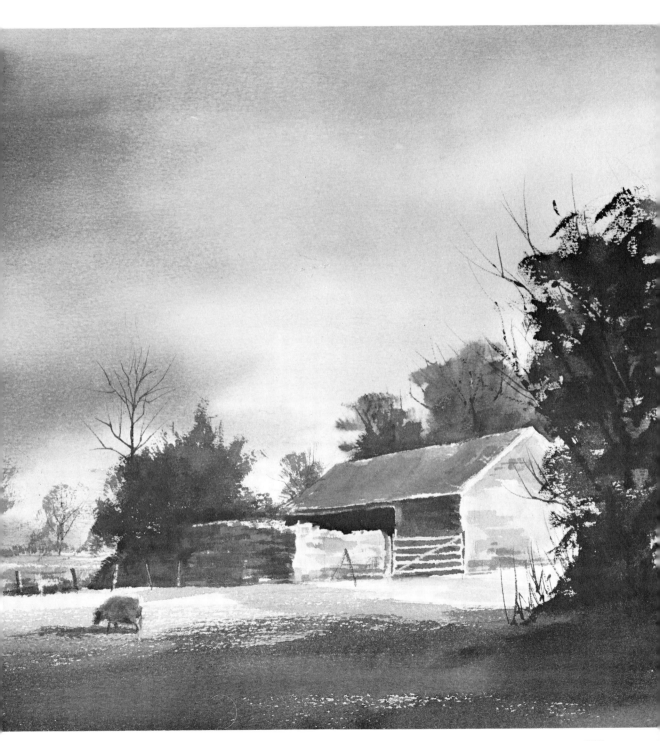

131

Using photography properly

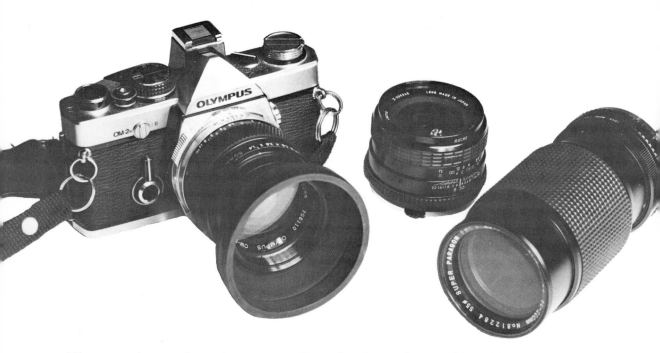

Misty mornings and evenings are my favourite times: dawn driving offers endless temptations to stop and capture a mood for future reference.

However, I've found that the camera functions most effectively when used in conjunction with a sketchbook. The two form a team. The drawing records the composition which I saw and responded to. The camera records the details and fills in whatever the sketch may have missed.

Now, let's assume that you have your photograph in front of you and you're ready to start painting. As I said, the very worst that you can do is to copy it wholesale. Before you pick up a brush, consider the photograph carefully. You still have some of the same problems as painting outdoors. Firstly there is simplification. Cut out all the superfluous detail and just paint the essence of the scene. This needs a lot of willpower and self discipline as your other self is saying 'Go on, it's there—put it in.'

The second thing is to sort the whole picture mentally into planes. Let's imagine there are three planes—distant hills at 2 miles, woods at $\frac{1}{4}$ mile and the foreground trees at 100 yards. On the photograph the tones will probably be very similar but when you paint it you must use your own aerial perspective (*see page 57*). Fade the hills back, use more blue in the greens and cut out

Above: My camera together with an additional wide-angle lens which covers a much larger area on any given photograph, useful for example in a narrow street, and a zoom lens which enables me to magnify, say, a distant cottage, rather like a telescope.

any detail. The sky will probably look white so that needs to be made more interesting and the foreground will probably need strengthening.

You'll see, therefore, that the photograph, however good, can only really provide the basic subject matter—a sort of launching pad for the artist's own creative skills, rather like the little notebooks full of tune titles used by professional pianists who play by ear.

You can also combine several elements from several photos into a single painting. Use them as a starting point for evolving scenes that in the long run may bear little resemblance to the photos from which they originated. Condense and revise the photographic images into simpler forms. In short, think of them more as a creative stimulus than as something to be rigidly followed.

One thing I do find the camera useful for is to teach the beginners how to use their brushes and how much, or mostly how little, water to use with their paint, and also to gain confidence—rather like a ski instructor keeping his first timers on the nursery slopes for a day or so. It's no use philosophising about being free and creative until you can use your tools properly.

Rather than make students practise graduated washes and rows of squiggles, I give them two or three simple photos such as tree with misty hill in the background or close up of a river bank. By giving them a strict time limit and large brushes they are forced to simplify and select the basic essentials of the scene—the same thought process which they will need when they are painting outside on location. This factor is far more difficult to teach than the mere application of paint.

Next day, when they've got the feel of things, out they go into the garden or on the river bank to face the real challenge of the countryside which previously would probably have scared them to death.

All this will horrify the academics. I only know the process has worked, time after time. Creativity is no good without confidence, and giving confidence and enthusiasm to students is one of my main aims.

One final word. I sincerely believe that if you use your camera, with integrity and imagination, as just one step in the process of producing a beautiful picture there is no need to apologise to anyone.

Painting courses

You've only got to look at the pages of *Leisure Painter*, *Artist* or *American Artist* to see that painting courses and holidays seem to be growing in numbers every year. So I thought it would be helpful to do a frank appraisal of some of the advantages as well as possible pitfalls of courses, and how to choose them.

The one thing you can really depend on is that your fellow students are going to be nice people. I've dealt with literally thousands and I can count on the fingers of one hand the ones I wouldn't like to meet again. Don't ask me why—it may be the same with all bridge players or golfers but I doubt it. I only know it makes my life a lot easier as a tutor. However, for you who may be contemplating going away on your own for the first time, perhaps just widowed or divorced, and feel a little apprehensive, have no fear, I guarantee you'll be welcomed into the fraternity within minutes.

Now to the choice of course. There's a bewildering array in the magazines, most offering brochures which you can send for to study at your leisure and gain a better idea of what they each offer. From the way a brochure is written and by reading between the lines you should be able to get some idea of their aims and atmosphere.

A demonstration in the studio at Wyeholme.

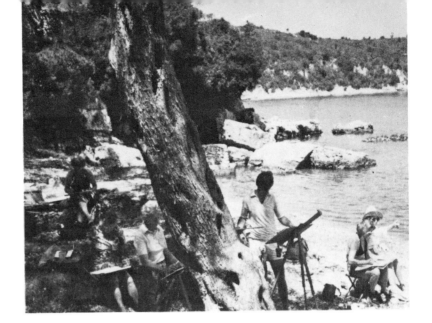

A group of painters on a sunny beach on Paxos.

If you're already in an art society it's easier, you just pump people. They usually can't wait to tell you about so and so's course they went on last year. 'My dear, the instructor was divine but the food was rotten. We had to go out afterwards for fish and chips', or 'He used to send us off in the morning and we never saw him again until the crit at night.' I'm not exaggerating, I've actually overheard both conversations—not about my own courses I hasten to add.

Now, about the instructors themselves. Some run courses because they enjoy people as much as paint, others see it as a necessary chore to help them out financially because they couldn't live on the proceeds of their paintings alone. Yet others are brilliant artists who seem somehow to be unable to pass on their enthusiasm and skills, or are inarticulate when it comes to explaining actual techniques. I have felt as a student that one or two were reluctant to give away all their precious professional secrets.

Art tutors sometimes share a fault with other teachers in that they often tend to concentrate much of their time on the obviously gifted pupils and neglect the elderly plodders, who have paid just as much for their course and really need help more. It's also not unknown for the pretty women in the party to get more than their money's worth of attention.

Instructors can certainly be divided into two groups: the first do plenty of demonstrations, enjoying them and feeling it is the quickest and easiest way to teach painting; the second group, who wouldn't be seen dead demonstrating, feel that the students should discover their own destiny and creativity and just walk about making encouraging noises. I suspect that some of them may be a little afraid of losing face should a demo go wrong. But there again, I'm probably thoroughly biased.

135

Painting courses

Courses themselves may be held, say, in a village where everyone meets at the village hall at ten, works together during the day, then departs to their own separate little bed and breakfast places in the vicinity, and the only possible meeting place is the local pub. My own feeling is that in this situation one loses a great deal of the pleasure of companionship and good conversation round the dinner table at night with its cross fertilisation of ideas. Yet others are held at hotels, conference centres or private homes where everyone is together most of the time.

I once suggested to the editor of one of the painting journals that she should run a sort of *Which?* guide to painting courses, but I had the feeling that she thought it might be something of a hot potato. This thought reminds me of a car magazine which lists all the makes of cars under headings such as 'interesting' or 'boring'. I can't really see the art magazines getting round to doing this, though.

Another thing you should find out is if the tutor specialises in watercolour, oil or pastel and, if possible, look at some of his or her work to decide if it is the type of approach you wish to pursue yourself. I once went on one holiday where the tutor was mainly interested in abstract painting and I hardly ever saw him!

If I've portrayed the choice of painting courses as something of a minefield—I haven't meant to. I've tried to do it with my tongue firmly in my cheek and my advice has been based on some of my experiences as a middle-aged student who felt, and still does, that it is the very best way to learn painting quickly. The intensity and excitement of some of these courses is very infectious and you can sometimes learn more in one weekend than in a year of evening classes.

Now let's consider overseas painting holidays. These usually last a fortnight and are held in Dordogne, or Provence in France, or suitable regions in Italy or Spain. My own experience of these has been both as a student on Pyrenees mountain holidays and latterly as a tutor having run thirteen holidays in the Greek Islands, four in Provence and one in southern Italy. I must admit my thirteen trips to the Greek Islands have taught me more about human psychology and behaviour than one would normally learn in a lifetime.

Put about eighteen people together on a tiny island with ages ranging from nineteen to ninety and anything can happen, and

it usually does. I could write a book this size entirely with adventures and minor disasters, in fact many of my friends have urged me to do just that. It would make an excellent T.V. series too—somewhere between 'Hi-de-Hi' and 'Who Pays the Ferryman'.

I can't resist giving you a few snippets from my experiences. There was the time I rescued a really charming Scottish titled lady from a loo when the door had jammed by climbing through a tiny window, to the cheers of the other painters.

I once left a bewildered lady behind on a beach during a boat trip round an island. I still think it was her fault, and she did manage to get home by the island taxi. It took me two days to console her.

I've battled with everything from waist-high floods to merry widows and the romantic atmosphere is such that two of my middle aged painters married each other within eight weeks of the course.

Another holiday all the painters were divorced. Boy, did I have trouble that time!

On these trips the tutor is often expected to act as courier, father-confessor, marriage guidance counsellor, dancing teacher and boatman, as well as teaching them to paint—I have loved it all.

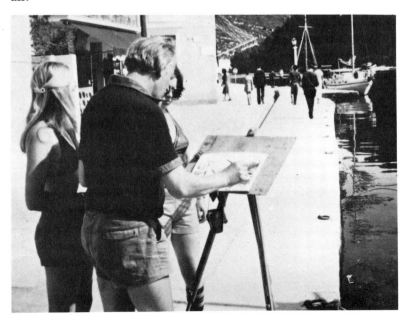

On a Greek quayside.

Painting courses

But I've just realised I haven't mentioned the actual water-colour painting. I've found it an excellent thing to get away to a completely different environment with all its attendant difficulties. One could easily get complacent painting in one's own backyard, in my case the beautiful, misty Wye Valley. To be suddenly asked to demonstrate on the morning after arriving, with the hot sun beating down on you, can be a chastening experience. It certainly gets you out of the rut. Endeavouring to paint in southern Italy with about ten kids all around you also has its problems.

A few other tips—always enquire if easels are available on site. If they are, you could avoid lugging your easel half way across Europe, although I must say I always take my own metal one everywhere. I first take off all the loose bits and pack them in my case and carry the bare structure as hand luggage. So far it has never been taken off me as a possible hi-jacking weapon.

Another thing to enquire about is the possibility of buying art materials on the course itself. Some, like my own in England, have a local art shop which visits every course to sell the basic requirements like paper, brushes and paints, even standard sized mounts or frames for the finished paintings.

However, there are usually no art materials on a Greek Island. I remember one horrific incident when I decided to try and buy some turps in the village. Armed with a simple plastic bottle, I tried to explain to the shopkeeper what I wanted. A few hours later the liquid he had given me had eaten through the plastic bottle and the bottom of my plastic art bin had turned into what looked like hot sticky chocolate.

The advantage of my simplified and restricted collection of materials is that they are so easy and light to carry around. I've seen elderly ladies with so many materials that they've had to pull them around on trolleys, slowing the party down considerably.

Then there is the problem of single rooms—often at a premium on art courses. People seem to value their privacy more and more as they get older, but don't be too afraid to accept a shared room if necessary. As I've already said, other painters are easy going and I've known some permanent friendships formed this way.

Do try it, though you may never be the same again. But I repeat, everyone will be nice to you so don't ever be afraid of going alone.

Evolving your own style

There comes a time, after you've struggled to control those paints, brushes and water for a year or two, that you really begin to work with a reasonable amount of fluency and confidence. In other words, you're becoming efficient at your craft. This is where the next stage in the struggle begins—to be able to stamp your own personality on your work so that people will be able to recognise your paintings even without your signature.

I once went into a gallery with about twenty of my paintings and the owner gradually went through them and put about six aside, not always, I thought, the best of the bunch. They were, he said afterwards, all reasonably competent, saleable paintings but those six had had a recognisable quality, they all looked unmistakeably as though they had been done by the same person. He also said that when a painter had really arrived you should be able to recognise his work from across the street. His words had quite an effect on me and since then, when I've compared the work of the actual R.I. members in the annual exhibition with the work of the outside contributors this uniqueness of approach has always appeared to have been the secret factor—quite apart from their skill with the brush.

Everyone has their own particular star who can do no wrong, indeed it may be that seeing a particular artist's work may have sparked you off to start painting in the first place. However, as you progress you may change your allegiance many times. I went round a large Picasso exhibition a few years ago and I could plainly see how during his early years he had been influenced tremendously by one after the other of the famous painters of his day until, inevitably, his own strong personality completely took over.

You have to build on something and there's absolutely no need to be ashamed of it, a superb artist's work can be a spur and a goal to keep aiming at. The only danger is that you might be tempted to make carbon copies of the work of your idol. They may teach you a little but you'll be dealing with something that has been seen, selected, organised and painted by someone else—predigested.

Even if the painting itself is not copied, we've all visited exhibitions and seen work which, at a glance, may look exactly like one of the current nationally known artists. All the mannerisms are there, the subject matter, the use of this and that idea to get foreground texture. Everything that is except the talent—it's

Evolving your own style

a caricature of the great man's work, and nothing more than that.

The wary selection committees at the national exhibitions can spot them a mile off and usually reject them.

The way to tackle it is to find your own subject and try to imagine it through the eyes of the famous man you admire: how would he have painted it and dealt with the various problems of colour and composition? Basically, go after the principles underlying the work rather than the mannerisms and superficial techniques. I try to do this myself with Edward Seago in mind—he had no gimmicks anyway but his ability to simplify is a constant inspiration.

How then should you go about acquiring this elusive personal quality? One thing you can't do is go out and choose a style like you would buy a new suit. It will evolve slowly, without you really being aware of it, from your own gut reactions to what you see around you. Style isn't so much a matter of technique as a mental attitude. You mustn't be self-conscious and up-tight about it or try to push it along too fast. Think of that unique thing—your signature. When you write it you don't direct it carefully. Just for a second your own personality takes over and something completely unique to you appears.

A style is an inevitable growth of both the artist's skill and his or her own philosophy, if that doesn't sound too pompous. A style is no good if it is restricted to a very narrow selection of subjects. We've all been to one-man shows and seen what appears to be a lot of variations on the same basic theme. 'You've seen one, you've seen the lot', is the usual reaction from the public. No, your style should be flexible enough to encompass all types of subject and different ideas.

Something else you should avoid doing like the plague is moulding your style too much on what you think will sell, otherwise you'll begin to make a straight-jacket for yourself. It will limit you to paintings that won't rock the boat. You'll feel you have to put in a figure or an animal everytime to help sell it, or perhaps avoid bright colours because they might offend your potential customer's colour scheme.

I know in my own mind that I could probably turn out misty dawns in the Wye Valley till kingdom come and folk would still buy them for their sitting rooms. They suit my own particular wet-into-wet technique but I would probably die of boredom. I love the challenge of a new subject or even a new country and all

its hazards and excitement, even if the paint does dry almost before it's on the paper.

It's all very well to say that a style will take a long time to develop but isn't there something we can do to give it a gentle shove? One way perhaps is to collect all your paintings together, put them around the room, sit in the middle and just look at them.

You'll probably find them a pretty mixed bunch, with all sorts of conflicting attitudes and techniques. In spite of that, try and find some sort of common theme running through them, something that keeps appearing regularly. Ask yourself if you are basically an orderly, tidy painter or a carefree, lighthearted one. Which paintings did you enjoy doing most and which ones did you find a bit of a bore? Are you best at moody, atmospheric work or crisp, detailed drawing? It's often your 'quickies' that are the most revealing of your work—done swiftly like a signature; they often show more about yourself than the finished, studied ones. Perhaps they can show you the way you should be going in the future.

Whatever style you evolve in the end it will probably be the product of two opposing sides of your nature, one the inspired, creative visionary and the other the craftsman/critic putting it all together with a calm, objective professionalism.

Right: It might be appropriate at this stage to show you, rather ashamedly, my very first attempt at watercolour, done a few years ago. Practically everything is wrong with it—branches in front of trees, and I seemed to be obsessed with scratching the paper afterwards with a razor blade; but I thought it might possibly encourage a few people.

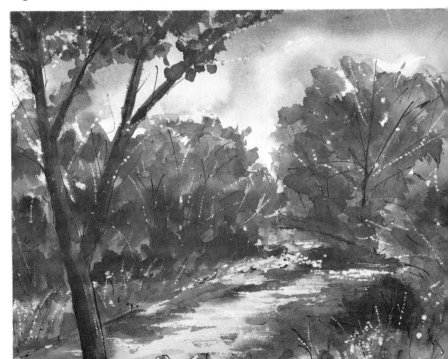

Photographing your paintings

Once you get past a certain stage in your painting you begin to want to keep a record of your work. It is nice, for instance, to be able to show some examples of your skills as an artist to your friends in a handy form, but later as you progress you may want to interest a gallery or try to persuade a publisher that your work is suitable for reproduction. The answer is to photograph your work and show it either as colour prints or slides.

Many of the national painting competitions require artists to submit transparencies or prints of their entries so that a preliminary selection can be made. The approved originals are then invited for exhibition.

It is also useful to retain a record of your best pictures. They, of course, are the ones that sell immediately and go out of your life forever.

Sometimes when a painting has really come off you're tempted to think you may not be able to match its quality again in the future. Records of past paintings are helpful if only to make you realise that you have, in fact, progressed over the last few years and that the original wasn't quite so good as you thought it was at the time. Your critical faculties should, at least, keep pace with or even be ahead of your current abilities.

So far so good, but how often have we heard the excuse even before the photographs are shown, 'The colour wasn't really like this,' or 'This one was a bit out of focus', or the 'Light wasn't very good at the time'. In other words, the standard of the photography has let the pictures themselves down. I thought it would be a good idea, therefore, to give a little practical advice on this specialised subject. A subject neglected in any art book I've ever come across and so complicated in the specialist technical books that you need a Physics degree to understand it. All you really need is enough basic knowledge to enable you to avoid the common pitfalls and to be able to present photographs of your work which at least will do justice to the originals.

First, you may wonder if your own camera is suitable for the job. The main criteria is that it is possible to have the picture in focus at a short distance away. A single lens reflex camera is ideal. If you have a cheaper variety you may have to get a close-up attachment to enable you to get near enough. You'll need a separate tripod too. This is necessary because you need a fairly long exposure—too long to hold the camera without a support anyway.

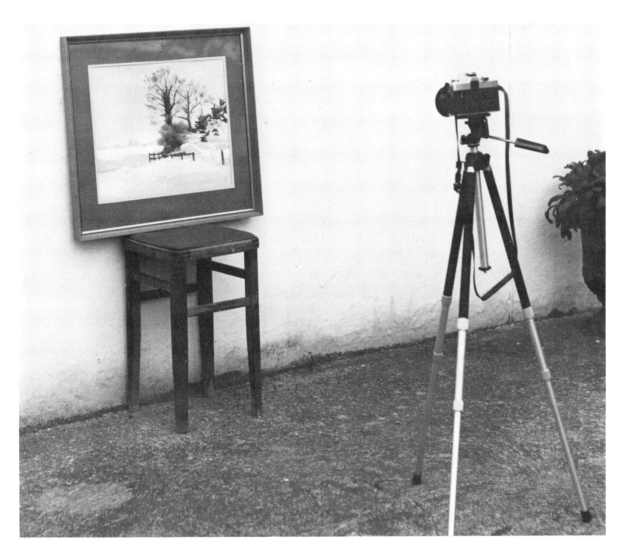

The outdoor set-up.

Life is full of decisions and the one you have to make is whether you want to have transparencies or colour prints of your work. Each requires a different type of film in your camera. Transparencies have the disadvantage of having to be shown on a projector in a darkened room, or used with a hand viewer, or at worst squinted at against the light, but the colour is very rich and impressive. Prints are obviously easier to view and can be exhibited in albums with transparent plastic pockets. They both have their advantages and your decision depends on the use you're going to make of them. For example, if your work is to be

143

Photographing your paintings

reproduced in colour in a magazine or a book such as this, it is preferable to provide a transparency rather than a print as the first stage of the reproduction process.

The easiest way to take a colour photograph of your pictures is to do it outside in the shade. This is because all colour film is balanced for daylight. Set the picture up against a wall with the camera on your tripod directly in front of it and level with the centre. If it is not level the sides will look distorted. The distance from the picture to the camera will usually be about three feet but, of course, this will depend on how it fills the viewfinder. To get a correct reading for the exposure it's useful to first hold a grey or fawn sheet of card in front of the picture.

The next danger, if you are taking the picture through glass, is picking up reflections. These can be avoided with a bit of thought, for example, don't wear your white shirt, wear something dark, you may even need to cover up the tripod with a cloth if it's a silver one. That's about all there is to it. Go out and buy a roll of film and experiment.

If you want to take indoor photographs of your pictures it's a bit more complicated—but not much. As I said before, colour film is balanced for daylight so if you want to use electric light you will have to fool the film. You can do this easily with a filter over the lens. If you're using ordinary household tungsten lamps you'll need an 80A filter but if you're using photo-flood lamps generally used by photographers you'll need an 80B filter.

So, let's say your picture is on the wall and you have two 500 watt lamps on stands. They should be about three feet away and at a 45° angle to the picture to avoid reflections. You can test this by the old dodge of holding a pencil against the picture and if the two shadows cast from it are equal the lighting is even. As a very rough guide to exposure with the set up I've described and using 100 ASA film, which I always stick to for simplicity, it would be about 1/30 second at F8 aperture. Incidentally, you have a little bit more latitude with your exposures if you are taking prints rather than transparencies.

If you are only taking black and white photographs of your work it's much easier. You don't have to worry about colour temperature and filters. It's also simpler, of course, if you don't have glass in front of your painting when you photograph it as you don't have to bother about possible reflections. You'll also find you get much more of an impression of the paper texture.

The indoor set-up showing the picture hanging on the wall with the two photo-flood lights and, in this case, an 80B filter on the camera.

There, I've tried to give a sort of child's guide to the subject. I've often wished that more people would write child's guides to politics or computers, then perhaps even I could understand them.

Don't be scared to have a go. You learn very fast once you've taken the plunge and may never have to make excuses again—about the quality of your photographs anyway!

Presentation

There's nothing quite so good for morale as putting a mount on one of your paintings. It seems to improve it at least 50%. In fact, I keep a few mounts in the studio just in order to prevent depressed students from disappearing up the lane in despair. Once the mount is placed over their work their little despondent faces light up with renewed hope. As for me, if I've been painting down by the river I can hardly wait to get back to the studio and put a mount over my work before showing it to my sternest critic—my wife. I hope this gives you some idea of the importance of presentation.

On the other hand, I've seen so many otherwise competent watercolours in art society exhibitions ruined by tatty, badly cut mounts and poorly made frames where the corners don't quite meet. It's like going to the trouble of preparing a lovely banquet and serving it on chipped and cracked dishes.

The Logan hand mount cutter and its use. With this model the cutting is done from the reverse side of the mount, thus avoiding possible fingermarks.

I know professional framers are expensive and that you or someone you know can probably knock one up for half the price but all I'm saying is be at least as critical about the frame as you are of your picture. Remember that a painting is only as good as its worst part and that includes the frame.

The price of framing being what it is, I standardise on the size of my paintings, mounts and frames, I've gradually discovered what I believe is the right type of moulding, mount colours and proportions to suit my paintings and I now order them in bulk. None are ever wasted, though, because if I get a framed painting that doesn't sell, I've always got another painting which fits the frame perfectly.

As for mounts, I have a selection of these in Ingres coloured card. These vary in very soft colours such as grey/green, fawn, grey/blue and soft brown which I try out on the finished painting to see which best suits it. I try to match or tie up one of the dominant colours in the painting with the mount colour. I know plenty of people will quarrel with this and say that mounts should always be cream or off white so that the mount is completely unobtrusive but your own good taste is the only guide to this. I now use double mounts with what is called a cream slip, a second board stuck behind with a slightly smaller hole than the front board giving that expensive stepped look.

I'm not going to try and teach you how to make frames as I don't do it myself but I have a very friendly local professional who I've used for years and who keeps a good stock of my favourite moulding. As I said, I have standardised my mounts and frames to three sizes and he and I both have dimensional drawings marked A, B and C. All I then have to do is ring him and say 'Six A's and 4 B's with the usual mount colours, Brian.' This method has got me out of many a panic situation.

We've expanded on this idea to my students and they can now buy the standard frames and mounts at the beginning of the courses which is a great incentive to produce something worthy of taking home afterwards.

One thing I have done for years, and often still do, is to cut my own mounts. First wash your hands. When you're in a last minute rush as I usually am, and eating a sandwich on the side instead of lunch, I've found that the front of the mount is extremely sensitive to the slightest trace of grease on the fingers and it's almost impossible to remove—so watch it!

The Dexter mount cutter and its use. In this case the cutting is carried out on the front surface of the mount.

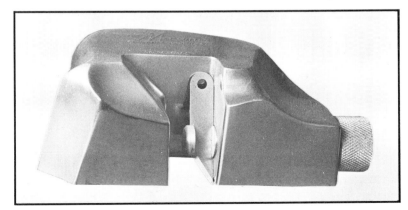

Presentation

The next thing is to draw out carefully in pencil the outside of the mount and the inside hole. One important thing here is not to skimp on the width between the edge of the picture and frame. It looks so much better for a watercolour to have a generous setting. Another thing I always do is to add another $\frac{1}{2}$ in at the bottom over the other three widths.

The first stage in placing the picture in the mount. The tape is sticky side up with half of it under the picture.

The next stage is the cutting and this scares quite a lot of people. The outside is not much of a problem. Use a sharp Stanley knife with a steel rule and a thick card underneath and the job is soon done. The inside hole is more difficult, holding the knife at a set angle while accurately starting and stopping takes a lot of experience and not a little nerve. Luckily, little gadgets are available called matt cutters which make the job so much easier and with practice you can get a perfect bevel every time. They're certainly well worth buying.

Having got the finished mount, the next stage is to fix your picture in position. I always leave plenty of space around the picture for manoeuvring and making sure both that the horizon is parallel to the bottom of the mount and that the verticals are upright. I put a strip of sticky paper along the bottom of the picture, half of it protruding sticky side up, and holding the

Carefully positioning the mount over the picture before pressing down to locate it finally.

mount away from the strip until I'm satisfied that it's in exactly the right position, I press it down firmly on the strip and it's located. I then turn the mount over carefully and the other three sides can be stuck down.

After first checking you have signed it, put the picture and the mount in the frame and fix the hardboard backing in place. Then turn the whole lot over and look at the front of the frame to make sure there are no odd bits or crumbs of eraser showing behind the glass. These two checks may seem trivial but not doing them has cost me many hours of extra work over the years. Other hazards are finger marks on the inside of the glass which sometimes only show up in certain lights.

Now to put the hardboard back on securely. The old method was to tap panel pins in with a hammer. Much better however are the triangular things that professional framers use in their 'space guns'. I worked out a way of putting them in my frames without the hand gun, which is expensive, by using a steel rule and pliers as shown.

Far left: Using the professional type gun.

Left: The use of pliers to squeeze in the triangular darts. The steel rule is to protect the outside of the frame.

The picture should now be sealed by cutting four strips of gummed paper and taping them over the frame and hardboard backing.

I have a perfect gadget for putting in the hooks—an old pair of dividers. First it measures an equal distance down each side for the holes. I then use them to make the hole and, finally, by putting the two arms at right angles I can wind the screw eyes in with it, like a starting handle, quickly and painlessly—I should patent it!

I use nylon cord for hanging—very strong and easier to handle than wire.

I finish off by putting a sticky label on the back with my name, address and 'phone number—you never know, they might want to buy another painting at a later date.

One of my pet hates is non-reflecting glass. To me it makes the whole painting look as if it has been done on a milky plastic, so please don't use it for watercolours.

Below: Using the old pair of dividers to measure the distance, make the holes, and as a lever to wind in the screw eyes.

Marketing

This sounds a grandiose title for a chapter but all it means is the art of getting your painting on someone else's wall. This could involve dealing with the press, local or otherwise, organising your own private exhibition at home or negotiating with galleries, restaurants and pubs.

Artists as a breed are generally very bad at promoting themselves. They are inclined to hide themselves away and expect people to search them out without help, not realising that their paintings are merchandise which have to be actively sold in the same way as any other good product. Even if you're not going to earn your living from painting entirely it's a great feeling that people want to pay their hard earned wages for your work. It helps to bring that vital confidence in yourself.

There's an awful lot of rubbish talked about art being somehow above filthy lucre. You often hear art students talk loftily about not being willing to prostitute their art for mere money. What they are really saying is that nobody wants to buy it! When I found myself at the end of a fairly lucrative nine to five industrial job with my future prosperity entirely dependent on my wits I realised it wasn't just a case of learning to paint in as short a time as possible but of selling my work in enough quantities to keep my wife and myself, two sons, four cats and a dog and twenty-two radiators in the manner to which we had become accustomed.

Luckily, among my previous careers I had been a publicity and public relations manager with a large industrial company for twelve years. I was determined to apply all my skills as a publicist and experience of dealing with local press to promote myself and my work, and I want to pass on to you a few worthwhile tips in this direction.

Even if you think that you may never want to promote yourself you may wish to apply this knowledge to your art society. Good publicity can make all the difference between a well attended and successful exhibition and a sparsely attended disappointing one. There's a lot of general misunderstanding about 'the press'. Let's say you have an exhibition coming up soon. The usual thing is for the art society to take an ad in the local press and invite them to attend the opening night, hoping for a good notice in a week's time. So far, so good. But what you really want is plenty of editorial before the show starts to get the public to your door and not just a pat on the back at the end. This is where the

misconception occurs. People usually think you have to go cap in hand to get an editorial mention beforehand and the newspaper will probably only give you one if you take a big advertisement.

The truth is that most local newspapers are crying out for news to fill their pages every week and, anyway, the advertising and editorial departments are quite separate, with different jobs to do so they function independently. If you present your information to the editor in an interesting businesslike way in plenty of time to meet the copy date he is usually only too pleased to use it. The proper way to do it is to prepare a press release. This means that you write your story in a certain way, using very basic rules. First, you try and think of a good headline, this is very important. It should be short, pithy and as newsworthy as possible. For instance, I had a recent exhibition in Sydney and the headline I wrote was 'Local Artist's Personal Export Drive'. The first paragraph should then contain the whole story in brief, written of course in the third person as if the reporter had interviewed you. The next few paragraphs fill in more of the details and some of the background material, such as the great success of your last year's exhibition, and some details of the famous personality who is going to open your show.

Put some of the information in quotes (newspapers love quotes). If this is well written and typed with double spacing the chances are the whole thing will be sent straight to the compositors intact. This is usually more effective than an advertisement and, of course, is free. The usual method is to try and tie the two up in the same edition.

A good clear photograph of, perhaps, members putting up pictures helps too. I must admit, a picture of a beautiful woman adjusting one of my watercolours on the wall has sometimes publicised one of my one-man shows.

Measure the current width of your local paper and trim your photograph to fit either one or two columns. Everything you do to make life easier for the editorial staff pays dividends handsomely. Of course, if you can get on christian name terms with your local editor so much the better.

Now to actually selling your paintings. At the beginning I tried every trick in the book and I found the important things were opportunism and a certain amount of bravado. The conventional way, of course, is to join an art society and show your work at their exhibitions but I'm afraid I was a little too impatient for

The type of pre-exhibition photograph that few local newspapers can resist—a beautiful woman.

that. If you're painting on holiday other holiday makers are a good start. They're usually very willing victims because they want a souvenir of their visit, especially if they can tell their friends they actually saw it painted. Of course, everyone is much more willing to part with their money on holiday, or seaside gift shops would never survive.

One point, always have a few mounts with you as a mount can make a painting worth double, especially to the uninitiated. I hope you don't think I'm trying to teach you to sell by deception, anyway, the public is usually much more discerning than it first appears. (My tongue is firmly in my cheek.)

My own most important leap forward was to go to a local pub with some pictures under my arm and persuade the landlord to put one or two up on the wall. Luckily, they started selling from the bar quite quickly and I soon infiltrated my paintings along the corridors into the restaurant and eventually upstairs into the guest's bedrooms. I've rather made this sound like dry-rot spreading but I did finish up with about twenty paintings turning over at an average of two or three a week and the landlord was quite content with 10%—at first anyway.

Quite apart from the money it was a useful experience for it taught me a lot about what the buying public likes and does not like.

When your work is at a conventional exhibition folk are on their best behaviour and often make cooing noises out of politeness, however, when your paintings are hanging in a pub people are much franker, especially when they've had a few. It was quite interesting to sit quietly at the bar listening to remarks which they made, not knowing that I was the artist. This can be

153

an illuminating and sometimes chastening experience.

Another idea I tried earlier with some success was to send invitations out to an exhibition of paintings at my own home. I then took all the normal pictures off the walls in two or three rooms and put up about fifty of my own paintings. I stocked up with plenty of bottles of wine and cheese and typed out a catalogue with the prices. People arrived in large numbers, some I suspect out of curiosity, but within an hour buyers were queueing up at my desk with cheque books in their hot little hands and I sold three-quarters of the paintings in one evening with, of course, no commission to pay anyone.

Professional galleries are another matter. Sometimes they can be rather daunting places to enter, with their air of sophistication and exclusiveness, particularly if you're standing there timidly with your precious work wrapped up in a piece of scruffy brown paper, you feel about six inches high. Again, the image is often misunderstood. Galleries are always on the look-out for new talent and they need good saleable work to replace their stock.

I usually approach the gallery as a potential customer, looking round quietly to size the place up. If they're only dealing with oil paintings or abstracts I don't usually go any further but if I see some good watercolours around I chat to the owner, gently bringing the subject round to a possible appointment to show my own paintings.

Always try and show your work in as professional a way as possible. I can't over-emphasise the importance of presentation. Of course you can't cover up lack of talent but first impressions count, and there's nothing worse than trying to undo the knots in string while the gallery owner looks at his watch impatiently. I usually take about twelve of my best paintings in good mounts with perhaps an acetate overlay on each one. These I put into a good quality portfolio and, of course, I always try and arrive at the appointment on time. The gallery probably won't buy your paintings from you outright but they may agree to try them out on their walls on a sale or return basis. Commission varies a lot but, generally, it's about two thirds to you and one third to them.

The crunch comes when they ask you how much you want for them. Don't underprice them just to get your foot in the door. If they've already agreed to put your paintings on their walls they've acknowledged that your work is comparative with the existing pictures and you should already have done your home-

work beforehand and looked at the average prices. The gallery will soon tell you if your work is priced too high and you can come down a little but you'll find it difficult to do this in reverse.

I often turn the tables and ask them as professionals how much they consider the selling price should be, knowing I'll get two thirds of that.

Now to one-man shows in galleries. These are obviously what every would-be painter aspires to, but first let's not be carried away. They are always somewhat of a financial risk, so don't jump on the bandwagon until you're fairly certain that your work is acceptable to the buying public in sufficient quantities and at the right price. The soundest way of doing this is to try your work out at various galleries in small quantities and wait for results. As you sell your pictures try and get the name and address of the buyer, this will enable you to build up a mailing list for your future one-man show. A good mailing list is essential for its success.

I've found, once you've got clients who like your style they tend to stick to you and a fair proportion periodically come back for another and another. I've got a married couple who give them to each other as birthday presents.

In commercial parlance this is known as 'brand loyalty' and is to be encouraged.

Let's say then that you've decided your work is well enough known locally to have your own one-man show and you've persuaded a gallery to lay it on. Let's look at the outlays first. The cost of frames for about fifty to sixty paintings is not inconsiderable, but my idea of standardising on *page 146* means that none need to be wasted should some not sell. Invitations should be printed and sent out. Usually the gallery has its own list of customers or potential buyers but all your own friends and business associates should be persuaded to attend. What you musn't expect is that nearly everyone you invite will come. You'll get 50% if you're lucky but it could be as low as 20%.

Then, of course, at the private view you'll be expected to provide the obligatory red and white wine and the sweet and dry sherry—usually obtained on a sale or return basis, with borrowed glasses, from your local wine merchant. Don't forget the press releases and advertisements as I've already mentioned.

I hope by now that I've scotched the illusion that exhibitions are just a matter of painting pictures. But having said all that,

it's a wonderful feeling to be standing there in your best suit surrounded by all your paintings, greeting your guests and making small talk, accepting the accolades from friends with suitable modesty. But don't forget to watch for representatives from the press and be especially helpful and co-operative with them. Pose obediently by your best picture for them and all the time be watching out of the corner of your eye for the red stickers to appear.

Don't think I'm being a cynic—I've been through all this about twenty times before as I write this. I work late nights and early mornings beforehand trying to meet the deadline (I always procrastinate for weeks before I start a collection) but I thoroughly enjoy the private views. I believe, however, you should always regard these things with a twinkle in your eye—it stops you from getting too pompous.

I've said earlier that opportunism plays a large part in marketing your wares. Let me give you just two examples. I went to Dalers in Dorset and managed to persuade them to let me demonstrate on their stand at the big annual art material trade fair in Milan. I painted to large crowds, eight hours a day and during this time one gentleman pressed a card into my hand and said, 'I like your work, would you like a one-man show at my gallery in Luxemburg?' I of course said 'Yes' and I now exhibit there every eighteen months—usually a sell out, I'm glad to say.

Another chance meeting was on the tiny Greek island of Paxos where I was on a holiday. As I was painting a church somewhere in the middle of the island two photographers came along and said they wanted a picture of an artist in the brochure they were producing for a travel firm. It turned out the company wanted to start painting holidays to fill the villas at each end of the season. Sensing an opportunity, I wrote to the firm offering my services as a tutor which lead to thirteen memorable and profitable trips.

What I'm really trying to say is that self employment as an artist means that you have to develop sensitive antennae to detect opportunities as they present themselves and what is more important, do something about them quickly.

One meets so many people who 'often thought' of doing this or becoming that and then perhaps envy the folk who have stuck their neck out and done them. You need your fair share of luck in all this, of course, but you need to be ready to take advantage of this luck when it comes along.

What of the future?

I believe we're at the beginning of a new era in watercolour—a sort of watercolour renaissance. I hope that doesn't sound too trite or presumptuous in talking about something that has been around for hundreds of years. But, apart from the few notable exceptions like Turner, it's always been regarded through the ages as a second-class art form, lacking the prestige of oils and always considered too fragile and delicate in scale to compete in the same league. The old masters used watercolour a lot but mainly as preliminary sketches for their big, dramatic oils.

The fragility label has, I think, been disproved. Apart from the fact that watercolours obviously need glass protection, a 200-year-old watercolour, painted with non-fugitive colours will probably be in as good condition as the day it was painted, whereas an oil painting of the same age will have cracked and darkened considerably.

From the point of view of price too the gap is narrowing. In the past, watercolours have never been able to command the same sort of money as oils. However, very high prices are now being paid for imperial sized watercolours by the top artists.

Perhaps buyers in the past have tended to value paintings by the square inch as well as for their quality and, of course, most of the traditional watercolours have been very modest in size. Quoting from personal experience, I've been amazed how much more money people have expected and been willing to pay for a painting just because it's been done on a larger piece of paper. Although it may have taken little if any longer to paint than a small one—I've just used larger brushes.

In the relatively short time that I have been visiting art societies to demonstrate, I have noticed a very definite change of emphasis from oil painting to watercolour. It would be interesting to know if there has been a swing in demand for comparative art materials from the manufacturers.

In the big national exhibitions I'm convinced that the quality of work in the watercolour sections is often far superior to that of the oil paintings.

But where is watercolour going in the future? It's already grown as we said, from the medium once used almost solely for sketching and minor work to one on the same level as any other mediums. It's constantly changing too as artists explore new ways of using it.

Coming to you, yourself as a painter, once you have mastered

What of the future?

your tools and become reasonably proficient, don't rest on your laurels and get into a comfortable routine of producing efficient saleable works. It's fairly easy to tread the conventional road accepting the admiration of those immediately around you who haven't mastered the medium quite as well as you have. You can easily find yourself on a plateau of achievement where you can stay for years without progressing.

What I'm really asking you to do is stick your neck out a bit and start exploring unknown areas of watercolour.

Discovery comes from a strong desire to find another way of doing things. Of course, you can't do this without risk and the distinct possibility of ruining that piece of paper you've paid good money for. Risk is part of the process of reaching success. Watercolour is, by its nature, a risky business, that's all part of the excitement and I for one wouldn't have it otherwise.

Once you've accepted the risk element you've got a chance to develop further—but just expect that a lot of your paintings will end up as glorious failures.

I have a little pile of them in a drawer in my studio, face down, so that I can pick them out one at a time and enjoy painting something wild on the back without any qualms. Every now and again a real winner comes out.

When you're touring an art gallery, you're inclined to look at a famous artist's work on the wall and assume that they always come out like that—they don't. If he's anything of an innovator he has his pile of failures at home too. It would have been impossible for him to have developed so far without them.

Deliberately plan to explore new ideas in the next year or so and develop your own personal involvement. Don't be content to mimic someone else, however much you admire them and their techniques, any more than you would try to forge their signature. Be yourself.

Personally, I can hardly wait for the next twenty years. Unlike other professions there's no such thing as a retired watercolour painter. I'm hoping that my work will change and develop year by year. At least I'm determined my painting won't become stodgy or safe.

The future looks exciting and I'm determined to go on painting (and, hopefully, making a living) until I'm dead—it's like an insurance against old age—whoopee!

Index